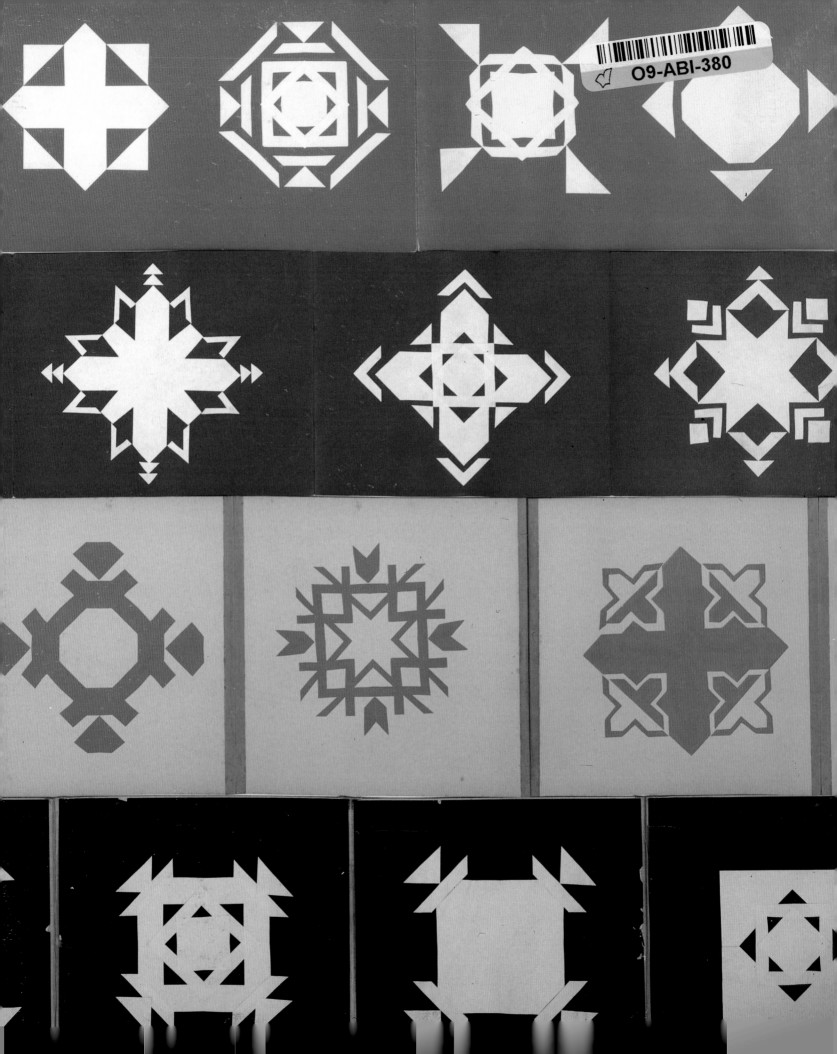

Inventing
KINDERGARTEN

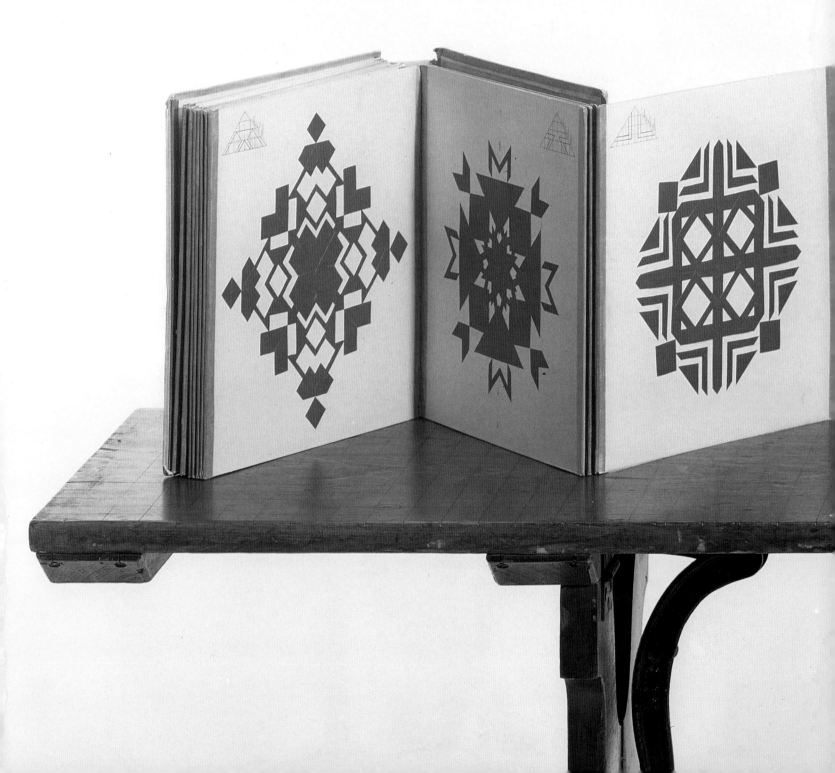

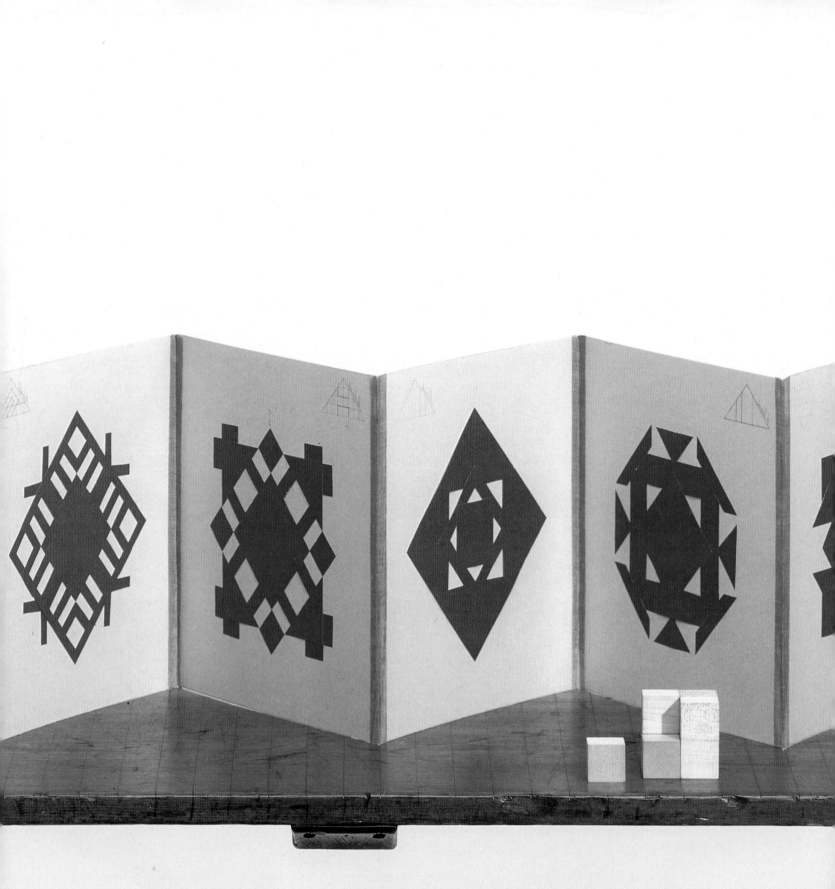

With original photography by Kiyoshi Togashi

Inventing KINDERGARTEN

NORMAN BROSTERMAN

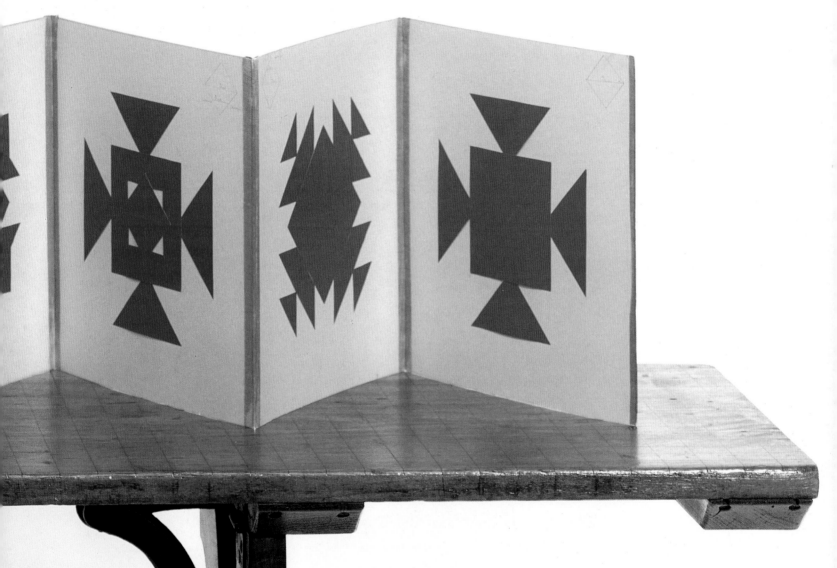

Harry N. Abrams, Inc., Publishers

In memory of
my grandmother Etta Walker
and my friend Richard Miller

Editor: Eric Himmel
Art Director: Samuel N. Antupit
Designer: Liz Trovato
Photo Editor: John K. Crowley

All works reproduced in this
book are in the collection of Norman Brosterman, unless the caption indicates otherwise.

Library of Congress Cataloging-in-Publication Data
Brosterman, Norman, 1952–
Inventing Kindergarten / Norman Brosterman; original photography by Kiyoshi Togashi.
 p. cm.
 Includes bibliographical references and index.
 ISBN 0–8109–3526–0 (clothbound)
 1. Kindergarten—History—19th century. 2. Kindergarten—History—20th century.
3. Kindergarten—Methods and manuals. 4. Fröbel, Friedrich, 1782–1852. 5. Art, Abstract—History—20th century.
6. Architecture, Modern—20th century. I. Togashi, Kiyoshi. II. Title.
LB1199.B76 1997
372.21'8—DC20 96–27191

Frontispiece:

Grace A. Lynde. Album of exercises for the thirteenth gift (paper cutting). United States, c. 1890. The album has been photographed, along with the cubic blocks of the third gift, on a six-foot-long kindergarten table manufactured by the Milton Bradley Company, Springfield, Massachusetts (patented 1893)

From the second half of the nineteenth century until 1930 or later, part of the required training for kindergarten teachers entailed making design work (cut paper in this case) and collecting it in albums. These albums, typically bound accordion-style, were sold specifically for kindergarten work, but blank books, Victorian scrapbooks, and homemade books were also used. The collection of original albums from which the images in this book were photographed constitutes an extraordinary record of the creativity of these otherwise untrained, almost exclusively female, artists. Children's work, similar but simpler, was often also saved and where shown herein is identified as such.

 The kindergarten table, available in different lengths from several manufacturers, is distinct from other furniture in that its entire top is scored with a grid of one-inch squares. Its folding legs were designed to facilitate clearing the classroom for dancing and group games.

CONTENTS

PROLOGUE: SEED PEARL OF THE MODERN ERA

ON OR ABOUT DECEMBER 1910, HUMAN CHARACTER CHANGED

When she made this understated observation in 1924, Virginia Woolf was recalling her response to an exhibition of Post-Impressionist art.[1] The tentative dissolution of pictorial reality in the paintings on view had been, to her, a portent of great changes to come, and, like many people who lived through the last decades of the nineteenth century and the early decades of the twentieth, Woolf needed no persuading that her time was different from any that preceded it.

Remarkable advances and achievements were made in every aesthetic, scientific, and intellectual realm as nineteenth-century linearity fractured into twentieth-century uncertainty. Literature was enriched with the works of Thomas Mann, Marcel Proust, and Guillaume Apollinaire, the boundaries of music were permanently expanded by Igor Stravinsky and Arnold Schoenberg, and Sigmund Freud and Edmund Husserl revised Europe's views on the nature of sexuality and human existence. Particle physics and nuclear fission's aspirations and nightmares were born concurrently as Max Planck, Ernest Rutherford, and Niels Bohr penetrated the heart of the atom. Albert Einstein, intuiting nature's abhorrence of stasis, postulated the equivalency of matter and energy, and turned three hundred years of self-confident Newtonian mechanics on its head. The architecture of Frank Lloyd Wright and Walter Gropius signaled a long-awaited, and definitive, rejection of the obsessive historical revivals of the nineteenth century, and Le Corbusier's early structural experiments foreshadowed the subsequent development of the International Style. And Georges Braque, Pablo Picasso, Piet Mondrian, Marcel Duchamp, Kasimir Malevich, Wassily Kandinsky, Constantin Brancusi, and Umberto Boccioni, among many others, successfully overthrew most of the conventions and traditions of Western painting and sculpture while inventing an entirely new aesthetic universe.

"Modernism," the confluence of historical, artistic, scientific, psychologi-

Left:
Ruth Taylor. *Rainbow Mat,* beauty form made with the fourteenth gift (paper weaving). United States, 1917

Right:
Paul Klee. *May Picture.* Weimar, c. 1925. Oil on cardboard, 16⅝ x 19½". The Metropolitan Museum of Art, The Berggruen Klee Collection, 1984

cal, and philosophical currents that breached the banks of Western civilization after the turn of the century, has been the focus of countless investigations. Although historians have pondered the influences and effects of this cultural upheaval, particularly in the plastic arts, few have been guileless, or perhaps foolish, enough to suggest any simple reason for society's sharp turn and quick acceptance of a radical new visual paradigm at that particular point in time. Attempts at a convincing exegesis tend toward the general—democratic stability (or instability), psychosexual emancipation, the "machine age"—or the specific—Paul Cézanne's brushstrokes, say, or African sculpture. Cubism played an obvious defining role, subsequently sparking the birth of a swath of similarly intellectual, geometric, and architectonic aesthetic movements, including Suprematism, Futurism, and Neo-Plasticism. But prior to their appearance upon the stage of history before World War I there would seem to be little to relate, and nothing to unite, the diverse pantheon of artists and architects mentioned above, except the obvious fact of their birth in the second half of the nineteenth century.

There was, however, an international force for change of dramatic potency that never appears in discussions about the roots of modern art and is only rarely mentioned as an influence on the movement's pioneers. The Victorian childhood of the seminal modernists and their audience at large coincided with the development and widespread embrace of a radical educational system that was a catalyst in exploding the cultural past and restructuring the resulting intellectual panoply with a new worldview. It was never fodder for argument over absinthe and Gauloises in Montmartre cafés, nor was it taught at the tradition-bound academies. It has been largely ignored because its participants—three- to seven- year-olds—were in the primary band of the scholastic spectrum. It was the seed pearl of the modern era and it was called kindergarten.

Introduction: A Nineteenth-Century Invention

Red, white, and blue bunting was in short supply in 1876 as communities across the country celebrated America's official hundredth birthday party. Patriotic Mecca was in Fairmount Park, Philadelphia, where from May to November more than eight million paying guests attended the Centennial Exposition, the largest world's fair ever mounted and the first in the United States. It was a fantastic display of unprecedented size and complexity, overflowing with the homemade and homegrown products of burgeoning Reconstruction America. The God-given freedoms that had been wrenched from England a century before and would be the theme of countless speeches and fireworks displays during the centennial year had been vehemently tested a scant ten years earlier in the democratic slaughter of the Civil War. Reinforcing the strained brotherhood of North and South was one of the conscious motivations for the fair, and the participation of every state from Massachusetts to Mississippi was welcome evidence of the strength of the Union.

The Centennial Exposition marked a turning point for the country's self-image and the beginning of American prominence in the community of nations. Although the predictive, futuristic displays that would become the hallmark of later world's fairs were not yet prominent, the seeds for several remarkable, indeed earth-shaking, advances were in evidence. The immensity of Machinery Hall was filled with steam hammers, screw-cutting lathes, walking-beam engines, and modern machines of every imaginable function that were propelling Western civilization into the technological future. The first electric-arc lighting in America was demonstrated at the hall, but its puny spark could hardly match the attraction of the thirty-foot-tall, 1,400-horsepower Corliss steam engines that dominated the very center of the huge building.

Opposite:
The Kindergarden
(*sic*) Cottage in
Fairmount Park.
Stereoscope photo-
graph by the
Centennial Photo-
graphic Company,
Philadelphia, 1876.
The Library of
Congress,
Washington, D.C.

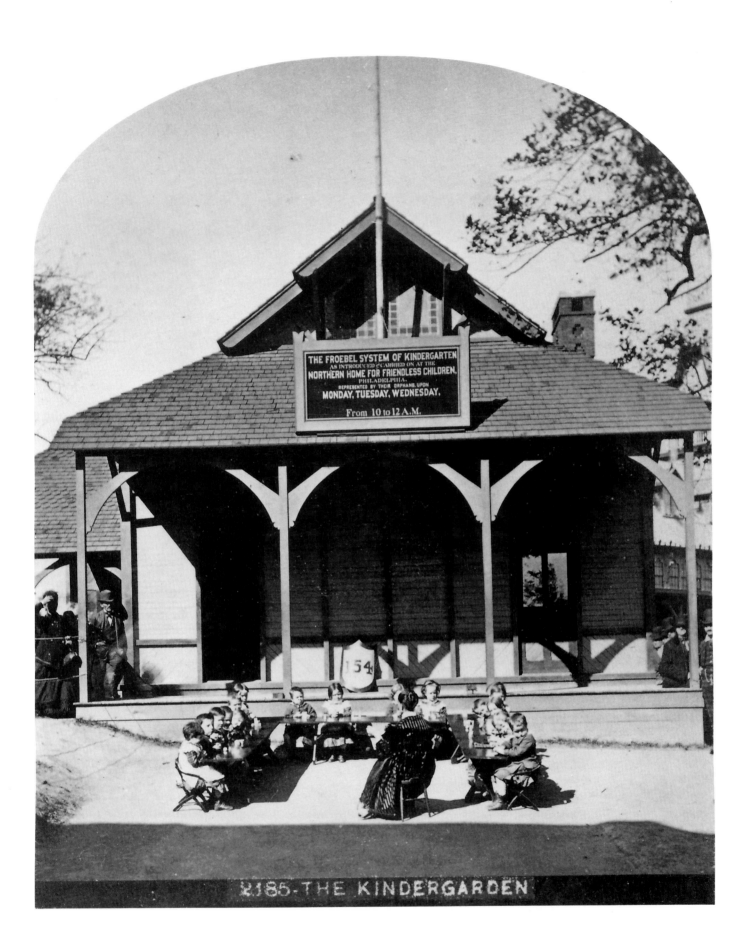

2185-THE KINDERGARDEN

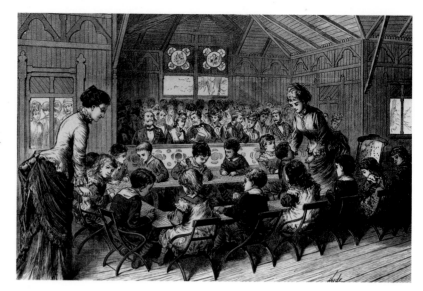

An un-Froebelian alphabet block is the only false note in this artist's view of the Centennial Exposition model kindergarten class. Engraving from *Frank Leslie's Historical Register of the Centennial Exposition,* New York, 1876

Here were the typewriter and the elevator; the gas cooking stove (an understandably popular display, although twenty years ahead of its wide acceptance), and Bell's telephone, patented just two months before the opening ceremonies.[1]

The Centennial Exposition was nothing less than a giant, engaging party for its lucky guests. Religious piety kept the fair closed on Sundays and smoking was banned, but alcohol was not. Noisy eating establishments and brassy bandstands were scattered throughout the 236 acres of lawns, paths, and roads laid out on the western edge of Philadelphia. Soft-drink stands offering a variety of flavored syrups with water or giddy, newfangled carbonated beverages dotted the fairground. Charles E. Hires promoted his Root Beer with demonstrations of its manufacture from dried roots and spices.

Linked by a four-mile, asphalt-paved loop road, a great novelty to the many tourists from rural America, almost two hundred buildings, pavilions, stands, and other structures were erected amid the gardens, ponds, and commemorative fountains of Fairmount Park. Included were Horticultural, Agricultural, and Pomological Halls, several Art Galleries, a Photographic Gallery, the Bible Society, and a Judge's Hall. There was a Shoe and Leather Building, a Butter and Cheese Building, the Singer Sewing Machine Building, the Gliddon Guano Building, the Yale Lock Building, a Glass Factory, three or more Newspaper Buildings generating continuous, nationwide press for the fair, separate pavilions for the many foreign countries participating, and even the arm of the Statue of Liberty.[2]

According to the adult reminiscences of her son, Frank, Mrs. Anna Lloyd Wright of Boston was one of the many visitors to take advantage of the railroads' special excursion rates. The building whose display most intrigued her, and would ultimately have the greatest cultural impact, was one of the smallest and most easily overlooked. A modest structure, actually an annex to the Women's Pavilion and small enough to have been omitted from some of the many guide maps sold at the fair, this revolutionary pipsqueak was called the Kindergarten Cottage.[3]

In 1876, kindergarten was a recent import to American shores, and Anna Wright was immediately impressed with the "fancy work" of the model class. She was fascinated by the systematic clarity of the toys and games and intrigued by the theoretical notions of "unity" expressed by Ruth Burritt, the young teacher in charge. Depending upon the day's activity and the age of the students, Mrs. Wright would have had the opportunity to observe the children engaged in active play, singing and dancing, and in focused concentration, seated at long, low tables with orthogonally gridded work surfaces, creating geometric designs from small pieces of wood, colored paper, thread, or wire. Convinced that the primary, structurally unified kindergarten activities would engage her own son and help him develop the skills of a great architect—as she had intended even before his birth—she excitedly returned to Boston and purchased for nine-year-old Frank a set of educational toys known at the time as Occupation Material for the kindergarten, or Froebel gifts, and also enrolled in a weekly training course that would enable her to teach the use of the gifts in the contemplative sanctum of her own home.

2352-KINDERGARTEN

A gridded blackboard with examples of abstract "net drawing" stands behind the orphans selected for the Centennial Exposition model kindergarten class. Stereoscope photograph by the Centennial Photographic Company, Philadelphia, 1876

Late in his brilliant and varied career, Frank Lloyd Wright credited his boyhood experience with the Froebel gifts as the foundation of his architecture.[4] Historians, aware of his propensity to exaggerate and even fabricate autobiographical detail, have been both intrigued and skeptical about Wright's claim that the kindergarten materials influenced his designs.

Is it plausible that kindergarten shaped Wright's aesthetic imagination? This question begs to be answered in the light of his trailblazing role in the history of both American and European modernism. If the answer is "yes," as I believe it is, then a further question presents itself: was Frank Lloyd Wright unique in the way his adult sensibilities were so profoundly molded by this simple set of widely available educational toys?

NINETEENTH-CENTURY CHILDREN/ TWENTIETH-CENTURY ART

Kindergarten has been around so long, and is so familiar, that it is natural to assume personal expertise on the subject. After all, kindergarten is . . . kindergarten. Memories of those sunlit days include drawing, paper-cutting, block-building, modeling with clay, singing and dancing, as well as observing the workings of nature—the growth of plants, the symmetries of crystals and seashells. One's teacher was usually a woman and she led the class in activities that would have been considered *play* outside the schoolroom.

All of these have been conventions of kindergarten from its beginning, and that beginning is well documented. The word *kindergarten* may be found in the dictionaries of a host of disparate languages, including English, Spanish, German, and Japanese. It is one of life's most familiar shared milestones. Although founded on classically democratic ideals, it is not a modern mutation of some ancient pedagogy. Only concepts and conventions of the world's great faiths match it in linguistic and geographic breadth, yet kindergarten, initially spiritual in the purest sense, was not a religion. Utilized creatively, it was designed to reveal the universal language of God, but it was not a standard sacrament or holy rite. It did not evolve from an older social construct or tradition. Its birth was the seed for cultural advances that were impossible to anticipate, and its presentation at the Centennial Exposition amid all that was up-to-date, modern, and prescient in society was entirely logical, for like the elevator and telephone, kindergarten, the garden of children, was a nineteenth-century invention, and it changed the world as surely.

Indeed, its early history is not obscure in the least: a German crystallographer and pedagogical revolutionary named Friedrich Froebel developed kindergarten and its play gifts in Germany during the 1830s as a teaching system for young children, opening the first one in the town of Blankenburg, Germany, in 1837. After Froebel's death in 1852, kindergarten was successfully transplanted to most of the countries of Europe, their colonies, the United States, and the Far East. It became entrenched in Russian life before the Revolution, and, as with Marxism, its embrace there promised a better, more equitable world for the working class. Like Napoleon, it conquered Prussia and the Austro-Hungarian Empire, but its influence was greater and far more lasting. The first Japanese kindergarten was established in Tokyo in 1876, and by 1900 there were two hundred kindergartens in Japan.

Unfortunately, kindergarten for us, and for most of the generations born in this century, was a distortion, a diluted version of what originated as a radical and highly spiritual system of abstract-design activities intended to teach the recognition and appreciation of natural harmony. Kindergarten's universal, perfect, alternative language of geometric form cultivated children's innate ability to observe, reason, express, and create. Its ultimate aim was to instill in children an understanding of what an earlier generation would have called "the music of the spheres"—the mathematically generated logic underlying the ebb and flow of creation. The explicit, programmatic goal of the early kindergartens was to awaken the senses to what Froebel considered to be the God-given structure underlying all growth—

animal, vegetable, mineral—in nature. The gifts were intended to be nothing less than a model of universal perfection and the key to recognizing one's place in the natural continuum. Froebel believed that learning the sacred language of geometry in youth would provide a common ground for all people, and advance each individual, and society in general, into a realm of fundamental unity.

That exuberant curiosity is children's most important learning asset was not acknowledged until Froebel's time. The twenty gifts and occupations he created were designed to harness and direct this natural impulse, all the while maintaining the impression that classwork was mostly fun and games. The swift dissemination of the radical, and curiously metaphysical, kindergarten system in the third quarter of the nineteenth century was due in part to the fact that in most countries at that time there was no prescribed early education whatsoever. The women who flocked to preach the kindergarten gospel eagerly grasped the opportunity to make what they hoped would be substantive, societal improvements for children *and* themselves, from two of the few acceptable power positions open to them—early childhood education and young motherhood. Although remnants of the original Froebelian system are still detectable in kindergarten classes today—particularly the emphasis on handicrafts and block play—the gifts, the solemnity in which they were used, and the spirituality they were designed to awaken are long dead.

During the system's heyday—roughly the half century before World War I—Frank Lloyd Wright was merely one of *millions* of people, including most of the so-called "form-givers" of the modern era, who were indoctrinated, in effect, programmed, by the spiritual geometry of the early kindergarten.

The kindergarten training that had shaped Frank Lloyd Wright's imagination and enabled him to envision the future of architecture and design is today merely a footnote in architecture and education curricula. Within a few years of Wright's experience in Boston, however, many other sensitive nineteenth-century youths would also master the abstract language of the early kindergarten. In Switzerland, there were the young Charles-Edouard Jeanneret, who grew up to be Le Corbusier, the brilliant architect and theorist whose influence is still pervasive today, and Paul Klee, indefatigable painter and teacher who mined the rigorously simple, spiritually expansive iconography of the gifts throughout his life. In Germany and Austria, there were Walter Gropius, Josef Albers, and Johannes Itten, founder and masters, respectively, of the Bauhaus, the Western world's most influential design school, and Wassily Kandinsky, one of the first champions of Non-Objective Art, who absorbed kindergarten's colors, geometric forms, and implicit celebration of abstraction as a viable artistic language from his early exposure to the gifts while living in Florence as a child. In Holland, Piet Mondrian and Theo van Doesburg, founders of De Stijl, cut their Neo-Plastic teeth on the grids and kaleidoscopic pinwheels devised by Froebel in the 1840s; while in Argenteuil-sur-Seine, on the outskirts of Paris, the coinventor of Cubism, Georges Braque, like most of the children of late-nineteenth-century France, would have begun his education in a class where the daily coursework entailed making *pictures* of the world—with small triangles and cubes.

I FRIEDRICH FROEBEL

NATURE Friedrich Wilhelm August Froebel was born on April 21, 1782, in Oberweissbach, a town in the small principality of Schwarzburg-Rudolstadt in central Germany. Nearby Weimar, the ducal capital of this wildly beautiful region of ancient forests and dark valleys, had become world famous at the end of the Enlightenment not as a tourist destination but as the adopted home of Germany's most notable citizen, Johann Wolfgang von Goethe (1749–1832), who moved there in 1775. Both Goethe's writing—masterpieces of Romantic literature and an impressive body of scientific observation—and Froebel's opus—the kindergarten—were rooted in their creators' independent meanderings through the Thuringian countryside. The almost fifty years Goethe lived in Weimar, the first decade of which he spent inspecting the royal forests and curious rock formations as the local duke's administrator of roads and mines, gave form to the intuitive appreciation of nature that became a driving force in all his creations. Froebel found in the same locales inspiration for his life's work.

In a long autobiographical letter penned in middle age, Froebel looked back upon a lonely youth devoid of parental attention. His mother died before his first birthday, and the sting of early solitude colored his entire life. His father, Johann Froebel, was the principal clergyman for several villages, and the care of his dispersed flock left him little time for the youngest of his three sons. Although Johann remarried when Friedrich was four, a new baby distracted his bride from any interest she might have taken in the upbringing of the sensitive boy. Froebel's yearning for motherly love was to be a significant motivating factor in the creation of kindergarten and helps to explain the worshipful, almost sacred, position young women were assigned in the system's administration.

Opposite:
Portrait of Friedrich Froebel. *Century Magazine,* February, 1893

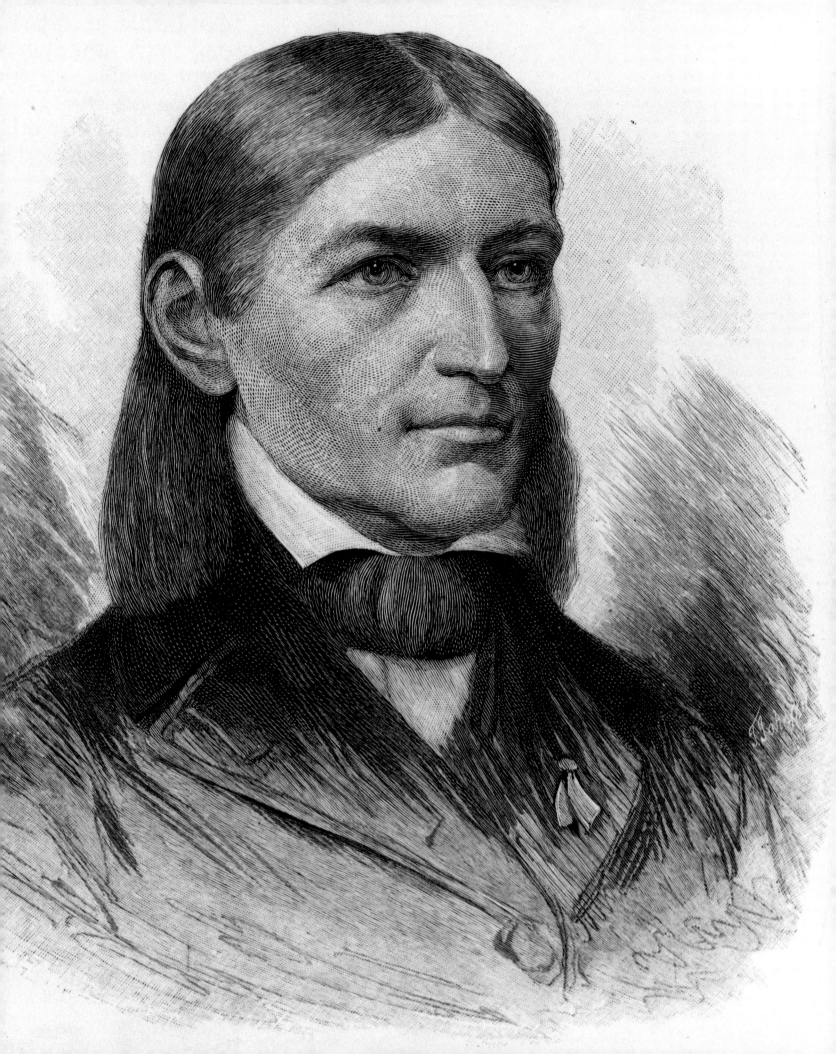

Friedrich scornfully described his father as "a theologian of the old school, who held knowledge and science in less estimation than faith,"[1] but the minister's sermonizing was not lost on the boy: a child of the Enlightenment who became an accomplished student of natural philosophy, Froebel was first of all the son of a Lutheran minister. Despite his embrace of physical science, he remained deeply religious, and all of his theories about nature and human development were inextricably intertwined with aspirations toward God. Throughout his life, his method for reconciling advances in scientific knowledge with the doctrines of Christianity was to transform, in his own mind, the one into the other, so that they became interchangeable.

Friedrich recounted his father's painful attempts to teach him to read, and the muddled and obscure writings of his adult years betrayed his poor language skills. As a teenager, however, Froebel recognized his talent and facility for geometry, surveying, map drawing, and other endeavors that rely on the graphic communication of data independent of language. This emphasis on the concise visual exploration of a system's underlying structure became central to all that he attempted and achieved.

Out of the isolation of his youth—playing alone in the gardens on his father's modest property—Froebel developed an early and unusually fervent love for nature that remained the most intimate spiritual force throughout his outwardly Christian life. Just as they did for Goethe, plants, particularly trees, became for him symbols of human life in its highest spiritual relations. Froebel had many opportunities to compare the disappointment and discord of his family life with the tranquil peace of the life of plants, and he remained in intimate communion with nature until his death.

When Friedrich was ten years old, an uncle on his stepmother's side who lived in the nearby district of Stadt-Ulm, recognizing the stifled, unhappy disposition of the boy and being recently burdened with the death of his wife and only child, requested of Johann Froebel that the child be turned over to his care. Like Froebel's father, Superintendent Hoffman was a well-known clergyman, but while the former was severe, the latter was mild and kind. The mistrust Friedrich garnered for his earlier reveries was here replaced by trust and latitude, and the straits of childhood were transformed to a boyhood of glorious liberty.

Reflecting upon the halcyon years in his uncle's house, Froebel first alluded to the theme that became central to his life and philosophy. Comparing his new freedom with his formerly stunted existence, he described his life as "harmoniously balanced." Harmony, unity, and the reconciliation of opposites are the concepts that formed the theoretical and practical underpinnings of the kindergarten. As Froebel grew they were intuited by the ten-year-old boy, explored by the twenty-year-old student, and put to practical use by the fifty-year-old pedagogue. The idea of the essential unity of nature and life under God, although a mainstay of German Romanticism and of the philosophical idealism that dominated intellectual discourse in Northern Europe during the first half of the nineteenth century, appears

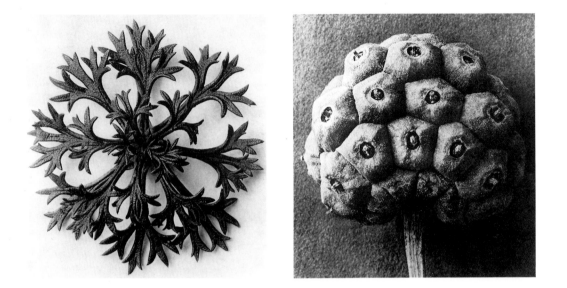

to have blossomed naturally in Froebel due to his own inclinations and the circumstances of his upbringing.

Froebel spent five of the most important years of his life in his uncle's home. At fifteen, he began a two-year apprenticeship to a woodsman in the Thuringian forest. Here, the familiar isolation of his youth was renewed, and Froebel found himself alone with his beloved trees once again. Making good use of his master's small library of excellent books on forestry and geometry and borrowing other texts on botany and language study from a doctor in the nearest town, Froebel reverted to his old habits of self-education, observation, and introspection. His nature walks took him through the still-primeval glens that became the focus of so much German Romantic art, from the paintings of Caspar David Friedrich to the stage sets of Wagner's mythopoetic operas. He closely observed the local flora, collecting and drying specimens for later classification and comparison. The succor he once took from the sermons of his father and uncle was now replaced by his ecstatic interaction with the world of the forest: "My religious church life now changed to a religious communion with Nature."[2]

At the close of his two-year apprenticeship Froebel made known his desire to pursue further study of mathematics and botany and convinced his father to allow him to join his brother in the university town of Jena. This was to be the beginning of a formal education that would proceed in fits and starts for many years. Interspersed with diverse lectures and classroom activities were periods of financial difficulty, military service, and employment as a private tutor, all of which added to the curious melange of experiences that would ultimately blossom into his unexpected and remarkable life's work.

Froebel intended his studies to further his career in forestry and forest management. He heard lectures on applied mathematics, arithmetic, algebra, geometry, mineralogy, botany, natural history, physics, chemistry, accounting, tree cultivation, architecture, house building, and land surveying, and took studio classes in topographical drawing. The lectures that were the easiest for Froebel to comprehend, particularly in mathematics, were those whose concepts were commonly expressed in geometric figures. Given his gift for the visual portrayal of information, he gravitated to areas (like map drawing and geometry) where the problems, as he says, could be "perceived with ease and pleasure." Courses that emphasized the arrangement and classification of physical specimens—mineralogy, biology, and botany—especially appealed to him. His view of nature as a single complex entity whose lessons could be deciphered by concentrated observation was reinforced by the apparent objectivity of early-nineteenth-century science. For example, natural-history lectures describing the mutual relationship of all animals existing in an extended network and what appeared to be a fundamental skeletal structure shared (with variations) by the higher and lower creatures of the world jibed with notions he had previously formed. Although it would be decades before Darwin's evolutionary theories clarified the actual ties that earlier scientists hypothesized, their concepts of biological interconnectedness (a linchpin of

Karl Blossfeldt. Natural geometry. Germany, c. 1900–28

German sculptor and art teacher Karl Blossfeldt (1865–1932) took remarkable close-up photographs of plants that were first published in his books *Urformen der Kunst* (Berlin, 1928) and *Wundergarten der Natur* (Berlin, 1932). Blossfeldt, who began primary school in 1871 in Harzgerode, about one hundred miles from Bad Blankenburg, where Froebel opened his first kindergarten in 1837, held that all of the forms of art could be found in nature and recorded hundreds of examples of living geometry with his camera.

twentieth-century ecology) were easily assimilated into Froebel's personal cosmology. "I could already perceive unity in diversity, the correlation of forces, the interconnection of all living things, life in matter, and the principles of physics and biology."[3] By his eighteenth year, the principle of unity, embracing the spiritual potential within a person, relations between people in a free society, the place of the individual in relation to the nature that surrounds and includes him, and the life force that controls growth in all things, had already become Froebel's true faith.

At the end of the summer of 1801 Froebel had a chance to sample some of his father's editions of the then popular Friedrich von Schiller (1759–1805) and Goethe. These giants of Romanticism, who created a unique literary form that had a defining influence on German art and politics throughout the nineteenth century, were contemporaries of Froebel and famed in their own time. Shortly after this literary encounter, still in need of a settled income and in no position to disobey his father, Froebel was sent to work with relatives to study practical farming—a pursuit that had little appeal to his poetic sensibilities. Nature for Froebel was apparently better appreciated with the senses than engaged with a plow. After Johann's death in February 1802, Friedrich was finally his own master and he moved on.

The next year found him in the former ecclesiastical principality of Bamberg, hoping to find work as a land surveyor: as a consequence of several unsuccessful German campaigns against Napoleon's forces at the end of the eighteenth century, France had acquired all of the territories lying along the left bank of the Rhine, and mapmakers were in demand. By 1805, he had decided on a career in architecture. This, the most technical of arts, might have been an excellent choice for him, given his familiarity with surveying, drafting, geometry, and construction techniques. Despite his apparent lack of discipline, Froebel, a man of curious passions and focused eccentricities, might have become an architect of lasting interest. By veering away from architecture to education at the very last moment, however, he influenced the history of architecture and all the plastic arts beyond any predictable proportion.

PESTALOZZI At this moment, a new path was opened to Froebel, and succumbing to an almost messianic idealism that remained unflagging until his death, he recognized and accepted his destiny. On the advice of a close friend (unnamed in his letters), Froebel cast aside his plans to pursue architecture and in the summer of 1805 accepted a teaching position at the Frankfurt Model School. The self-conscious inscription he left in his friend's album at the time has the ring of the New Testament: "Thou givest man bread; let my aim be to give man himself."[4]

The Frankfurt Model School was fairly new in 1805. Its founder, a man named Gruner, was a protégé of the Swiss pedagogue Johann Heinrich Pestalozzi (1746–1827), and his school was one of the first based on Pestalozzi's progressive pedagogy. Pestalozzi's influence on education and society, through the eventual international dissemination of his techniques and attitudes toward children, was nothing less

than revolutionary. At a time when the poorest children were systematically excluded from obtaining any education, the doors of his school in Yverdon, Switzerland, were opened to orphans and peasants. As the first practical proponent of "natural" education—where the innate desire to learn is nourished and curiosity is unfettered—Pestalozzi abandoned the tradition of interminable lectures followed by student recitation that characterized typical instruction for all age groups, in favor of more active, hands-on activities and what he termed *Anschauung:* "object lessons" or direct, concrete observation. The long reign of pedagogical terror, enforced by flogging, was to give way to voluntary obedience elicited by respect for the dignity of each beloved pupil.

Pestalozzi's impetus for replacing the stultifying conventions of traditional European teaching with pedagogy that emphasized the personal experience of the child supported by loving encouragement (the basis for all modern educational theory) was the strange and radical tract *Émile* of 1762, by Jean-Jacques Rousseau (1712–1778). *Émile*—which was widely read for a century after it appeared—was an unequivocal attack on conventional French society, an attempt to capsize the status quo in the realm of education and child-rearing. The very first line of the book summarized Rousseau's educational theories and served as a guide to action: "Everything is good as it comes from the hands of the Author of Nature; but everything degenerates in the hands of man."[5]

Émile is an imaginary boy upon whom Rousseau can test his theories of education. The treatise follows Émile from birth to age twenty, liberally dispensing advice on all aspects of child-rearing, with an overall emphasis on freedom and the hitherto unrecognized strengths and capabilities of youth. Rousseau implores parents to observe nature as it tests and excites children to activity. At a time when play was generally dismissed as an empty waste of time, he urged his readers to love childhood and encourage its sports, pleasures, and "amiable instincts": "Is it nothing to be happy? In no other part of his life will he be so busy." Teachers in *Émile* are no longer information dispensers but guides, and the child's willpower becomes the agent of his education, as he learns by doing. Books, evil repositories of secondhand opinion, are to be avoided until the child approached the age of twelve. Learning how to read too soon merely interferes with learning how to learn, reason, and be (as Pestalozzi later reaffirmed, "First form the mind and then furnish it"). Free from the meddling of lecturing teachers, children would absorb the lessons of nature (of which they are a part) immediately and in uncorrupted form. "Our first teachers of philosophy are our feet, our hands, and our eyes."[6]

Émile was a battle cry for educational reform from a man who made a career out of clashing with complacent society. Certainly, Rousseau made some perverse assertions in his tract that seem merely misguided now. Never allowing a child to wear a hat, at any age, is funny; preventing the inoculation of a child with the recently perfected smallpox vaccine so he may "take it naturally" is obstinacy in the service of polemics. Yet the grand themes of *Émile*—that childhood is a sacred period of human devel-

opment, that the child's own empirical explorations are the engine of the expanding mind—became the foundation for all progressive education to follow. With our late-twentieth-century sensibilities about childhood—shaped by Pestalozzi and Froebel, Sigmund Freud and Jean Piaget, universal education and child-labor laws—it is difficult to appreciate the shocking impact of Rousseau's ideas, with their emphasis on natural equality and personal freedom.

Within three days of his meeting with Gruner in Frankfurt, Froebel departed for Yverdon for his first brief meeting with the already famous Pestalozzi. With little actual training as a teacher, Froebel was not yet prepared to evaluate Pestalozzi's methods during the two weeks he spent at Yverdon Castle. A former stronghold of the dukes of Saxony that was built on the remains of a Roman fortification, Pestalozzi's school had been in operation only a few months when Froebel arrived. After many years of writing important tracts on education, including the awkwardly titled but highly influential *How Gertrude Teaches Her Children (An Attempt to Give Directions to Mothers How to Instruct Their Own Children)* of 1801, and several abortive attempts at starting schools based on his theories, the gift of the spacious compound from the local authorities was a blessing for the elderly Pestalozzi. For twenty years, until it closed its doors in 1825, this revolutionary institution received a stream of distinguished visitors from all over the world.[7]

Froebel taught in Frankfurt for two years before becoming the private tutor to three young brothers whose parents had set aside a small parcel of meadowland for their use as a garden. Transplanting and tending flowers and shrubs from the surrounding countryside reminded Froebel of his own youthful interactions with nature. The simple games he invented for his young charges confirmed the value of Rousseau's notion of education through action and direct observation and helped to form his notion of the kindergarten gifts.

In 1808, when he returned to Yverdon for a stay of two years, Froebel had greater success in assimilating the teachings of the master. Many of Froebel's ideas, including his motto, *"Last uns unsern kindern leben"* (which was translated as both "Let us live with our children" and "Let us live for our children," but actually means something like "Let us live in an exemplary fashion for our children"), are directly traceable to Pestalozzi's influence, and his first important treatise, *The Education of Man*[8] of 1826, is throughout reminiscent of Pestalozzi's own writings.

Like Rousseau, Pestalozzi frequently compared the development of the mind to that of a tree. Just as nature creates the largest tree incrementally from a single seed, the teacher must endeavor to make gradual additions to a child's knowledge in every action taken. Each new idea thus becomes an expansion of existing knowledge and is understood and accepted as it is compared to that which is already known. The central tenets of Pestalozzi's theories were elucidated in *How Gertrude Teaches Her Children:* 1. To be meaningful, all human activity must be self-generated; therefore, the traditional edu-

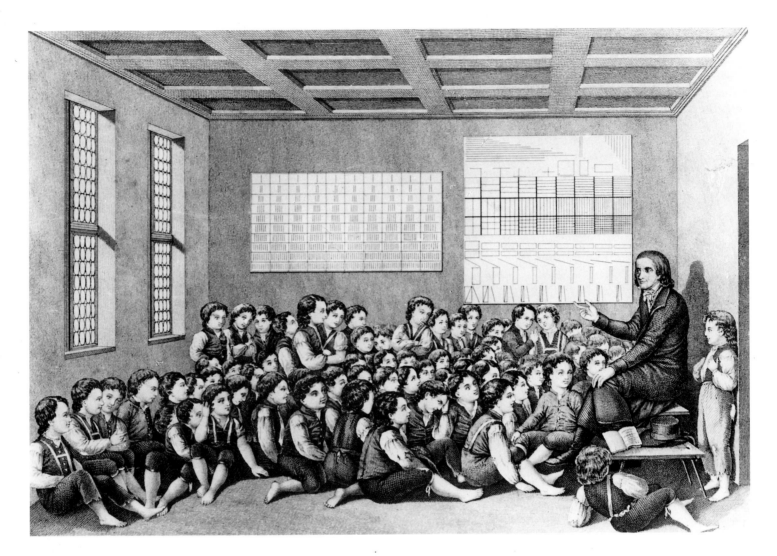

cational methods of rote memorization and mechanical drill are psychologically unsound. 2. Perception, developed by means of number, form, and finally language, is the fundamental source of all learning. 3. Because children learn through active engagement, physical education, progressing from simple to complex movements (whether in hiking, dancing, sports, or organized maneuvers), must be included in the daily coursework. 4. Ethical and moral education develops from the trust and love that are first manifested between mother and child.

Objects were used in the teaching of all classes and the primacy of books was greatly reduced. In arithmetic, tools of perception (apples, stones, and so forth) were used to develop distinct ideas by grouping (addition and multiplication), separating (subtraction and division), and comparing (ideas of more and less). Geography was taught on nature walks, and the terrain was evaluated firsthand. Samples of plants and minerals were collected and later described at school, and the older children (eight to ten years old) made topographical relief maps of the surrounding countryside out of clay. Published maps, with their ever-changing political borders (particularly at that time when Switzerland and most of Europe were under French control), were viewed as valueless abstractions.

The teaching of science was rudimentary. Pestalozzi, parroting Rousseau, urged that "fathers should lead their children out into Nature and teach them on the hilltops and in the valleys. . . . Let the child realize that She (Nature) is the real teacher." History and literature also got short shrift at Yverdon. On the positive side, Pestalozzi was the first to introduce music into the primary-school curriculum as an aid to moral education. The songs that were sung in groups as the students went on their country walks did double duty: most came from the standard Protestant hymnals, but Pestalozzi was less inter-

ested in the religious content of the children's songs than in the music itself, which he recognized as a spiritual and civilizing force that could be appreciated intuitively by even the youngest children.

The traditional educational activity of drawing was greatly emphasized at Yverdon, as Pestalozzi considered it of primary importance in the teaching of writing and the comprehension of form. Recognizing that children manifested a natural "taste for drawing" and, just as commonly, an aversion to the study of letters, Pestalozzi developed techniques that incorporated a combination of both. In their joint publication of 1803, *ABC der Anschauung,* his assistant Johannes Buss went so far as to construct an experimental "alphabet" of form consisting of various segments of lines drawn in the squares of a gridded matrix. Abstract and unintentionally iconographic, the *ABC* was a tool developed to facilitate observation and the learning of writing by fragmenting letters and pictures into their basic components. Pestalozzi hoped to create a method whereby any series of letters called out to little children would be immediately comprehensible in specific visual form.[9]

When Froebel determined to make primary education his life's work, when he set about creating a system for educating the very young, the Pestalozzian insistence on the recognition and appreciation of form before nomenclature was at the forefront of his thoughts. The short segments of line and simple geometric shapes that were components of letters and pictures in Pestalozzi's universe were for Froebel symbolic of the building blocks of *the actual universe. Anschauung* was defined by Pestalozzi as "things before words, concrete before abstract." Kindergarten, designed by Froebel to launch young souls on their lifetimes' passage of spiritual growth, was closer to *forms* before things before words.

CRYSTALS

In 1811, Froebel enrolled in the University of Göttingen. More than ever convinced that the spiritual unity that was the proper subject of human education was manifested in nature's laws, he immersed himself in physics, chemistry, mineralogy, and natural history. The publication of the *New System of Chemical Philosophy* (1808), by the English chemist John Dalton (1766–1844), along with the work of his contemporary in France Joseph-Louis Gay-Lussac (1778–1850), describing the first application of atomic theory to chemistry (c. 1810), was viewed by Froebel as excellent further justification for his personal views.[10] Dalton, by measuring the weights of compounds, and Gay-Lussac, by measuring their volumes, proved what Plato had first proposed before the birth of Christ, that the world *was* made from tiny particles and all the things under the sun were created from different combinations of the same basic units.

The year 1812 found Froebel in the Prussian army, a tour of duty brought to a close by the Treaty of Paris on May 30, 1814, signaling Napoleon's final defeat and exile to Elba. Froebel had received, through the influence of friends, the promise of a post after the war as assistant at the Mineralogical Museum of the University of Berlin under Professor Christian Samuel Weiss, and so the thirty-two-year-

Opposite:
Wood teaching models of crystal forms. Germany, c. 1900

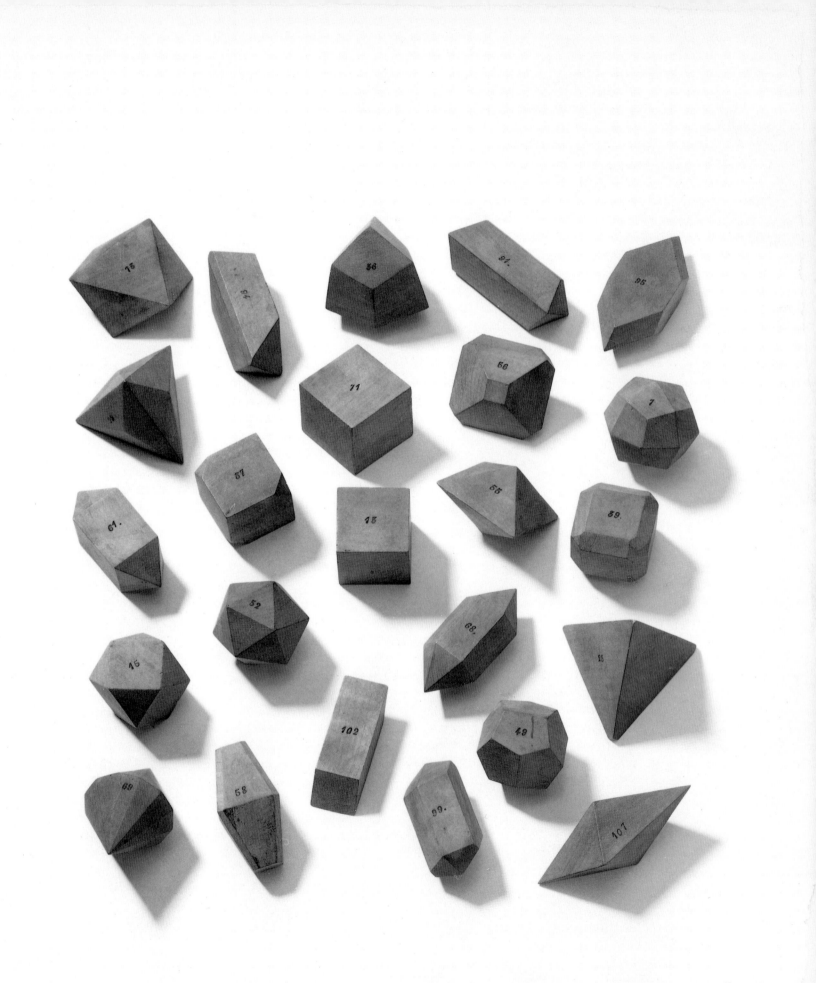

old tyro moved to Berlin, where he heard lectures on mineralogy, crystallography, and geology, and embarked at once on the care, arrangement, and, in part, investigation and description of the museum's crystal collection.

In Berlin, Froebel suddenly found himself near the top of a major scientific discipline. From 1811 to 1815, coincident with Froebel's tenure at the museum, Weiss was in the process of formulating the theoretical parameters and objective techniques of modern crystallography, changing the field from a branch of philosophy to an exact mathematical science. The natural philosophers of the early nineteenth century compiled data and evaluated experimental results without direct knowledge of the forces they were observing, and crystallography, not unlike zoology and paleontology, was a science of speculation. Well before the mid-twentieth century, when the existence of atoms was confirmed with the invention of X-ray diffraction, the naturally occurring forms of crystals were correctly assumed to be external manifestations of the regular arrangement of minute particles in three-dimensional grids. Such grids were portrayed graphically as space lattices of different size spheres—like elaborate store displays of intermingled grapefruit, oranges, and tangerines. It was the genius of Froebel's mentor Weiss to recognize that the number, type, and relative *direction* of a specimen's observable geometric symmetries were a consequence of its unique internal structure and would ultimately reveal its specific chemical composition.

The procedure for determining in which of the thirty-two possible classes in six major groups any crystal sample belongs is still essentially the same as it was when Weiss deduced its parameters almost two hundred years ago. First locate all axes of symmetry, then rotate completely around each and count the number of times identical faces come into view. For example, the cubic form of the common mineral pyrite, or "fool's gold," contains the highest degree of crystallographic symmetry. With rotational axes and mirror symmetry planes passing through all six faces and twelve edges, and rotational axes through every corner, crystals of the cubic, or isometric, group are relatively easy to identify.

Because these geometric symmetries are direct evidence of the incremental growth of the molecular lattice within, they also serve as clues to a crystal's invariable physical and chemical properties. So specific is the relationship between form and content that crystal class is a reliable gauge for qualities like piezoelectricity, where pressure on an axis will cause a slight current at the opposite pole, as well as internal refraction and the direction of cleavage planes, the two critical issues for gem cutters.

Reacting to accepted theories about crystal development from the union of a limited number of "primitive forms"—a still popular Platonic "building blocks of nature" view with wide support around 1800—Weiss's work transformed crystallography from a speculative endeavor with roots in the pantheism of German *Naturphilosophie* to a rational one based on systematic geometric analysis.[11]

Froebel worked each day for almost two years in a "locked and perfectly quiet" room organizing the diverse and dazzling samples of the mineralogical museum's splendid omnibus collection. Before

science was capable of complete chemical analysis, the arrangement of objects in a display of the kind Froebel maintained would have been based on physical taxonomy, not accurate knowledge of molecular composition. The shapes of crystals in particular—the systematic variations in the design of their forms, planes, and symmetries—provided an obvious structure for the categorization of mineral classes, ultimately leading to Weiss's theories.

For Froebel, inclined as he was to view nature as a great work of design by a higher power, this intense and prolonged occupation with the geometric handiwork of God would have profound and lasting impact. He now perceived "transforming, developing energy" in the smallest fixed forms of nature's infinite palate and learned to recognize people, plants, and crystals as equivalent consequences stemming from the same laws of growth: "And thereafter my rocks and crystals served me as a mirror wherein I might descry mankind, and man's development and history. . . . Nature and man now seemed to me mutually to explain each other, through all their numberless various stages of development."[12] What once seemed obvious to Froebel about living things—that their essential development was governed by fixed laws from above—now resonated even in the salt on his table and rocks beneath his boots. Furthermore, and more significantly for the generations to follow, Froebel discovered forms of symbolic unity that could, with pencil and straightedge, be transferred to paper and bound into books. Whereas leaves and flowers might be collected and pressed for future inspection and bones and shells displayed in cabinets as evidence of nature's diverse creativity, crystals, whose surface planes are geometry incarnate, can be copied in wood and cardboard and manipulated like the mathematical formulas used to describe them. Simply put, Froebel perceived that since the shapes of crystals—combinations of triangles and tetrahedrons, squares and cubes—are the outcome of the same natural laws that result in the growth of children, people, and entire societies, handling and manipulating models of these forms correctly would reveal and illuminate the logic of creation. It was during these two years of daily work with crystals that Froebel's two major interests, nature and education, finally intersected in a cohesive and easily demonstrable fashion that would result, many years later, in the creation of the first kindergarten.

LIVING FOR CHILDREN

In 1816, Froebel was offered a professorship of mineralogy in Stockholm—remarkable testimony to the quality of his largely self-directed education. Somewhat surprisingly, he declined the position in favor of founding his own small school for children (a desire of his dating at least from 1807), the Universal German Educational Institute in the town of Griesheim. The death of his brother Christoph that year accelerated his plans, and he took over the care of his nephews Karl and Julius, as well as the sons of his other brother Christian, in his first practical attempt at initiating the concepts he had for so long been formulating. A year later, he transferred the school to nearby Keilhau and was joined by Heinrich Langenthal and Wilhelm Middendorf, two friends from his army days who had gone on to study phi-

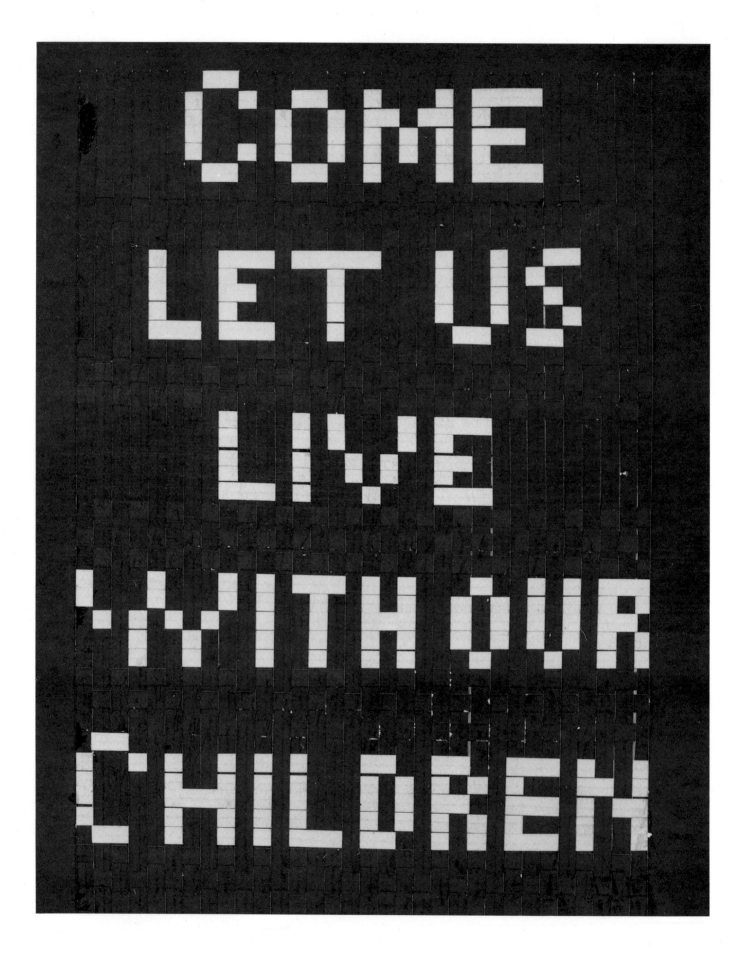

losophy in Berlin while Froebel was employed as a crystallographer. Both men spent many years teaching at the Keilhau Institute, and Middendorff became the closest friend and associate Froebel ever had, remaining with him through years of struggle until their respective deaths in 1853 and 1852.

The institute, as required by the Prussian authorities, was attended by children seven years of age and older—it was neither a preschool nor a kindergarten. Froebel ran it until 1830, concentrating on providing a balanced education of the kind he had always sought but never encountered. In 1818, he married Henrietta Wilhelmine Hoffmeister who, along with other close members of his circle at Keilhau, sustained him through the periods of disappointment that seem to have continuously befallen him. In 1821, he published the first of a series of pamphlets, articles, and periodicals outlining his educational philosophy and the aims and coursework of the institute, *Principles, Aims, and Inner Life of the Universal German Educational Institute in Keilhau. The Education of Man* was also published during the days at Keilhau, and although it captured the attention of the educational establishment and gained some powerful friends for Froebel's ideas, its impact in the Church-dominated milieu of traditional Prussian education was negligible.

In 1831, at the request of the duke of Meiningen, a member of the local nobility, Froebel drew up plans for a new school in which, along with their ordinary coursework, children would spend half of each day engaged in such handicrafts and activities as woodworking, weaving, bookbinding, and gardening. Seen by Froebel as a means to gratify the student's innate desire for creative and useful occupation, it was his first attempt at expanding the object-teaching of Pestalozzi to include direct learning and self-directed education. Although this new school was never realized (thanks, in this as in many other instances, to the interference of members of the rigid local bureaucracy), creating the program led Froebel to many practical experiments in which elements of the future kindergarten occupations can be seen.

Meanwhile, Froebel's reputation as an educator was growing outside Germany, and he was invited in 1831 to open satellite schools in Switzerland. Froebel and other members of the Keilhau community, Protestants all, were at a great disadvantage in their attempts to transfer Froebel's free spirituality to what they had hoped would be new, fertile ground across the border in Catholic territory. Railed at as heretics by Jesuit priests and accused of serving the devil, their five years in the Bernese canton (later, one of the very first municipalities to include kindergarten in its public-school system) at Wartensee, Willisau, and Burgdorf were fraught with conflict but quite fruitful.

In Burgdorf, Froebel opened an orphanage and normal school at the request of the government of the canton. Near the end of his stay there, he began to focus his efforts on designing a curriculum for the very young. Some games and exercises preliminary to the gifts and occupations of kindergarten date from this period, and at one time almost sixty teachers, including some sent by the local government, were being trained there in Froebel's methods.

Opposite:
Unidentified kindergartner. Motto, made with the fourteenth gift (paper weaving). United States, c. 1890

Froebel's motto, "Kommt lasst uns unsern Kindern leben," was translated as "Come let us live with our children" and "Come let us live for our children." He actually meant something like "Come, let us live in exemplary fashion for the benefit of our children."

In 1837, after a brief sojourn in Berlin, the couple relocated to the spa town of Blankenburg in Froebel's native Thuringia, on account of Henrietta's health (she was to die two years later). That year, he finally opened his first institution for early childhood education. Without fixing upon a name that would clearly differentiate the new experiment from traditional infant asylums, he staffed the school with women (then only sparsely represented in the teaching profession) and began teaching with rudimentary examples of the first five gifts. Two years later, after an inspirational hike in the local forest mulling over how best to describe his latest effort, he exultantly fixed upon a brand-new word, "kindergarten." This clever neologism encapsulated two ideas: its organizational model (the children's garden) and its spiritual foundation (the garden of children).

In 1840, timed to coincide with the four hundredth anniversary of Gutenberg's invention of movable type, Froebel opened the Universal German Kindergarten at Blankenburg as a joint-stock company, selling shares in the enterprise for about ten dollars each. He also issued a call to his countrywomen in which he strove to rouse them to a sense of the holy mission of intelligent educational culture. Striking a chord in the generally disenfranchised female population, he garnered for the Blankenburg kindergarten a steady pool of teacher-trainees. The school prospered until 1844, during which time its founder wrote his most popular and influential book, *Mother-Play and Nursery Songs*,[13] and further refined the system, including the gifts and occupations, that would live and grow long after his death. For the next five years, Froebel and Middendorf crisscrossed Germany attempting to gain support for kindergarten. By 1847, there were seven kindergartens in the whole country. In the following year, another forty-four opened. Settling in Liebenstein, Froebel founded in 1850 the *Weekly Journal of Education*[14] and, a year later, the *Journal for Friedrich Froebel's Educational Aims.*[15]

In 1851, at age sixty-nine, Froebel married Luise Levin, one of his protégés, and through the influence of another well-placed member of his circle, Baroness Bertha von Marenholtz-Bülow, received the neighboring country seat of Marienthal from the grand-duke of Weimar to start the first true normal college for the training of kindergartners, as kindergarten teachers were called. A second training institute opened in Berlin in 1851, and, in the last two years of his life, Froebel also started kindergartens in Hamburg, Dresden, Leipzig, and Gotha.[16]

In August 1851, when public attention to the kindergarten goals and methods was expanding and Froebel's dream of overhauling traditional education was finally gaining ground, the Prussian court issued a decree forbidding the teaching of kindergarten and the establishment of any public kindergartens. So great was the influence of this key Germanic power, and so easily were the fears of the lesser states aroused when distant hints of democratic insurgence were disclosed as the reason for the decree (the jitters from the failed uprisings of 1848 not having been dispelled), that Froebel immediately faced indifference and even hostility where he so recently had developed genuine support. The Prussian

authorities mistakenly ascribed to him authorship of an inflammatory pamphlet *(High-Schools and Kindergartens)* actually written by his nephew Karl. First branding the tract socialistic and atheistic, they then ignored Froebel's written clarification and the passionate personal entreaties of the highly placed Baroness von Marenholtz-Bülow and adamantly refused to rescind the law. Because education of the people was considered the most dangerous weapon in the hands of the revolution and kindergarten espoused the universal, harmonious interrelation of *all* men (in fact, Froebel himself called kindergarten "the free republic of childhood"[17]), the authorities qualified their ban with additional objections and simply ignored his protests. Mention of the importance of kindergarten in many letters confiscated from persons who had been politically compromised justified the expedience of the prohibition in the mind of the king's minister and reinforced the public's association of the new education with generally radical tendencies.

Karl Froebel, prior to this episode, had been the director of the public schools of Zurich and then the founder of a lyceum for young ladies in Hamburg. Persona non grata after the scandal, he emigrated to Great Britain and eventually opened a school in Edinburgh. His older brother Julius, a protégé of the distinguished polymath Alexander von Humboldt, had been a deputy to the National Assembly at Frankfurt in 1848. After the forced dissolution of that budding representative body, he was condemned to death along with many of his compatriots in the democratic movement, escaped to Switzerland before being arrested, and later fled to New York. For Friedrich Froebel the prohibition of kindergarten was truly the final blow, and he died less than a year after the ban, on June 21, 1852. Although the Prussian interdict was legally abrogated in 1860, the mistrust of Froebel's great invention created by official interference was never quite cleansed from the German psyche, and augmentation of the system on its native soil was from then on driven by the efforts of family institutions and private individuals— parents, teachers, social reformers, and intellectuals—working in concert to maintain the spirit of his simple motto for the benefit of all future generations. By the 1860s, however, kindergarten was well on its way to becoming a common institution throughout the world.

2 KINDERGARTEN

THEORY Before Froebel invented kindergarten, children under the age of seven did not attend school. There was, other than ubiquitous religious instruction, no general educational curriculum geared to young children and no socially recognized value in attempting to teach them. That one might, in the first stage of life when constant motion is manifested as play, be capable or focused enough to learn intellectual or emotional skills, as a foundation for *real* education and life to come, was not widely accepted. Although many of Froebel's observations about human development anticipated modern beliefs about children, the significance of his genius in the era in which he lived lay foremost in his recognition of those aspects of child-life that would clearly benefit from coordinated direction. Before Froebel concluded that the world needed a new instructional system specifically for infants, he had evaluated the gaps and weaknesses in traditional education, analyzed children's motivating psychology, and knew the educational objectives he intended kindergarten to fulfill. Froebel had seen what others could not or would not: because learning begins when consciousness erupts, education must also.

In 1859, Froebel's protégé Bertha von Marenholtz-Bülow compiled a short list of "natural needs of earliest childhood" that would be satisfied with the kindergarten method. Practical and incisive where Froebel was profound and effusive, Von Marenholtz cut to the heart of kindergarten's aims in a straightforward and comprehensible manner:

> The kindergarten method satisfies 1. The need for *physical movement,* through gymnastic games that develop the limbs; 2. A child's need to occupy oneself in a *plastic* fashion, through exercises that produce manual dexterity and develop the senses; 3. A child's need

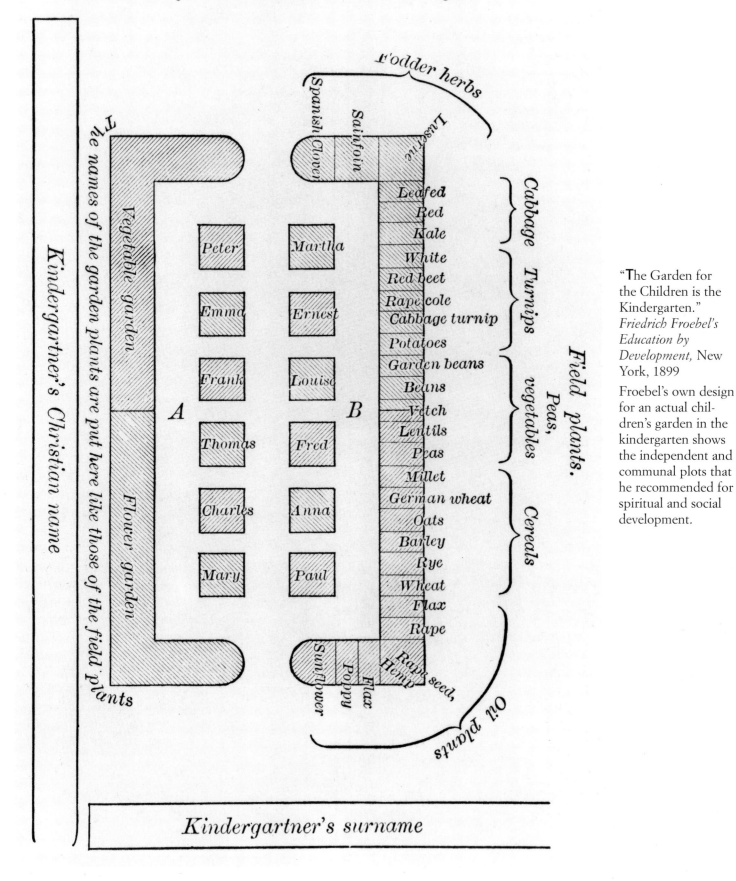

The Garden for the Children is the Kindergarten.

Spanish Clover · Sainfoin · Lucerne

Fodder herbs

Vegetable garden

Flower garden

The names of the garden plants are put here like those of the field plants

Kindergartner's Christian name

Peter	Martha
Emma	Ernest
Frank	Louise
A	B
Thomas	Fred
Charles	Anna
Mary	Paul

Leafed
Red
Kale
White
Red beet
Rape cole
Cabbage turnip
Potatoes
Garden beans
Beans
Vetch
Lentils
Peas
Millet
German wheat
Oats
Barley
Rye
Wheat
Flax
Rape

Cabbage
Turnips
Peas, vegetables
Cereals

Field plants.

Sunflower · Poppy · Flax · Hemp · Rape seed,

Oil plants

Kindergartner's surname

"The Garden for the Children is the Kindergarten." *Friedrich Froebel's Education by Development,* New York, 1899

Froebel's own design for an actual children's garden in the kindergarten shows the independent and communal plots that he recommended for spiritual and social development.

to *create* through small tasks that develop one's artistic faculties; 4. A child's need to *know*, or natural curiosity, engaging in observing, examining, comparing (which is how intellectual development is brought about); 5. A child's tendencies to *cultivate* and *care for*, through gardening and carrying out small tasks, which result in the development of the heart and conscience; 6. The need to *sing*, through games and songs, which produce the development of feelings and esthetic taste; 7. The need to *live in society*, through life in the kindergarten community: this mode of existence produces social virtues. 8. The deepest need of the soul: to find the *reason behind things*, to find God.[1]

Froebel's own pedagogical writings, generally in *The Education of Man*, and on kindergarten, in the compilation *Pedagogics of the Kindergarten*, were weighted with philosophical discourse in the Romantic style at the expense of practical advice. It is no wonder knowledge of the system was commonly transmitted in a kind of apprenticeship program that resulted in the many teacher-made examples of occupational work reproduced in this book. Like the students they would someday teach, the kindergartners themselves must have found learning by doing more meaningful than attempting to evaluate Froebel's ideas from books alone. Yet to understand kindergarten or to fully appreciate the far-reaching nature of Froebel's advances, a general knowledge of his thinking is crucial.

The one universal law upon which Froebel based all of his educational principles was *unity* or *inner connection*. The interconnectedness of all things was the governing force in Froebel's philosophy and pedagogy and the broad foundation for all of his developmental concepts. Perfecting a feeling of unity between the child and God (not the God of organized Christianity but the pantheistic font of life and growth of Romantic philosophy) so that humanity might gain consciousness of its own sublime power and fully realize its own spiritual potential was the key goal of education. Since God manifested Himself in nature as the principle of unity, Froebel believed that the study of natural history and botany would yield insights of the highest moral value. Out of his belief that the same principle applied to the social realm, he devised the simplest of pedagogical tools to lay the groundwork for perfecting social relationships in the family and state and across cultural, linguistic, and rational boundaries. And, more than any teacher before him, he recognized the unity of an individual's physical, intellectual, and spiritual powers; clarified the influence of every conscious act in the creation of character; and greatly expanded the objective realm of education in the modern era.

If unity was Froebel's fundamental law, *self-activity,* the essential principle of *Émile,* was his basic educational process. Self-activity (or free activity, self-occupation, or self-employment), the spontaneous impulse of the child to explore and act motivated simply by intellectual curiosity, was actively discouraged in the early-nineteenth-century schoolroom. Where traditional teaching demanded only response, Froebel sought individual action. Where tradition erected a barrier between the teacher and the taught,

self-activity made them co-workers. In the kindergarten, the impulse to action, and therefore to learning, originated with the child itself, and expression became self-expression instead of recitation. The role of the teacher was thus transformed from lecturer to guide, as she now directed the child's natural movement toward play with one another and with the freely expansive, but carefully defined, gifts.

Play was fundamental to the success of the kindergarten. Froebel discerned that harnessing the natural activity of children, often referred to in kindergarten literature as children's "work," was the key to educating the young. By harnessing the impulse that impels children and, indeed, many other animal young to play, learning would be made easier and knowledge more long-lasting. Froebel recognized the significance of play in childhood years before his involvement with kindergarten, and he devoted one of the introductory essays in *The Education of Man* to its importance: "Play is the purest, the most spiritual, product of man at this stage, and is at once the prefiguration and imitation of the total human life,—of the inner, secret, natural life in man and in all things. It produces, therefore, joy, freedom, satisfaction, repose within and without, peace with the world. The springs of all good rest within it and go out from it."[2]

All of the kindergarten activities, the singing, dancing, gardening, storytelling, gifts, and occupations were play: it was the engine that propelled the system. This early acknowledgment of children as something other than simply small, stupid people engaged in useless activity set the stage for the acceptance of child psychology and the Child Study movement at the end of the nineteenth century.

After many years of teaching, Froebel had come to believe in the futility of attempting to educate children who were already by age seven, when they started their schooling, too intellectually rigid to make good use of their subsequent lessons. The importance of *early training,* beginning with children of only four months old, was emphasized in his *Mother-Play and Nursery Songs* of 1844, which included more than fifty simple songs and games for mothers to use with their children. In keeping with Froebel's total program, it was written as a means to educate children even before they reached kindergarten age. He reasoned that, as infancy is the period of human growth when the power centers of the mind and heart are organized and fundamental sensations and emotions are first defined, it was imperative to engage children's nascent faculties as early as possible. Each song in *Mother-Play* is accompanied by music, a picture illustrating a simple concept or lesson, and a motto or short instructive commentary for the use of the mother. Froebel wrote new lyrics to traditional German folk tunes (and American kindergartners then wrote their own versions of Froebel's songs as well as many new, additional tunes). Mothers were provided with opportunities for explicit and subliminal lessons of development (grass growing, sunlight), unity to the external world (falling, taste, smell, sound), unity within the family (mother, grandmother, hide and seek, "This Little Piggy"), unity to nature (animal and garden songs, "Twinkle Twinkle Little Star"), unity to others (baker, carpenter, toy maker), and many more.

Drawing on Pestalozzi's experience at Yverdon, Froebel also made music and group singing essential elements of kindergarten. Just as the shapes and colors of the gifts constituted a symbolic, visual language for the linguistically inexperienced, songs with simple or even nonsense lyrics for infants were embraced by Froebel as a potent means of nontraditional communication that he utilized for lessons of every sort. In its use of simple actions set to music as a means to express complex insights, *Mother-Play and Nursery Songs* was the forerunner of the songs ("Happy Birthday to You"), dances ("Ring around the Rosie"), and movement plays ("I Am a Little Teapot") that most of us remember from kindergarten.

In its demonstrations of unity, opportunities for self-activity, and adaptability for early training, *nature study,* the observation of life, rather than plant analysis or classification, was critical to kindergarten. Froebel believed that an early introduction to the force manifested in all living things secured for the child an irrevocable comprehension and respect for the spirituality of existence. Froebel objected to formal lessons on duty, morality, and religion, because he deemed it futile to attempt to convey an understanding of these complex concepts until they were rendered comprehensible through experience. In keeping with his efforts to make all lessons and symbols multidimensional, nature study was therefore stressed not only for its scientific, geometric, and artistic value, but as the basis of an eloquent and explicit ethical education. For example, kindergarten taught children to plant seeds and water them, to observe the unfolding of their immature parts when they sprouted, and to care for the seedlings as they grew to maturity, all as a means to reveal the power to aid in bringing forth life and to symbolize the inherent responsibility of people to one another in society. The study of nature sensitized children to the underlying logic of the structures and symmetries in the plant and mineral kingdoms so that they might recognize perfection within themselves and learn to appreciate the interdependence of all things.

Like Pestalozzi, Froebel made *objective work,* or object teaching, central to his pedagogy, recognizing that the handling of material things aided children in the development of their creative faculties and provided varied and complex experiences through simple means. By examining real things, kindergarten pupils developed originality in thinking and problem solving. Kindergarten's object teaching can be traced back, via Pestalozzi's *Anschauung* and Rousseau's ideal of a bookless education, to Kant's quest for knowledge of "the thing in itself." This principle ultimately infiltrated modern education on all levels.

Object lessons with simple things like seashells, acorns, or quartz crystals might be employed by the astute kindergarten teacher to illuminate the processes of growth and unity in nature. Object lessons with the gifts, accompanied by analogies and stories, might lead to an exploration of growth and unity in the lives of her students. The common thread connecting the two—the use of something tangible to enhance the understanding of something conceptual—may be categorized as *symbolic education.* Froebel recognized children's ability to see analogies and draw conclusions by comparison. In their ten-

dency to anthropomorphize inanimate objects, personalize the mundane, and discover associations and relationships between unrelated elements, he found fertile ground for every sort of lesson. Opportunities for symbolic education were consciously programmed throughout the kindergarten system of gifts, occupations, plays, games, songs, and stories, as Froebel wove his simple, yet all-encompassing, tapestry. In 1894, Susan Blow, founder of the St. Louis kindergarten system and one of the most astute and important early American kindergartners, wrote, "Froebel knows that the mind may be trusted to universalize its ideas, and leaves to its own alchemy the transmutation of the symbol into the reality symbolized."[3]

The habit of pointing out "the moral of the story" that was traditional in education, and particularly in Sunday school, was anathema to Froebel, as it robbed the child of the opportunity of drawing her or his own conclusions and blocked the development of mental habits that would ultimately, with a good teacher's guidance and in the natural course of learning, flower into complex understanding.

GIFTS AND OCCUPATIONS

Froebel called the materials of the kindergarten *gifts*. While these play objects—balls, blocks, sticks, paper, pencils, and clay—were not in themselves new, the integrated educational method in which they were used was, and radically so.[4] Starting with the fundamental idea that education for the very young must begin by sensitively channeling children's constant activity and interaction with the physical world, he consciously modeled the curriculum on the natural relationship of trust between a young mother and her growing child. The gifts were toys, the teacher was the loving mother, and the schoolroom was an extension of the garden (actual gardens were also included in the original Froebelian system).

There were about twenty kindergarten gifts. By 1836, Froebel had designed the first five, although the second and fifth were later amended. Comprehensive written and graphic descriptions of numbers one through five appeared in his self-published *Sunday Paper for Like-Minded People*[5] of 1838–1840. In 1850, he described a "System of Gifts and Occupations" similar to the one that was later adopted. Because his life was cut short before he was able to fully explain their use, some historians ascribe the design of a portion of the gifts to his followers; however, as all the gifts with the exception of the curved rings were in use in England as early as 1851, it is likely that the entire sequence sprang from the imagination of its founder. Generally speaking, the first nine gifts—primarily wood forms for design work—were not altered by use. Numbers ten through twenty (with exceptions) were materials for more craftlike occupations, for example, paper that might be cut into "snowflakes" or folded like origami. Such "fancy work" could be saved in scrapbooks or displayed on corkboards in the classroom.

Although Froebel never emphasized the distinction between the gifts and occupations, his followers codified them with perhaps too much rigor, as in the following statement by W. N. Hailmann, an important American kindergartner:

The gift gives the child a new cosmos, the occupation fixes the impressions made by the gift. The gift invites only arranging activities; the occupation invites also controlling, modifying, transforming, creating activities. The gift leads to discovery; the occupation, to invention. The gift gives insight; the occupation, power.[6]

The attributes Hailmann ascribes to the gifts could just as easily be used to describe the occupations, and vice versa. Because Froebel wanted each gift to foreshadow those succeeding it, the system progressed from solid, to plane, to line, to point, and then reversed to arrive back in three dimensions with activities in "peas-work" and modeling clay. With the simplest of tools, he brilliantly deconstructed all physical and conceptual realms and conveyed a vivid impression of the continuity of nature.

In 1871, Von Marenholtz, writing in the dense but comprehensible manner that, when compared to the meandering and often enigmatic essays of her mentor, makes her insights so valuable, summarized the essence of the kindergarten training in this way:

If the child's mind, through his own outward creative activity, imitates in a measure the building-up and development of the universe, in that he, starting from simple, solid bodies (Gifts 1–6), perceives the material in its most elementary division and articulation; if the awakening mind of the child recognizes in the concrete world the consecutiveness in material development, and is led from the material body and its regular division to the contemplation of the surface (Gift 7), from this to the contemplation of the line (Gifts 8, 9, 10) and to the point made visible (Gift 11); if he learns to see the connection of all things, and nothing comes broken and isolated before his senses; if things, from the simplest up to the most complex, appear to him fixedly arranged in their natural, logical succession, from unity up to manifoldness or plurality, and his own handling of material leads to plastic formation, starting from simple fundamental forms and rising to ever high [sic] linking together of the same; and if his own formations are shaped according to one and the same law,—this child's mind must, in later stages of development, arrive at the consciousness of the organic life imitated by his own hand, and will find it again in nature in its most original state of existence. And thus he recognizes the agreement between the intellectually organic linking of his own being with that in the material world.[7]

In this remarkable passage that foreshadows Wassily Kandinsky's eventual theory of the point, line, and plane as hierarchical components for the creation of art (Kandinsky was in kindergarten the very year this was written), Von Marenholtz explains how the gifts work and what they seek to teach, and unknowingly paraphrases one of the key aesthetic philosophies leading to the development of modern art.

The methodology that, when properly utilized, provided children with an infinite number of con-

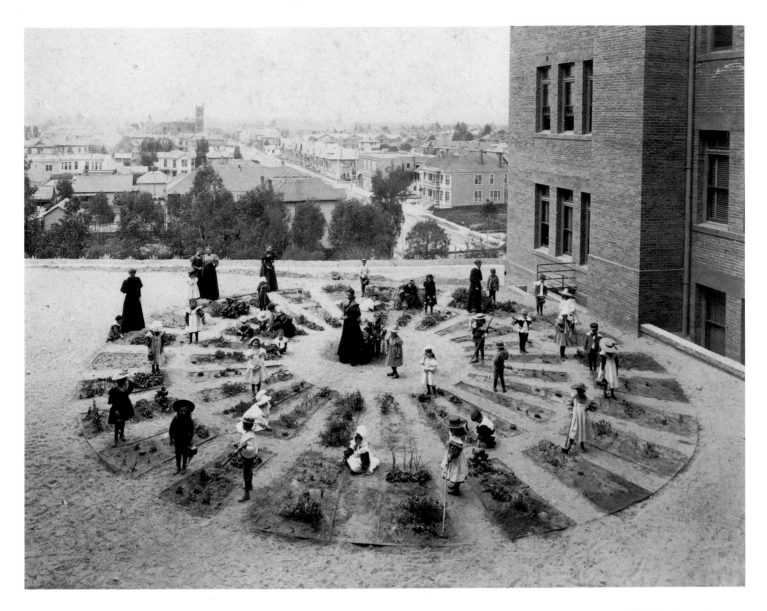

ceptual links between the gifts and the ideals of unity manifested in growth and interconnectedness involved exercises in what were usually called the *three realms*. In short sessions of directed play, the gifts were used to create pictures or structures that fit loosely into three fundamental categories—*forms of nature* (or life), *forms of knowledge* (or science), and *forms of beauty* (or art). Unlike the building blocks, mosaic toys, and traditional crafts that were their forebears, the gifts were never available for entirely "free play." Always tethered in some fashion to the forms of the three realms, their use was subordinate to the greater whole.

Exercises with the gifts usually began with the creation of a few nature forms, which were not, in spite of their title, limited to God's creations but included simplified versions of all sorts of things that were familiar from children's daily life. Buildings, trains, furniture, and clothing were suitable subjects, as were birds, dogs, flowers, and people. The nature forms were "discovered" in every gift and fashioned from the materials of every occupation. The solid forms made good, albeit symbolic, models of objects, so that a ball might become a hopping rabbit, a stack of cubes a bed, and the more prismatic building blocks an entire miniature town. Flat and linear gifts afforded greater control of pictorial imagery as they translated the cubistic geometry of the block forms into a zigzagging, fractured rendering, like life viewed in a broken mirror. The paper occupations worked their variations on reality, resulting in the distinctly different expressions of weaving's digitized imagery, folding's origami, and cutting's

traditionally accurate silhouettes. Modeling clay, the most plastic of the gifts and finale to Froebel's sequence of analysis and synthesis of form, enabled the older and more practiced students to create actual models of the things they had previously deconstructed.

Children's work in the nature realm opened avenues for songs, stories, and plays, in which the abstractions they created became conceptual props in teacher-directed group activities. If birds were made, the little students might march around singing as birds; if tables were built, they might make up stories about eating with their families. Thus, in spite of the ephemeral nature of work with the gifts, the apparent authenticity of what was wrought was continuously reinforced. The interface between the symbol and what it symbolized was transposed so fluidly that after a year or two of daily engagement, the equivalency of one with the other—of the abstraction with its obviously real counterpart—became a quotidian fact.

After introducing children to the activities and stories of the nature forms in any particular gift, exercises in the knowledge realm would typically follow. The simple materials previously modeled into symbolic images were here utilized for the teaching of basic arithmetic, geometry, and the beginning of reading. The eight cubes of the third gift that children had just made into the chairs and stoves in their mother's kitchens would now be laid in rows and expressed as 2×4 or $4+4$. The small sticks of the eighth gift that might have been a barn with horses and pigs in the nature realm could now easily become numbers or markers for a tentative alphabetical sequence. The triangular tablets of the seventh gift, well known to the class as constituents of faces or even entire human figures, were the perfect tools for primary instruction in plane geometry and the Pythagorean Theorem. In the knowledge realm, Froebel's materials were facts, and they trained the youngest children in skills that had traditionally been reserved for the education of students in higher grades.

The final leg of the tripod that was the real kindergarten had several names. Called forms of beauty, art, symmetry, or dance, these were compositions whose educational value lay in the sensitization of the very young to esthetics. The beauty forms were pure pattern and exuberant design, and their potency in the growing lives of children was comparable to the first hushed squint at a snowflake's spiky perfection or the moiré of ripples intersecting on a pond in moonlight.

Because symmetry was a regulating feature in the plant and crystal forms that inspired Froebel and he felt it to be the most comprehensible representation of beauty for the very young, the art forms were typically organized in rotational or bilateral arrangements and remained as such throughout their potentially infinite cycle of permutations. While each of the gifts was more or less suitable for the creation of nature and knowledge forms, the potential outcome from work with each in the less restricting beauty realm was predictably diverse. All the blocks and sticks and rings and slats were used in plain view on the ever-present grid of the kindergarten table, arranged and rearranged into shifting, kaleidoscopic pat-

terns or decorative, geometric borders. Simple repetitive fields pricked onto paper cards and stitched with colored thread evolved into complex, overall patterns of crosshatched color, freeing the embroidered handicraft of traditional clothing from its functional past. Chicken-scratch designs of pencil on gridded slates or graph paper were organized into patterned webs of pure form, redefining forever the meaning of the phrase "to draw." Colored paper was regenerated as miniature, eye-popping weavings that are reminiscent of nothing so much as the Navaho wearing-blankets of the American Southwest or folded, sliced, and transformed into ingenious designs whose striking "modernity" belies their roots in the mid-nineteenth century. With the addition of the beauty forms, Froebel had effectively assembled all the components of the universe into his training program for infants. Children could make anything they saw, perceived, or imagined, and while doing so would enter the world—and it would enter them.

A day (usually three hours) in kindergarten would typically begin with "good morning" music and a simple sing-along tied to the weather or season or other particular focus. After a group chat with the children seated in a large circle, the students would each find a place at communal worktables for their daily gift-play. Each child would have his or her own gift, and more than one type might be in use simultaneously if several teachers were present. Including distribution and collection, which was performed by the children themselves, the gift period would last thirty to forty minutes. The seated activities were followed by about forty-five minutes of active games and simple gymnastics. Occupation work for another half hour resulting in a take-home creation and a final ten-minute goodbye song ended the day.

No two days in the kindergarten week were exactly the same. Gifts and occupations changed, music and games were varied, nature walks and gardening were included, and daily themes rotated—unity in diversity was the basis of Froebel's system.

The intended result of this all-encompassing instruction was the creation of a sensitive, inquisitive child with an uninhibited curiosity and genuine respect for nature, family, and society; a reasoning and creative child who would later have few problems learning the three Rs or anything else, while gracefully incorporating all manner of diverse knowledge and experience into a unified and supple life. Equivalence and balance were kindergarten's foundation, expressed in all things and at all times. For four-, five-, and six-year-olds, transforming the very same materials into something new each day, as the class shifted from gift to gift and from realm to realm (for after the numbered sequence in which they were first introduced, there was no prescribed order in the original plastic system), the ultimate lesson of kindergarten was straightforward: the world (nature), mathematics (knowledge), and art (beauty) were interchangeable, and their perceived borders were misleading, artificial constructs. A chair might become numbers, numbers art, and art either or both. Used correctly, with patience and flexibility, Froebel's method worked, and the lucky children who experienced it early on were transformed as if embraced by Mother Nature herself.

3 GIFTS

Opposite:
"Descriptive List of
Kinder-Garten Gifts."
*Catalog of Games and
Home Amusements,*
Milton Bradley &
Company, Springfield,
Massachusetts,
1873–74

This introduction to Froebel's kindergarten gifts is greatly condensed from many sources and only hints at the scope and grace of the original system. It is necessarily more an exercise in cultural exploration than a manual for contemporary educators. The real kindergarten is long gone, the gifts have been transformed, the educational objective for what is left of the occupations has been lost or corrupted, the world today is radically different than it was at the beginning of the Industrial Revolution, and, superficially at least, today's children may not be comparable to their nineteenth-century peers. Also gone is the crucial element that was always most difficult to maintain—a cadre of qualified kindergarten teachers sufficiently versed in the subtleties of the system. Proficiency in the details of Froebel's technique, philosophy, and spiritual cosmology, which was hard enough to absorb under his direct tutelage, became that much more difficult after his death and the deaths of his protégés. Women trained by the core group of Froebel's early disciples—including, in America, Elizabeth Peabody and her sister Mary Mann, the wife of Horace Mann, and Ruth Burritt, whose experimental class first piqued the interest of Anna Lloyd Wright—possessed a far deeper comprehension of both the practical and spiritual harmonics of the system than the many who followed. As later trainees were forced to learn from books, and from women who had themselves learned from books, important nuances of the original training were changed and abandoned.

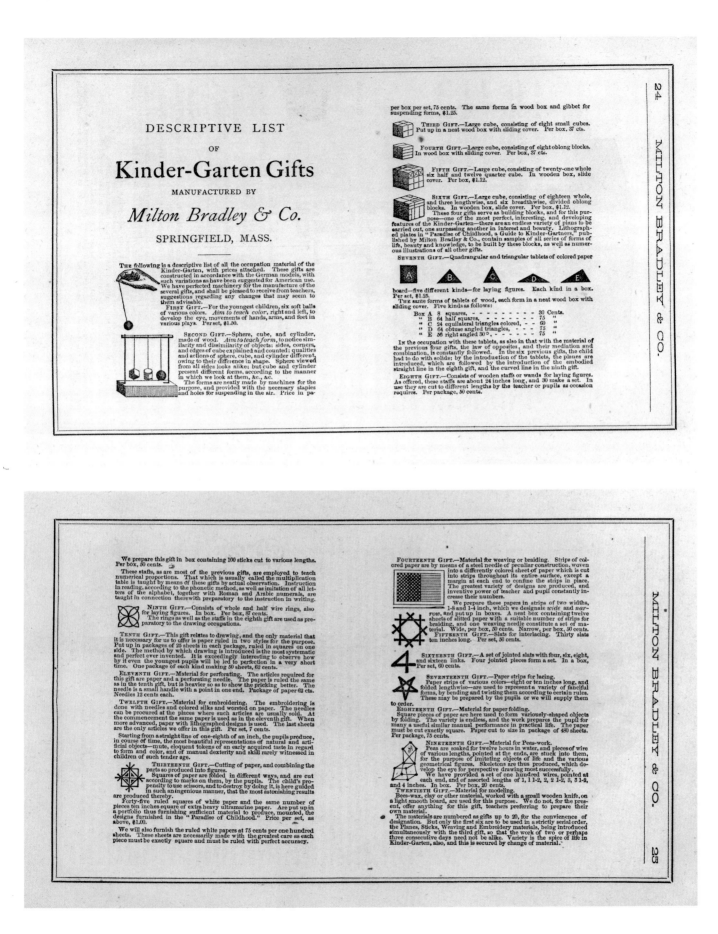

DESCRIPTIVE LIST

OF

Kinder-Garten Gifts

MANUFACTURED BY

Milton Bradley & Co.

SPRINGFIELD, MASS.

THE following is a descriptive list of all the occupation material of the Kinder-Garten, with prices attached. These gifts are constructed in accordance with the German models, with such variations as have been suggested for American use. We have perfected machinery for the manufacture of the several gifts, and shall be pleased to receive from teachers, suggestions regarding any changes that may seem to them advisable.

FIRST GIFT.—For the youngest children, six soft balls of various colors. *Aim to teach color,* right and left, to develop the eye, movements of hands, arms, and feet in various plays. Per set, $1.50.

SECOND GIFT.—Sphere, cube, and cylinder, made of wood. *Aim to teach form,* to notice similarity and dissimilarity of objects; sides, corners, and edges of cube explained and counted; qualities and actions of sphere, cube, and cylinder different, owing to their difference in shape. Sphere viewed from all sides looks alike; but cube and cylinder present different forms, according to the manner in which we look at them, &c., &c.

The forms are neatly made by machines for the purpose, and provided with the necessary staples and holes for suspending in the air. Price in pa-

per box per set, 75 cents. The same forms in wood box and gibbet for suspending forms, $1.25.

THIRD GIFT.—Large cube, consisting of eight small cubes. Put up in a neat wood box with sliding cover. Per box, 37 cts.

FOURTH GIFT.—Large cube, consisting of eight oblong blocks. In wood box with sliding cover. Per box, 37 cts.

FIFTH GIFT.—Large cube, consisting of twenty-one whole six half and twelve quarter cube. In wooden box, slide cover. Per box, $1.12.

SIXTH GIFT.—Large cube, consisting of eighteen whole, and three lengthwise, and six breadthwise, divided oblong blocks. In wooden box, slide cover. Per box, $1.12.

These four gifts serve as building blocks, and for this purpose—one of the most perfect, interesting, and developing features of the Kinder-Garten—there are an endless variety of plans to be carried out, one surpassing another in interest and beauty. Lithographed plates in "Paradise of Childhood, a Guide to Kinder-Gartners," published by Milton Bradley & Co., contain samples of all series of forms of life, beauty and knowledge, to be built by these blocks, as well as numerous illustrations of all other gifts.

SEVENTH GIFT.—Quadrangular and triangular tablets of colored paper

board—five different kinds—for laying figures. Each kind in a box. Per set, $1.25.

THE same forms of tablets of wood, each form in a neat wood box with sliding cover. Five kinds as follows:

Box A 8 squares, - - - - - - - - 30 Cents.
" B 64 half squares, - - - - - - 75 "
" C 24 equilateral triangles colored, - - 60 "
" D 64 obtuse angled triangles, - - - 75 "
" E 56 right angled 30°, - - - - - 75 "

IN the occupation with these tablets, as also in that with the material of the previous four gifts, the law of opposites, and their mediation and combination, is constantly followed. In the six previous gifts, the child had to do with solids; by the introduction of the tablets, the planes are introduced, which are followed by the introduction of the embodied straight line in the eighth gift, and the curved line in the ninth gift.

EIGHTH GIFT.—Consists of wooden staffs or wands for laying figures. As offered, these staffs are about 24 inches long, and 30 make a set. In use they are cut to different lengths by the teacher or pupils as occasion requires. Per package, 50 cents.

We prepare this gift in box containing 100 sticks cut to various lengths. Per box, 50 cents.

These staffs, as are most of the previous gifts, are employed to teach numerical proportions. That which is usually called the multiplication table is taught by means of these gifts by actual observation. Instruction in reading, according to the phonetic method, as well as imitation of all letters of the alphabet, together with Roman and Arabic numerals, are taught in connection therewith preparatory to the instruction in writing.

NINTH GIFT.—Consists of whole and half wire rings, also for laying figures. In box. Per box, 87 cents.

The rings as well as the staffs in the eighth gift are used as preparatory to the drawing occupations.

TENTH GIFT.—This gift relates to drawing, and the only material that it is necessary for us to offer is paper ruled in two styles for the purpose. Put up in packages of 25 sheets in each package, ruled in squares on one side. The method by which drawing is introduced is the most systematic and perfect ever invented. It is exceedingly interesting to observe how by it even the youngest pupils will be led to perfection in a very short time. One package of each kind making 50 sheets, 62 cents.

ELEVENTH GIFT.—Material for perforating. The articles required for this gift are paper and a perforating needle. The paper is ruled the same as in the tenth gift, but is heavier so as to show the pricking better. The needle is a small handle with a point in one end. Package of paper 62 cts. Needles 12 cents each.

TWELFTH GIFT.—Material for embroidering. The embroidering is done with needles and colored silks and worsted on paper. The needles can be procured at the places where such articles are usually sold. At the commencement the same paper is used as in the eleventh gift. When more advanced, paper with lithographed designs is used. The last sheets are the only articles we offer in this gift. Per set, 7 cents.

Starting from a straight line of one-eighth of an inch, the pupils produce, in course of time, the most beautiful representations of natural and artificial objects—mute, eloquent tokens of an early acquired taste in regard to form and color, and of manual dexterity and skill rarely witnessed in children of such tender age.

THIRTEENTH GIFT.—Cutting of paper, and combining the parts so produced into figures.

Squares of paper are folded in different ways, and are cut according to marks on them, by the pupils. The child's propensity to use scissors, and to destroy by doing it, is here guided in such an ingenious manner, that the most astonishing results are produced thereby.

Forty-five ruled squares of white paper and the same number of pieces ten inches square of extra heavy ultramarine paper. Are put up in a portfolio thus furnishing sufficient material to produce, mounted, the designs furnished in the "Paradise of Childhood." Price per set, as above, $1.00.

We will also furnish the ruled white papers at 75 cents per one hundred sheets. These sheets are necessarily made with the greatest care as each piece must be exactly square and must be ruled with perfect accuracy.

FOURTEENTH GIFT.—Material for weaving or braiding. Strips of colored paper are by means of a steel needle of peculiar construction, woven into a differently colored sheet of paper which is cut into strips throughout its entire surface, except a margin at each end to confine the strips in place. The greatest variety of designs are produced, and inventive power of teacher and pupil constantly increase their numbers.

We prepare these papers in strips of two widths, 1-8 and 1-4 inch, which we designate *wide* and *narrow,* and put up in boxes. A neat box containing twelve sheets of slitted paper with a suitable number of strips for braiding, and one weaving needle constitute a set of material. Wide, per box, 50 cents. Narrow, per box, 50 cents.

FIFTEENTH GIFT.—Slats for interlacing. Thirty slats ten inches long. Per set, 50 cents.

SIXTEENTH GIFT.—A set of jointed slats with four, six, eight, and sixteen links. Four jointed pieces form a set. In a box. Per set, 60 cents.

SEVENTEENTH GIFT.—Paper strips for lacing. Paper strips of various colors—eight or ten inches long, and folded lengthwise—are used to represent a variety of fanciful forms, by bending and twisting them according to certain rules. These may be prepared by the pupils or we will supply them to order.

EIGHTEENTH GIFT.—Material for paper folding. Square pieces of paper are here used to form variously-shaped objects by folding. The variety is endless, and the work prepares the pupil for many a useful similar manual performance in practical life. The paper must be cut exactly square. Paper cut to size in package of 480 sheets. Per package, 75 cents.

NINETEENTH GIFT.—Material for Peas-work. Peas are soaked for twelve hours in water, and pieces of wire of various lengths, pointed at the ends, are stuck into them, for the purpose of imitating objects of life and the various geometrical figures. Skeletons are thus produced, which develop the eye for perspective drawing most successfully.

We have provided a set of one hundred wires, pointed at each end, and of assorted lengths of 1, 1 1-2, 2, 2 1-2, 3, 3 1-2, and 4 inches. In box. Per box, 20 cents.

TWENTIETH GIFT.—Material for modeling. Bees-wax, clay or other material, worked with a small wooden knife, on a light smooth board, are used for this purpose. We do not, for the present, offer anything for this gift, teachers preferring to prepare their own material.

The materials are numbered as gifts up to 20, for the convenience of designation. But only the first six are to be used in a strictly serial order, the Planes, Sticks, Weaving and Embroidery materials, being introduced simultaneously with the third gift, so that the work of two or perhaps three consecutive days need not be alike. Variety is the spice of life in Kinder-Garten, also, and this is secured by change of material.

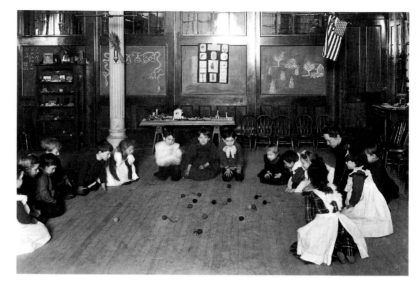

The ball in the totality of its properties is in manifold respects as instructive a type for the child, as the All (the universe), with its phenomena, is for the adult.[1]

THE 1ST GIFT
Balls

Froebel intended the ball to be the catalyst for the child's first learning experience. Although gift one was part of the kindergarten sequence and adaptable in its simplicity to stories and games for all age groups, its proper utilization began when an infant first took notice of its surroundings—about six to eight weeks after birth. As a kind of summary of all the gifts to follow, the ball—typically a small, squashable, wool ball on a string in one of six rainbow colors—was imbued by Froebel with manifold physical and symbolic attributes. It was the general expression of every independent object and, in its uniqueness, of the child himself. It could be used to symbolize the self within and the physical body without. Perfect in form, the ball, or sphere, was the practical expression of stability and the material expression of motion. By grasping, rolling, dropping, hiding, and swinging the ball, the child gained intuitive and experiential knowledge of object, space, time, color, movement, attraction, union, independence, and gravity. Nuts and berries were natural balls, as were the seedpods of the dandelion and sycamore and the sun and the moon. Eggs and cabbages and eyes and heads were balls, and the good kindergartner could lead her children through the realm of nature with only a ball. In play, it might become a bird as it flew, a cat as it sprang, a dog jumping over a hedge, or indeed any one of a million other everyday events in the life of a child. Mathematically, it was a point and the number one. Together, the six balls represented the realm of knowledge in the form of a line for counting and a set for learning addition and subtraction and the beginning of multiplication and division. In the realm of beauty, the balls together encompassed the primary colors—red, blue, and yellow—and the synthesis of their unions—violet, green, and orange. The first gift was the germ of everyone, the model for everything, and the most sublime expression of unity: "In the first plays with the ball the life of the child makes itself known, and the outer world makes itself known to the child in unity."[2]

This page:
Suggested exercises with the first gift. Plates 1a and 1b, *A Practical Guide to the English Kindergarten* by Johann and Bertha Ronge, London, 1855

Opposite:
Marion Barreuther. The first gift (balls) portrayed by the twelfth (sewing). United States, c. 1900

Plate I(a). FIRST GIFT.

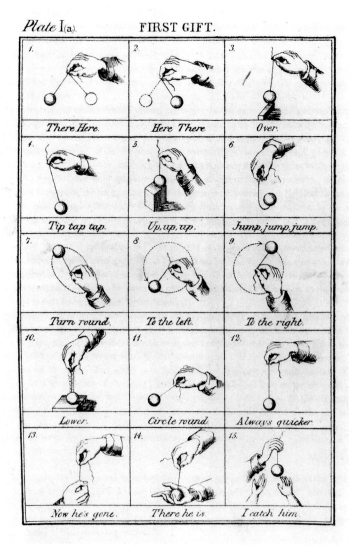

Plate I(b). FIRST GIFT.

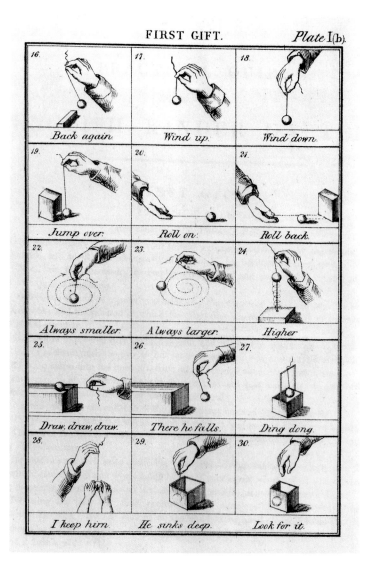

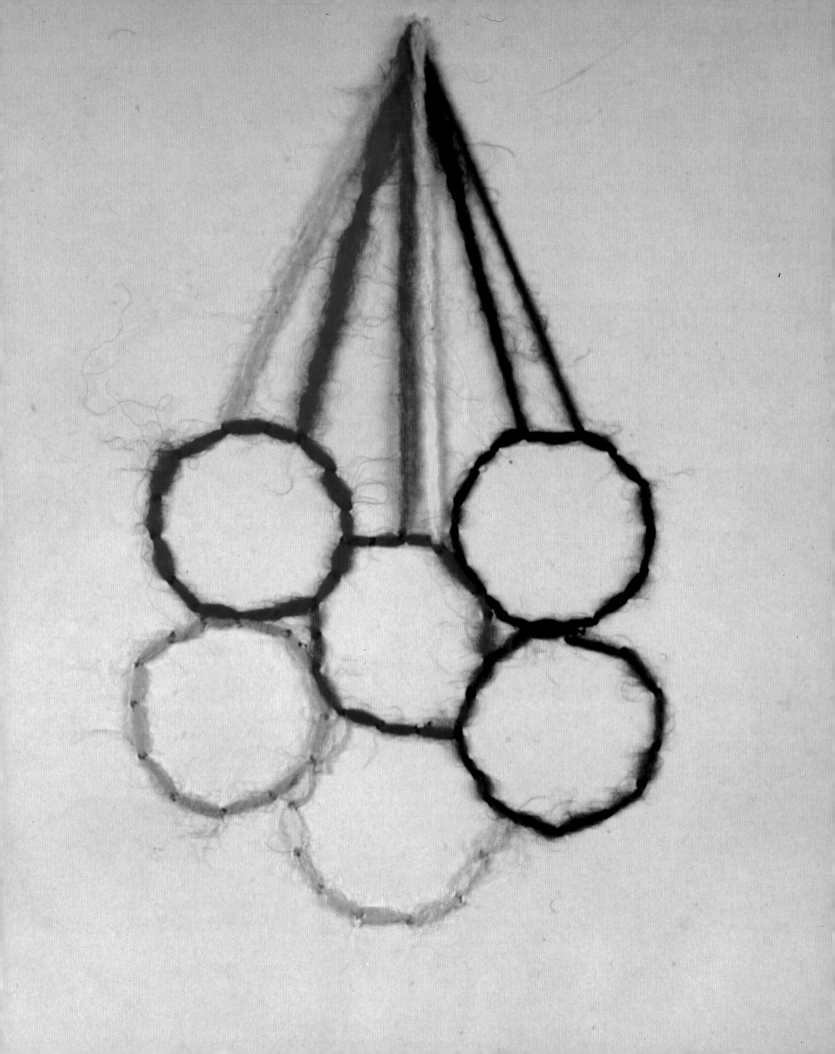

As the cylinder is contained in the cube and the ball in the cylinder, so all consequences lie dormant in their antecedents. Thus great truths enveloped in simple figures are presented at once to the soul and the senses of the young human creature.[3]

THE 2ND GIFT

Sphere, Cylinder, and Cube

Opposite:
The second gift.
J. W. Schermerhorn &
Company, New York,
c. 1890

The block gifts were usually made from finely milled maple in America and beech in Europe. For hanging, swinging, and spinning, each of the forms of the second gift was equipped with metal loops at different points and drilled through for the penetration of thin dowels.

A second plain cube was included in this gift as the transition to the block gifts.

Froebel developed the concept for the second gift by 1836. He considered it the most profound of all, claiming that to understand the second gift was to understand kindergarten. Consisting of a sphere and a cube linked by an elucidating cylinder (which he only added around 1844), it became the identifier for the system, the trademark of unity. Alike in their perfection, the sphere and cube are, in respect to form, pure opposites. Thus, the second gift is the dialectic incarnate—Hegel for tots—and the clearest expression of Froebel's law of opposites. Theorizing that learning is accomplished only by way of comparison, he insured that the gifts and occupations incorporated opportunities for expressing antitheses for every object and action. The sphere with no flat planes, the cube with no curves; the sphere an expression of motion, the cube of absolute rest; the immutable sphere was unity, the cube with its edges and corners, unfolding in diversity from every angle, was variety. The cylinder, curved and flat, motion and rest, variable and static, was synthesis.

Georg Wilhelm Friedrich Hegel (1770–1831), like Froebel, was a teacher for most of his life. Changing course in middleage he had become, by the time of his death, the dominant figure in German and European philosophy. While Froebel never mentioned specific knowledge of Hegelian thought, the well-known philosopher's writings are certain to have been familiar to him.[4] Hegel postulated a German society governed by cycles of dialectical instability and resolution, incrementally leading to an ever greater development of *Geist,* a sort of mental and spiritual reality. A pantheist like Froebel, he believed that God and the world are interchangeable, and that *Geist* is manifested in all the things we can know. Froebel, focusing on the individual, substituted the lessons of childhood (learned in the Hegelian fashion—by reconciling opposing forces) for historical experience and unity for *Geist,* and arrived at a similar conclusion about human growth.

With the second gift, Froebel hit upon a method of demonstrating Hegel's philosophical construct to the youngest members of the kindergarten. In wonderfully simple fashion, he objectified the abstraction of unity between disparate things by showing infants that a cylinder *actually* contains a sphere and a cube *actually* contains a cylinder. The solid maple forms of the second gift have small wire loops on their planes and edges so they may be hung from short strings. They also have holes drilled completely through from plane to plane and edge to edge so that long thin dowels may be pushed through them to form tops. By spinning the cylinder around the axis that bisects it from side to side, the *appearance* of a sphere is described; by spinning the cube around an axis that bisects it from side to side, the *appearance* of a cylinder is described. Without mirrors, nothing up his sleeve, and right before their eyes, Froebel, in a sleight-of-hand worthy of a resourceful magician, created the ultimate gambit—a straightforward demonstration

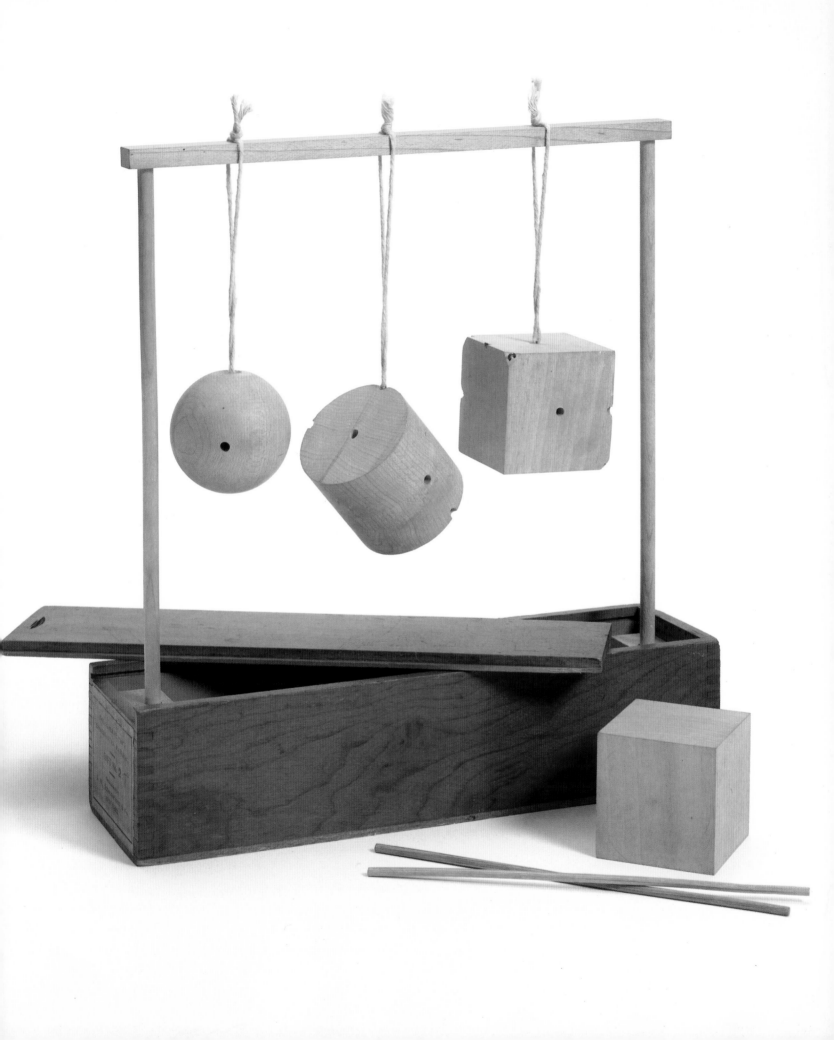

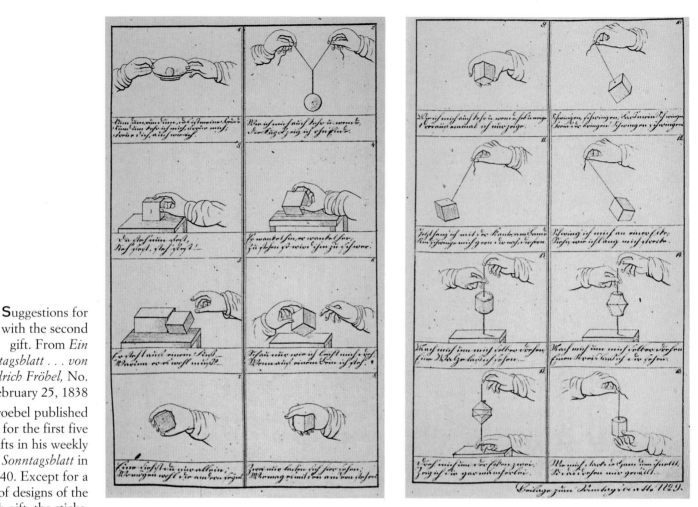

Suggestions for play with the second gift. From *Ein Sonntagsblatt . . . von Friedrich Fröbel,* No. 9, February 25, 1838

Froebel published plates for the first five gifts in his weekly *Sonntagsblatt* in 1838–40. Except for a page of designs of the eighth gift, the sticks, the rest of the system was first portrayed graphically only after his death in books produced by his protégés.

of cosmic mutuality and universal interconnectedness that even a child could understand. Froebel's spinning forms, one into the other into the other, were yet again, unmistakably, unity.

The objects of the second gift were also used as actors at story time, and might represent people, animals, buildings, or other forms of nature. They would be employed as knowledge forms for mathematics lessons, and the cube especially with its many edges and angles was an excellent introduction to arithmetic and basic geometry. And they would serve as the basis for the awakening of the aesthetic sense, as the fundamental forms of beauty that nature wields in the creation of all harmonious design.

The second gift was so representative of the essence of kindergarten that Froebel's followers erected a large granite version of the cube, cylinder, and sphere above his grave at Schweina in central Germany. It remains today as one of the few tangible links between the familiar "Kindergarten" and its unsung, but visionary, inventor.

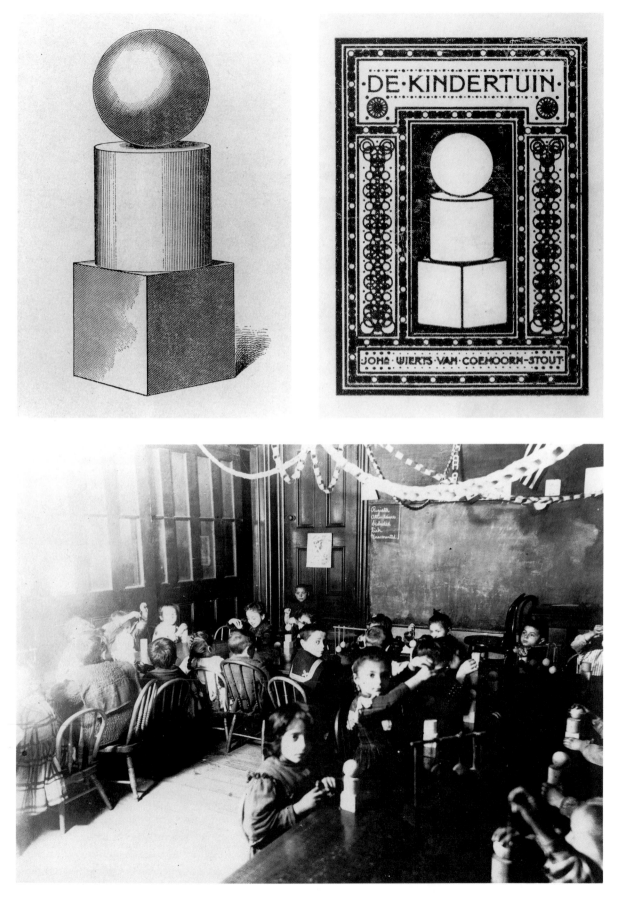

Top left:
The second gift.
E. Steiger & Company
catalogue, New York,
1900

Top right:
Froebel's modernistic
second gift on the
cover of the early-
twentieth-century
Dutch kindergarten
manual *De Kindertuin*
by Joha. Wierts Van
Coehoorn-Stout,
Amsterdam, 1904

Bottom:
The first and second
gifts are visible in this
photograph of immi-
grant children in a
Children's Aid Society
kindergarten on New
York's Lower East
Side, c. 1890

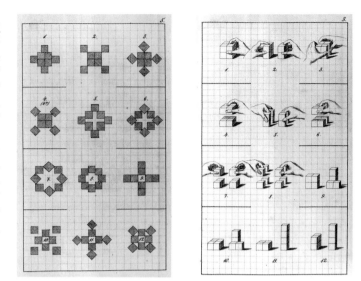

Left:
Beauty forms of
the third gift. Plate 5,
*Die Pädagogik des
Kindergartens* by
Friedrich Fröbel,
Berlin, 1862

Right:
Hand exercises with
the third gift. Plate 3,
*Die Pädagogik des
Kindergartens* by
Friedrich Fröbel,
Berlin, 1862

> After comprehending the outside of the object, the child likes also to investigate its inside;
> after a perception of the whole, to see it separated into its parts; if he obtained a glimpse of
> the first, if he has attained the second, he would like from the parts again to create the whole.[5]

THE 3RD, 4TH, 5TH, AND 6TH GIFTS
Blocks

So many lessons may be learned with blocks that it is something of a surprise to discover that, like kindergarten itself, they have not been with us forever. The open-ended nature of good building blocks provides opportunities for instruction in social studies—in mapping, the layout of cities, and people's work; socialization—in cooperation, cleanup, respect for others, and self-confidence; art and architecture—in pattern, balance, symmetry, and construction; language—in function, storytelling, planning, and conceptual exchange; science—in gravity, weight, trial and error, and inductive thinking; and mathematics—in geometry, number, measurement, classification, fractions, and much more.[6] By the 1880s, both the spread of Froebel's system and the burgeoning manufacture of deliberately related toys by dozens of European and American companies insured that most Western children, at all levels of society, would be exposed in youth to building blocks.

Borrowing Froebel's own thesis of form and growth in nature, it may be said that the development of building blocks, the ubiquitous learning tool of early childhood and one of the lasting contributions of the kindergarten, proceeded in somewhat the same fashion as the evolution of flowering plants used to be understood. The classic botanical theory (recently disputed) posits flowers progressing over millions of years from *more* physically complex to *less.* Blossoms of the ancient magnolia, with their lush sexual parts, and ginkgos, whose rank yellow fruit results from the union of distinct male and female trees, are examples of this primitive overdesign. Conversely, daisies, sunflowers, and grasses, whose streamlined reproductive systems insure prolific seed harvests for widespread distribution, were assumed to be "modern" refinements of earlier biological strategies. The elaborate flowers of the magnolia are independent structures, each with its large and fragile stamens, pistils, and petals. If one compared a magnolia bloom with a building, these parts would be columns, arches, and domes. Every sunflower and grass plant is similar to a beehive or a coral reef—a set of modular units that integrate functions for the success of the species. The architectural comparison here would be to a brick serving as a small, interchangeable part of a larger foundation or wall.

Before Froebel designed the first of his gifts, few children were reared on building blocks comparable to those of a modern kindergarten. Of the construction toys that existed, most were either fairly detailed models with accurate, custom-made parts or somewhat more abstracted versions of reality that included miniature classical components. German toys of the nineteenth century are sought after by adult collectors today for the very reasons Froebel deemed them unsuitable, even destructive, for children. They were so elaborate, realistic, and complete—carefully wrought models of boats, trains, carousels, and towns—that they discouraged discovery and creativity. Calling these beautiful and

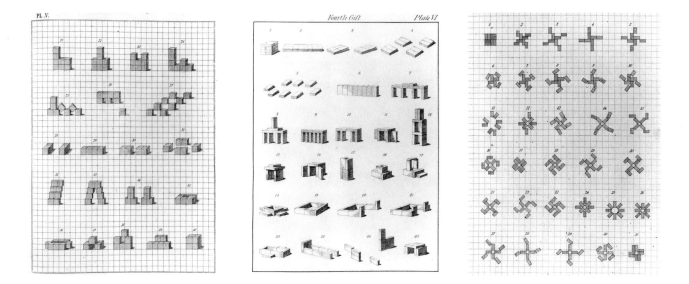

charming folk-art wonders "an element which slumbers like a viper under roses," Froebel railed against their reality and called for simple playthings that allowed children to "feel and experience, to act and represent, and to think and recognize."[7] Typically, the *baukasten,* or building bricks, that were available were also highly decorative and rarely systematic—they lacked mathematical and geometric logic. Perceiving modularity as the key to a successful building-block set, in 1826 Froebel designed a large box of five hundred blocks based on the incremental repetition of one-inch cubes. Consisting of colored cubes and square columns two inches to twelve inches long, the set, which he used to teach mathematics at the Keilhau school, was the direct ancestor of the Montessori counting apparatus.[8] Soon thereafter, Froebel designed the building-block gifts for his kindergarten.

The third gift begins the sequence of four block toys that initiated constructive play in the original kindergarten. After the first self-contained gifts, Froebel introduces a toy that satisfies the child's curiosity-driven need to take things apart: a two-inch cube divided through its center by three perpendicular planes, creating eight smaller cubes. Diverse in its simplicity, the third gift embodies lessons of outer and inner, unity and divisibility, scale, and complementary form. Implicitly it teaches, as do all the cube "plays," the concept of relativity—of the whole in its relation to the parts and of the parts in relation to the whole. Infinitely adaptable for the three- to four-year-olds who were its intended user group, the cube divided was a revolutionary apparatus for the new education.

The simplest set of building blocks ever devised, the third gift is also, in many ways, the most sophisticated. When it was designed, it was a radical repudiation of traditional conceptions of play, playthings, and education. Nonspecific, open-ended, and symbolic, Froebel's blocks were also paradoxically more *real* than any doll, ark, or building block on the market. During utilization in the creation of nature, knowledge, and beauty forms, they remained unequivocally themselves—conceptually pure yet tangible, graspable solids subject to gravity's unyielding pull. When stacked to form abstracted chairs and buildings, a pair of boots, or a thousand other things encountered in the child's daily life, they spurred imagination and conceptualization and taught lessons in balance, coordination, and concentration; when sorted into long rows by the entire class they got kids used to working in groups and sharing responsibility as they learned form, size, position, and combination, as well as elementary mathematics and solid geometry; when used to create "two-dimensional" designs on the gridded field of the kindergarten table, they became "star, flower, and picture" forms and the beginning of an aesthetic sensibility. The eye-catching, rotationally symmetrical beauty designs even incorporated the idea of movement: never destroyed but always kaleidoscopically transformed by the symmetric rotation of elements at paired axes, these patterns were also referred to by Froebel as *dance* forms, approximating the "dance of the seasons, or of Nature; wherein each individual is there on account of the whole and the whole on account of the individual."[9]

Left:
Knowledge and nature forms of the third gift. Plate V, *Manuel Pratique des Jardins D'Enfants* by J.-F. Jacobs, Brussels, 1859

Center:
Knowledge and nature forms of the fourth gift. Plate VI, *The Paradise of Childhood* by Edward Wiebé, Springfield, Massachusetts, 1869

Right:
Pinwheeling beauty forms of the fourth gift. Plate XIII, *Manuel Pratique des Jardins D'Enfants* by J.-F. Jacobs, Brussels, 1859

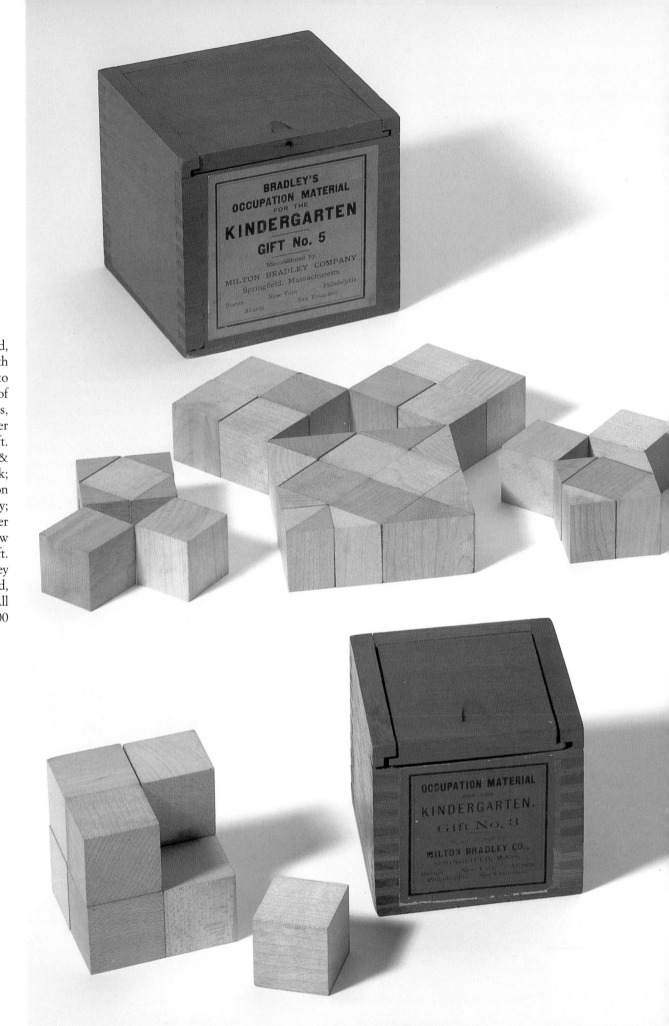

Blocks of the third, fourth, fifth, and sixth gifts assembled into forms from each of the three realms, clockwise from upper left: Fifth gift. J. W. Schermerhorn & Company, New York; Sixth gift. Milton Bradley Company; Fourth gift. E. Steiger & Company, New York; Third gift. Milton Bradley Company, Springfield, Massachusetts. All c. 1880–1900

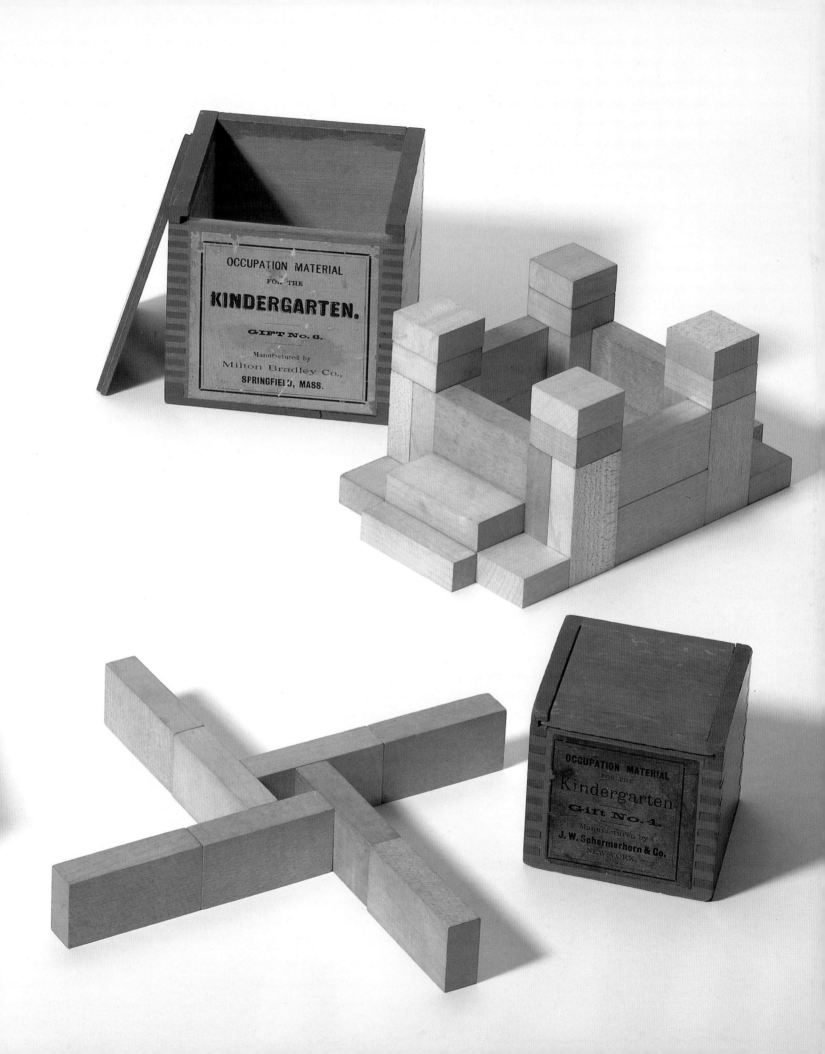

PL. XXVI.

Sixth Gift Plate XIX

Left:
Nature forms (buildings) of the sixth gift. Plate XXVI, *Manuel Pratique des Jardins D'Enfants* by J.-F. Jacobs, Brussels, 1859

Right:
Beauty forms of the sixth gift. Plate XIX, *The Paradise of Childhood* by Edward Wiebé, Springfield, Massachusetts, 1869

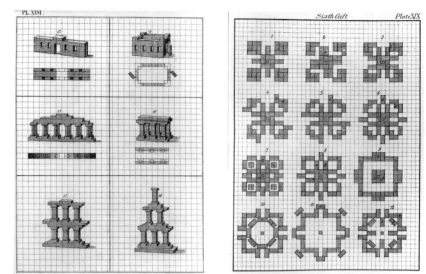

Substituting the cubes of the third gift with equivalent flat tiles in the next, Froebel maintained the progressive sequence that marked the development of the entire system as it methodically addressed the possibilities of design and growth in three and two dimensions. The tiles of the fourth gift, which he specifically called "building blocks," are both like and not like their cubic predecessors. They form the same-sized cube and pack into the same-sized box as the eight blocks of the third gift, but are flattened and elongated like dominoes. Where the units in the third gift were all alike and also like the whole, these new toys are all alike but unlike the whole. Where the cubes in the third gift were particularly *volumetric,* these, with their three unequal axes, are *directional.* Where the three principal dimensions of space were expressed by *position* in the third gift, they are, in the fourth gift, reiterated as *size.* The diversity the child found in the fourth gift's "bricks," with their 1:2:4 modularity, delivered new insights as it allowed for more realistic and vertical life forms, more complex knowledge plays, and much more elaborate beauty designs.

Within the realm of beauty forms that could be created with the fourth gift, one discovers the first obvious indication of the cruciform motif that prevailed throughout the remainder of Froebel's ordered system and evidence of the surprising similarities it shared with some of the early twentieth century's most revolutionary art. Here we find, in embryonic form, the floor plans of Frank Lloyd Wright and Mies van der Rohe; the "'windmill'" paintings of Piet Mondrian, Theo van Doesburg, and Lyonel Feininger; the Architectons of Kasimir Malevich; and, insidiously, the swastika of Adolf Hitler's Third Reich. While stopping short of attributing authorship of all these diverse icons to conscious quotation of Froebel's humble block toy, it is still notable that all of the above were children during the period when kindergarten swept the Western world, and all were raised in, or close enough to, its initial spheres of influence to have experienced the system firsthand. Because Froebel specified that all the parts of the fourth gift (and, for that matter, of all the block gifts) must be used for every new design (to reinforce the concept of metamorphosis of one unity into another which is different yet equivalent), and because many of his designs were rotationally symmetrical as a consequence of their methodical transformation by degrees in a circular motion, the class of "pinwheel" designs bred an infinite number of variations on one of kindergarten's outstanding graphic themes. Crosses abounded in the system's biaxial flowering but they were neither metaphoric (in a religious sense) nor a distracting visual residue of some cultural interaction. Directional, environmental, and mathematically coherent, the crosses of the kindergarten *were* the lessons; in the realm of beauty, the cruciform *was* the message and the message was unity. That this intense early experience with the logic of Froebel's compositional strategy might reemerge as a key structural element in the mature works of the first kindergarten generation seems hardly coincidental and, in fact, perfectly reasonable. The kindergarten kids understood these forms and were comfortable with both their derivation and manipulation. They appreciated the potential of

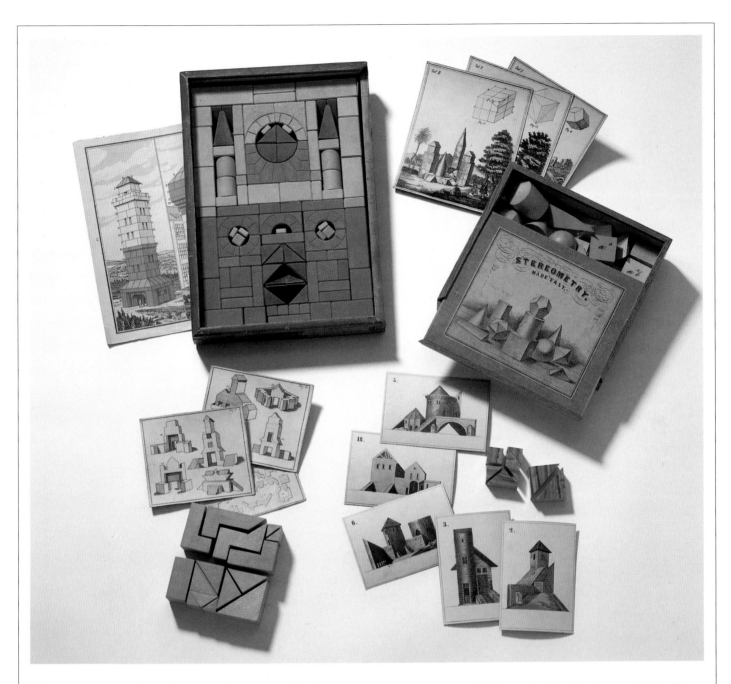

The modern toy industry began in Germany in the late eighteenth century. While most early building block sets were random collections of classical parts, some were based on the kind of systematic geometry that was further refined for symbolic play by Froebel. Like the kindergarten gifts, these toys reinforced the kind of creativity that soon after crystallized into the geometric art and rational architecture of early Modernism.

Clockwise from upper left:

Richter's Anchor Stone Building Blocks, set #6. Rudolstadt, Germany, patented 1884

Friedrich Richter was marketing kindergarten material when he purchased the rights to produce what became the most elaborate and successful building-block toy of all

time—the remarkable *Anker-Steinbaukasten*. Made of highly compressed sand and based on a cubic module that owed its logic to Froebel's system, Anchor Blocks were eventually made in over one thousand different shapes and in sets weighing several hundred pounds.

Stereometry Made Easy. Germany, c. 1840

Stereometry is the art of measuring solid bodies.

The Magic of Geometry. Germany or England, c. 1830

In this highly elaborate version of the ancient Chinese game of Tangram, the usually flat designs are rendered into bizarre, cubistic buildings.

Angenehme Architectonische Unterhaltungen (Agreeable Architectural Amusements). Germany, c. 1840

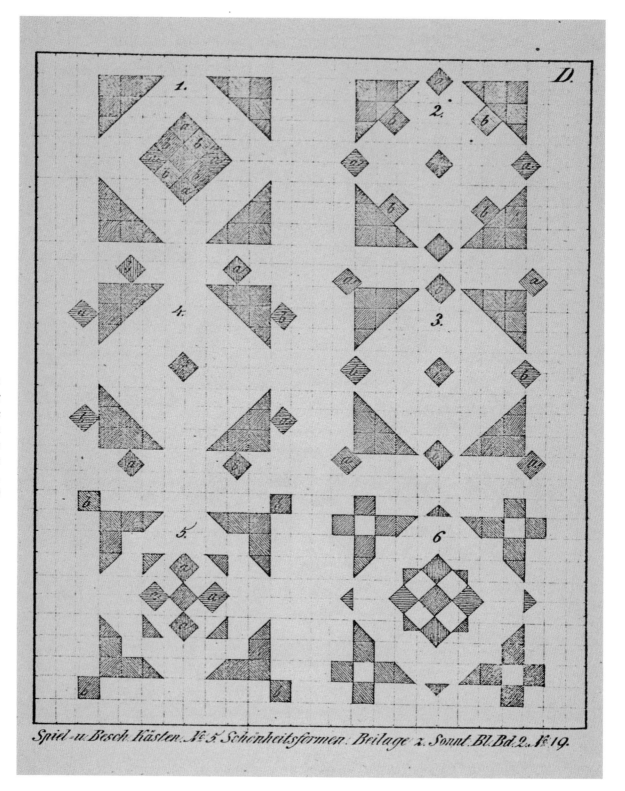

Right and opposite: **F**roebel's designs for beauty and knowledge forms of the fifth gift. From *Ein Sonntagsblatt . . . von Friedrich Fröbel,* Volume II, 1838–40

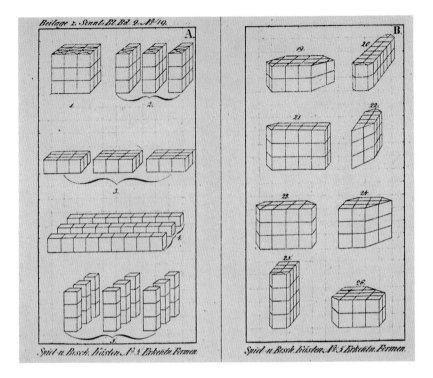

the cruciform as they would also come to value the grid and triangular crystalline matrix. The children of the early kindergarten knew how to think and work in these visual realms because at the most impressionable period of their lives they were deliberately *taught* to.

The fifth gift is a three-inch cube that has been divided equally, twice in each dimension, producing twenty-seven one-inch cubes. Three of these are divided into halves by one diagonal cut, and three others into quarters by two diagonal cuts crossing each other, making in all thirty-nine pieces. The sixth gift is a three-inch cube divided by various cuts into thirty-six pieces, eighteen of which are bricks like those of gift four, twelve of which are half cubes made from bricks cut horizontally, and the remaining six of which are "columns" made from bricks cut vertically. The fifth gift was to be familiar to the child as a larger variation of the third with the addition of prismatic forms, and the sixth gift would resonate as an extension of the fourth gift. Each was designed to further the sequence of nature, knowledge, and beauty forms previously explored, in more complexity and with greater variety. The introduction of diagonals in the fifth gift provided a new set of connecting devices, leading the child to the consideration of fractured geometries, lifelike architectural constructions (with the sloped roofs of the archetypical child-designed "house"), and crystalline artistic forms that resembled snowflakes in their kaleidoscopic unfurling. The expanded modules of the sixth gift allowed for lessons in cube roots, the erection of larger building models with austere columns and cantilevers, and beauty forms that edged remarkably close to the plastic strategies of Neo-Plasticism and Constructivism. While the little "roofs" of the fifth gift still embodied tradition, the sixth gift read as a miniaturized preview of modern. Like all the block toys, the fifth gift and sixth gift taught lessons on volume, planarity, construction, and enclosure. The building play encouraged with these new cubes resulted in architectural designs that did not so much look back to the organically ornamented forms of the Classical and the Gothic as they did forward to the imminent invention of the severely geometric International Style. Dispensing with the natural curves of history, the crystallographer Froebel drew plans for educational tools that implicitly foreshadowed the actual buildings that Wright, Mies, Adolf Loos, and Le Corbusier would design when they *grew up.*

That the basic units of complex structures are commonly described as "the building blocks of [nature, biology, chemistry, and so forth]" is directly attributable to Froebel's influence, an inevitable consequence of his having made building blocks the foundation of *his* system.

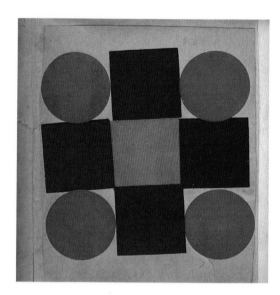

THE 7TH GIFT

Parquetry

The three-dimensional forms of the first six gifts inhabited the realm of objects. Modeled into simple expressions of other things, or organized as mathematical and artistic arrays, solidity was confirmation that their existence was actual. Transition to the seventh gift was considered a profound conceptual leap. Parquetry was the first of the gifts that Froebel considered truly abstract, as it was used to create two-dimensional *pictures* of things rather than tangible things themselves. Children were familiarized with the idea of planes in the manipulation of the cubic gifts and were taught to comprehend them as enclosures of volume. A recommended device for bridging from three to two dimensions had students cover the surfaces of cubes from the third gift with equal-sized square tiles from the seventh, and then "peel" them away in a graphic display of equivalence. Whereas the concept of surface was explored in the cube gifts in its relationship to volume, in the seventh gift, planes were isolated as distinct entities and functioned as the units of the traditional mosaic art from which they were descended.

In the block gifts, children learned the concept of whole and parts and explored the former by rearranging the latter. In the seventh, they were given a fixed but not necessarily significant number of pieces and guided in combining them into various new forms. Breaking apart the large cube of the third gift into its eight component cubes was an act of analytic transformation that was reinforced by the deliberate method in which the toy was revealed. The pieces were never haphazardly dumped out; instead the small box that held them was inverted and its cover gently removed. The container was then lifted, leaving the "whole" cube standing on the table ready for use. After each play session this procedure was reversed—the large cube was reconfigured, its wood box was slowly lowered around it to the work surface, the package was tipped upright, and the cover was replaced. By repeating these steps throughout the term, Froebel's basic lesson—unity and the interconnectedness of all things, people, and actions—was implicitly reinforced.

By comparison, play with the geometric tiles of the seventh gift was inherently synthetic. The gift consisted of separate boxes of flat wood or cardboard pieces in five shapes—square, half square (right isosceles triangle), equilateral triangle, half equilateral triangle (30° × 60° × 90°), and an obtuse triangle formed by two 30° × 60° × 90° triangles joined at their short sides (30° × 30° × 120°). All of these units were based upon the one-inch module of the cubic gifts and were thus scaled to the one-inch grid of the kindergarten table. Beginning with the squares (the shape most obviously related to the gifts preceding), children would advance, as usual, through their nature, knowledge, and beauty forms, creating flat images within the matrix of perpendicular lines scored into the surface of their low communal tables. Knowledgeable kindergartners were cognizant of the degree of suitability of each gift, and in the case of the parquetry tiles, each shape, for the formation of the forms in the three different realms, and would concentrate their efforts accordingly. For example, of the five tile shapes of the seventh gift, equi-

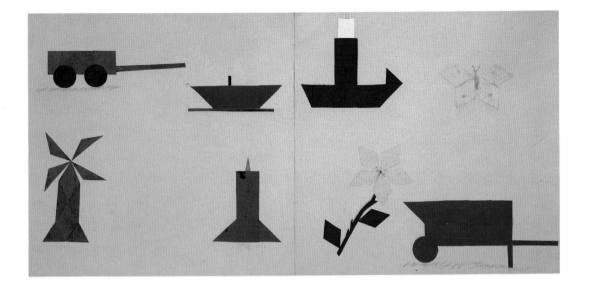

lateral triangles, which lack right angles both alone and in combination, proved most difficult to harness for the creation of life forms but were eminently suited for works in the beauty realm. The square pieces were also hard to integrate into convincing nature designs, whereas half squares and 30° × 60° × 90° triangles, which could make both rectilinear and prismatic forms, were highly adaptable for pictures of "real" things. And using a combination of two or more different shapes, a technique that may or may not have been strictly Froebelian but was sanctioned in textbooks before the turn of the century, allowed for the creation of abstract pictures of elegant sophistication.

The squares and triangles of the seventh gift could also be combined into all of the basic planar shapes of Plato's basic forms. Because of the peculiarities of the angles of the parquetry tiles and the shading of their neutral colors from light to dark, they could also be formed into convincing perspectival views of simple solids like tetrahedrons and cubes.

The flat geometric forms of the seventh gift were available from several manufacturers in a number of different materials and surfaces. (Frank Lloyd Wright's were red on one side and white on the other.) In smooth, stiff cardboard they were the distinctive rust-brown of manila or the pale yellow of old office files. They also came as gum-backed, colored-paper shapes (including, eventually, circles and semicircles) that were transformed from gift to occupation when licked and arranged in albums or on sheets of construction paper. They were sold in lacquer-glazed wood in a rainbow of brilliant colors that provoked one nineteenth-century author to question the kind of color scheme our post-Fauvist, twentieth-century sensibilities have long since accommodated: "extravagant and vulgar combinations of color, such as . . . a barn, with its front view checkered with violet, red, and yellow squares, or a pigeon-house with a particolored green and blue roof, an orange standard, and red supports."[10] And they were most widely available in natural-finished maple, beech, walnut, and mahogany whose muted tones made for crystalline abstractions of form in which color was transformed into a kind of sculptural surface modulator.

Pattern-making toys predated kindergarten, but kindergarten adapted and focused their essence in ways that were previously unimagined. Due to the distinctive mechanics of Froebel's system, the millions of young children who were "taught" to use the fractured particles of the seventh gift discovered more than the relationship between solid and plane, absorbed more than the rudiments of Pythagorean geometry, and developed more than simple design skills or a heightened visual acuity. The seventh gift, like all the kindergarten gifts, taught children the viability of abstraction and fragmentation in the creation of pictures and developed within them what amounted to an entirely new mode of perception. Since one might portray anything with the gifts, and was in fact urged by one's teacher to do so, the making of pictures with small, natural-colored, crystalline shapes on gridded, wood tables became not just a means to an end but a potent end in itself.

Jessie Georgina Barker. Parquetry nature forms. United States, c. 1895

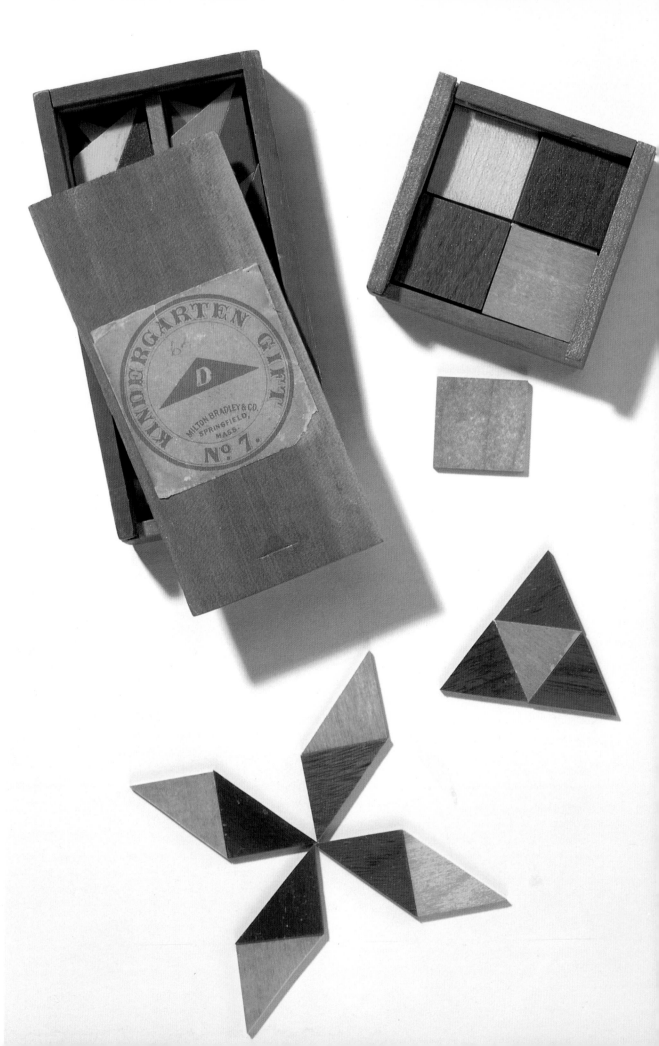

Left;
Seventh gift
(variations in natural
and lacquered wood).
c. 1870;

Right:
Seventh gift
(gummed parquetry
papers). c. 1890.
All Milton Bradley
Company, Springfield,
Massachusetts

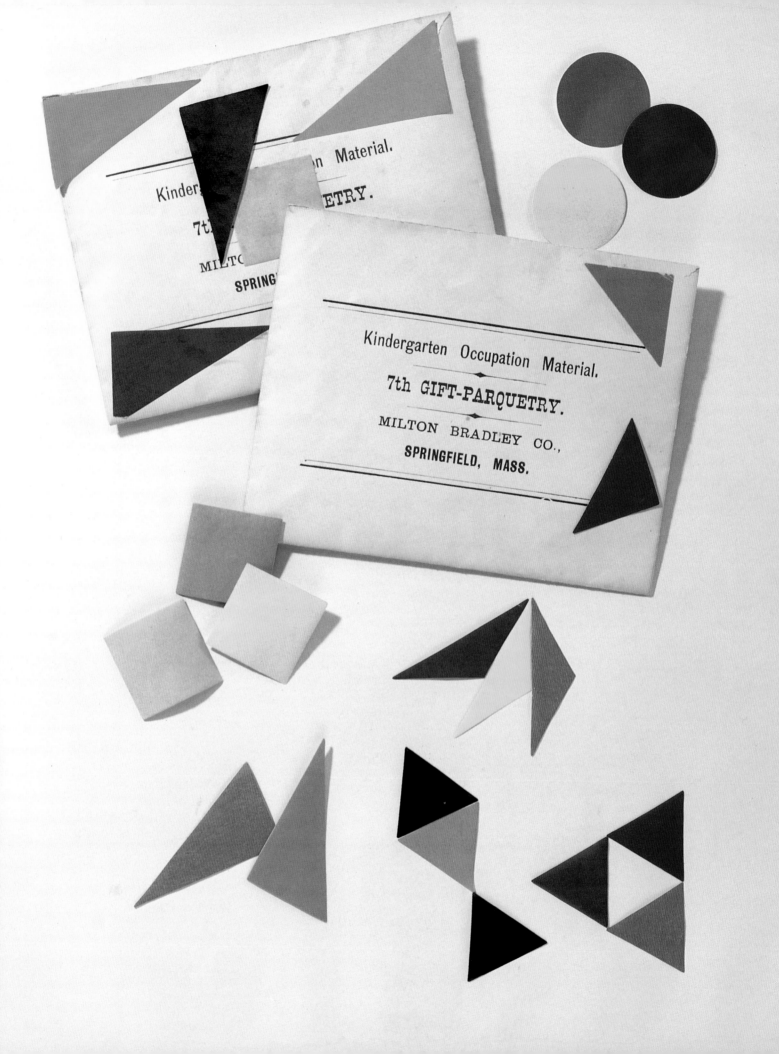

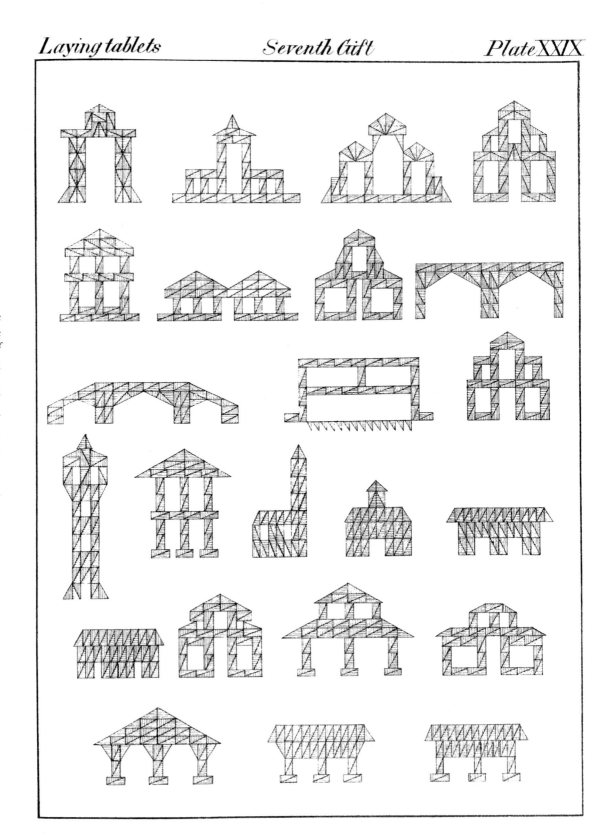

Nature forms for the seventh gift. Plate XXIX, *The Paradise of Childhood* by Edward Wiebé, Springfield, Massachusetts, 1869

Structural designs for the truss bridges and industrial sheds that pioneered steel construction are suggested in these forms for children.

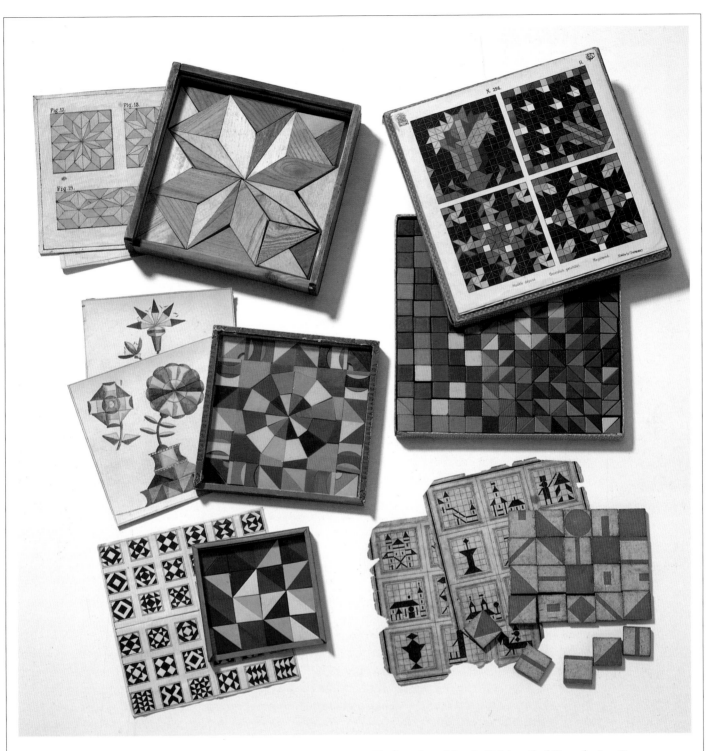

Mosaic toys were widespread in Europe throughout the nineteenth century and were a natural choice for adoption by crystallographer Froebel. Clockwise from upper left: Divided Square Puzzle. Germany, c. 1850;

Embroidery-Mosaic-Bricks. Carl Brandt, Jr., Germany, 1903; Variations of Figures. Germany, c. 1850; Improved Mosaic Recreations. England, 1862; Flora, the game of flowers. Germany, c. 1850

Stick laying.
Chromolithograph from
*Froebel's Kindergarten
Occupations for the
Family,* a kindergarten
teaching set for home use.
E. Steiger & Company,
New York, 1877

THE 8TH, 9TH, 15TH, 16TH, AND 17TH GIFTS

*Sticks, Rings,
Slats, Jointed slats,
and Interlacing*

After the volumetric gifts, one through six, and the planes of the seventh gift, the eighth gift, stick laying, was the first whose vocabulary consisted entirely of lines. Introduced as edges in the cubes and parquetry tiles, lines were here free and independent—the infinitely narrow represented for children by skinny sticks. While the cubes were used for making models of things, and the tiles for pictures, outline drawing with the sticks advanced Froebel's progression inexorably toward ever greater abstraction. Much more common than actual drawing (the tenth gift) was in kindergarten, stick laying was highly recommended in teaching manuals for its clarity, cleanliness, and ease of manipulation. Like wood matches without tips, the sticks were marketed in packages including one- to five-inch increments and, typically in this system that venerated the grid, lengths keyed to the diagonals of one- to five-inch squares. Perhaps the simplest gift, the sticks were also among the most valuable. They were equally suited for nature, knowledge, and beauty forms and, in more advanced classes, for children's first exercises in letter and word making as well. And because it resisted the creation of organic curves and elaborate detail, stick work led automatically to childish simulations of what may be viewed as the unornamented idioms of modern art.

Stick laying was one of several linear gifts in the kindergarten program, including the ninth gift (ring laying), the fifteenth gift (slats), the sixteenth gift (jointed slats), and the seventeenth gift (interlacing paper strips). (The twelfth gift, sewing, which also involved making linear patterns, is discussed in a separate section below.) All of these were suggested as variations of drawing, although each approached the making of lines and linear forms in different ways.

Ring laying, a practical addition made by Froebel's followers to include curved lines in the training sequence, consisted of incrementally sized whole, half, and quarter circles made from heavy-gauge steel wire. Because the rings were always round or arcs of circles, they were in direct opposition to the rigorous angularity of the rest of the system and were an important reference back to the sphere and cylinder of the first and second gifts. The slats, a throwback to basket-making traditions and progenitor of the still-popular art of popsicle-stick work, were available in plain or colored wood, and taught lessons in tension and interconnection. And since the end product of slat work was often a stable and self-contained object that could be hung from a string and spun by the wind, it was an opportunity for "drawing in space," and bridging, in typically Froebelian fashion, from two back to three dimensions.

The jointed slats, flat sticks of equal length connected at their ends by simple brass hinges, were available in combinations of four to sixteen sections that were unforgiving for nature and beauty forms, but extremely useful for introductory lessons in geometry. The connected slats could easily be configured into every pure form from triangle to dodecagon by overlapping the unnecessary sticks, and because they were physical things that could be held in the hand and adjusted at will, they made teaching the concept of angles as simple and effective as possible. Instead of watching a teacher draw shapes

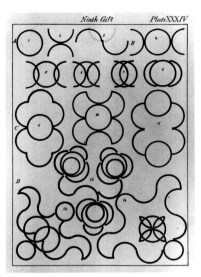

Left:
Nature and knowledge forms of the ninth gift. Plate XXXIV, *The Paradise of Childhood* by Edward Wiebé, Springfield, Massachusetts, 1869

Below:
Minnie Lawdham. Nature forms made with paper sticks. New York, c. 1900

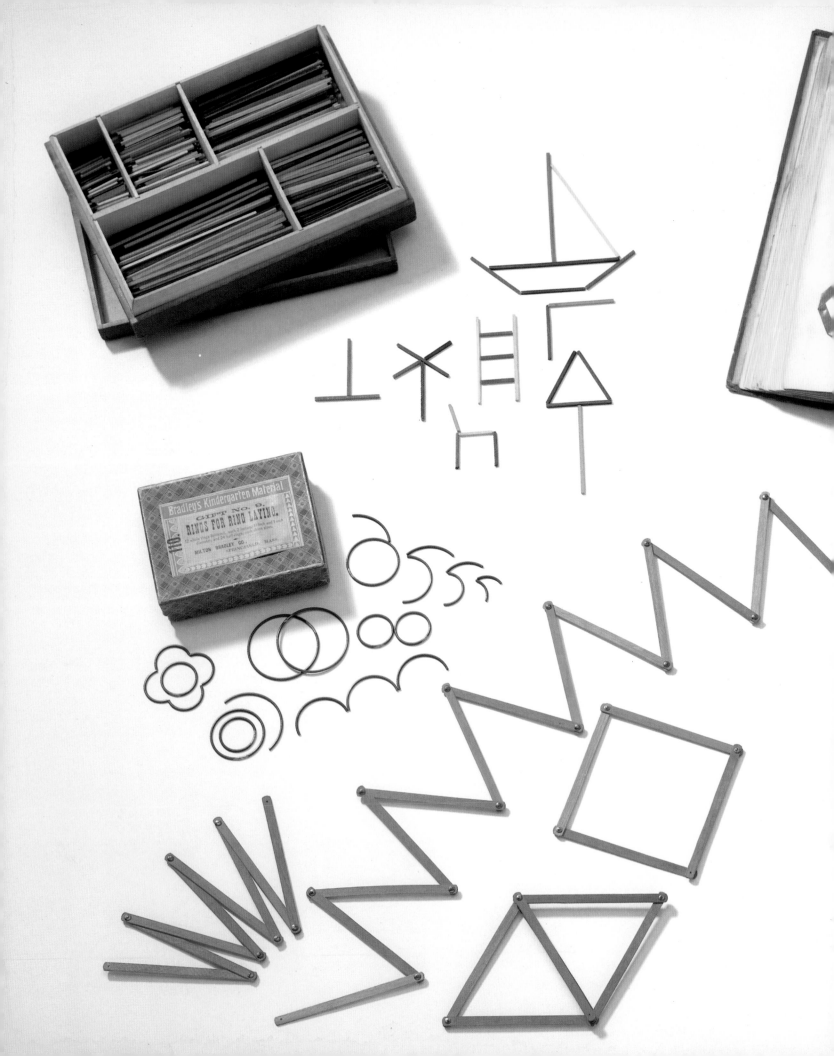

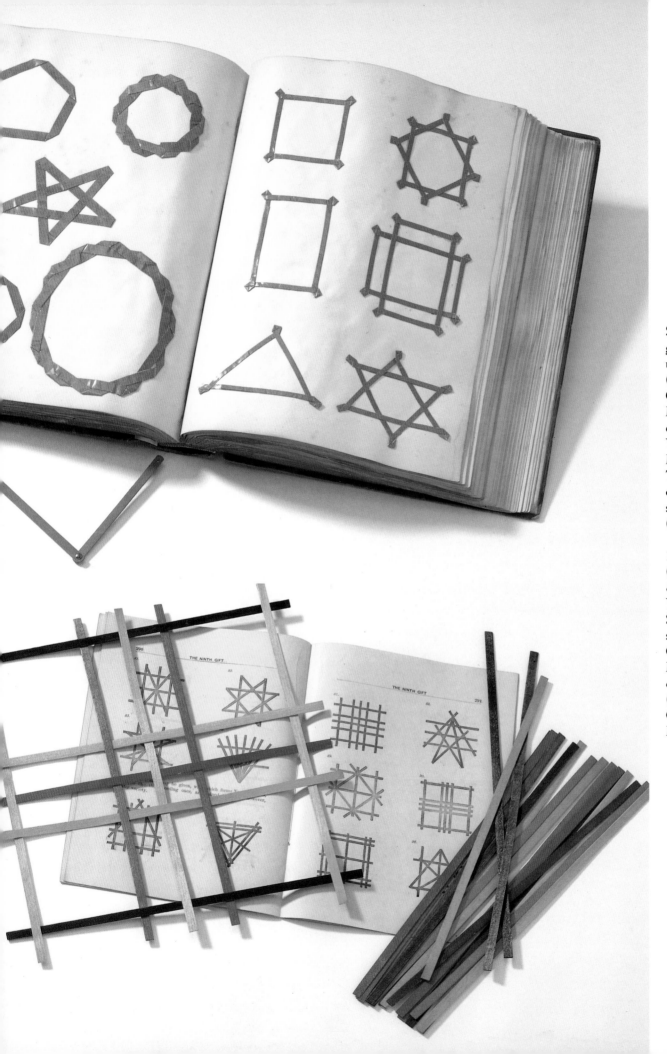

Some of the linear gifts, clockwise from upper left: Eighth gift (sticks). Milton Bradley Company, Springfield, Massachusetts, c. 1900. Collection Yvonne Simons and Max Spoerri; Ellen Thompson. Album of exercises for the seventeenth gift (paper interlacing). St. Louis, Missouri, 1878; Fifteenth gift (slatwork). E. Steiger & Company, New York, c. 1900; Sixteenth gift (jointed slats). Milton Bradley Company, Springfield, Massachusetts, c. 1880; Ninth gift (rings). Milton Bradley Company, Springfield, Massachusetts, c. 1880

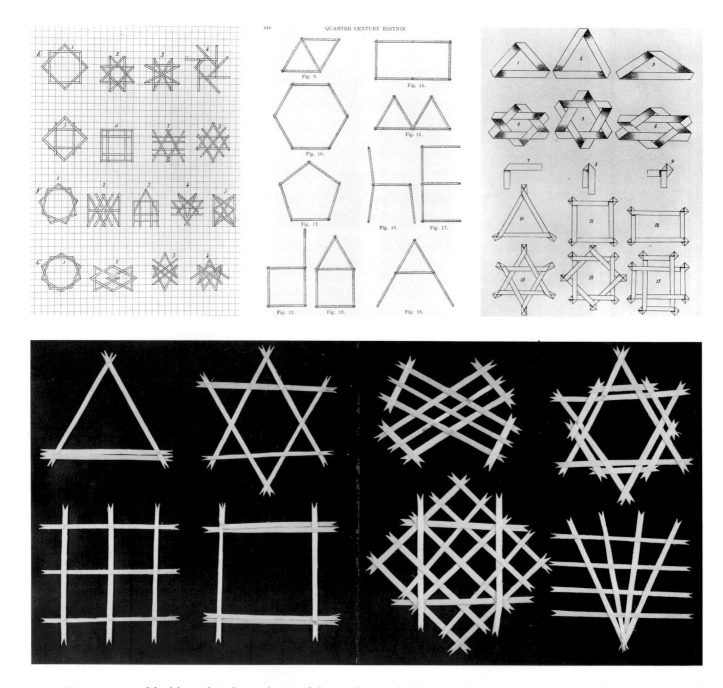

Above: Helen Atherstone. Slatwork beauty forms. Oakland, California, c. 1890.

Atherstone was a student at the California Kindergarten Training School, San Francisco.

on a blackboard and wondering if the angle was the lines or the space between, a child could play with the hinged slats and receive an object lesson of Pestalozzian purity.

Interlacing, the folding and bending of long strips of colored paper into geometric outline shapes, was one of the more difficult manual operations of the system, and its rather perfunctory appearance in many old teachers' manuals suggests it presented difficulties even to adults. Because a "one-dimensional" paper line can be bent at any point, the seventeenth gift offered a much more flexible medium of expression than its close cousin, the jointed slats, but it required a great deal of control over the materials to get presentable results. It was, though, the only one of the occupations where an individual line is permanently transformed into other forms, and was comparable in this sense to the "two dimensional" occupation of paper folding (the eighteenth gift), where a single symmetrical leaf was folded into myriad variations of abstract origami patterns, while the original shape, usually square, remained intact as the form-generating germ within.

Opposite top left:
Beauty forms for the fifteenth gift. Plate XL, *Manuel Pratique des Jardins D'Enfants* by J.-F. Jacobs, Brussels, 1859

Opposite top center:
Knowledge and nature forms of the sixteenth gift. *The Paradise of Childhood* by Edward Wiebé, Springfield, Massachusetts, 1896

Opposite top right:
Beauty forms for the seventeenth gift. Plate LXVIII, *The Paradise of Childhood* by Edward Wiebé, Springfield, Massachusetts, 1869

This page:
Nature and knowledge forms of the eighth gift. Plate XLI, *Manuel Pratique des Jardins D'Enfants* by J.-F. Jacobs, Brussels, 1859

THE 10TH GIFT
Drawing

Drawing, from printed images, actual objects, or verbal instruction, was a traditional academic disci-pline associated with studies in geometry, stereometry (the measurement of solid bodies), and art. Drawing was included in the education of gentlemen and women as a matter of culture, and in that of surveyors, craftsmen, and painters as a necessity. In contrast to academic drawing, pedagogical drawing focused on the portrayal of forms to enhance observational, and thereby comprehensional, skills, and on objects to explain their function and construction. The publication in 1803 of the *ABC der Anschauung,* which was directed by Pestalozzi but created by his assistant Johannes Buss, inaugurated the educa-tional discipline of drawing by children that steadily grew in popularity in the German States, Austria, France, and Switzerland, and became especially fashionable after the 1870s.[11] Pestalozzi's pupils Joseph Schmid and Johannes Ramsauer each designed their own pedagogical drawing systems after 1805, and many more were later invented that incorporated simple geometric exercises to be taught simultane-ously to an entire class.[12] Most drawing systems subsequent to Buss's were structured like his, on the division of squares into smaller components and the recombination of the resulting parts—composed of horizontal, vertical, and, later, diagonal and curved lines—first into patterns, and then into both let-ters and recognizable forms. As it considered drawing a kind of writing for the preliterate, Buss's man-ual established the discipline as a viable educational pursuit for even the youngest children. The *ABC,* which was only employed for a few years before being abandoned as too confusing, had an obvious and significant influence on Froebel. First encountering the book in 1805 at the Frankfurt Model School, Froebel was attracted to its systematic geometry, which supported his theories about the structure of organic, and later crystalline, growth. And Pestalozzi's intent—"to break down the complexity of nature into its constituent forms . . . to identify and 'elementarise' the underlying geometry of the visual world in a way which would make it assimilable for the child"[13]—was adopted almost verbatim as the basis of kindergarten.

Pestalozzi's goals in drawing were profound but impossible to satisfy. He hoped to teach children to recognize the outlines of objects and then read them like words. Each part, line, angle, and curve would be noted by a different letter so that their combinations could be expressed in written and spoken language, ultimately leading to the establishment of an actual alphabet of forms. An extension of his "object teaching," where every thing and action was evaluated concretely as it was simultaneously expressed in spoken language, the *ABC der Anschauung* was idealistic, interesting but impractical.

Like much of Froebel's educational philosophy, the universal grid, kindergarten's learning and playing field, was directly descended from previous concepts first outlined by Pestalozzi. With a slate pencil that left white lines on grid-incised, individual slates, or crayon or pencil on graph paper, chil-dren copied patterns, followed their teachers' verbal instructions, or created their own designs in this activity, which was considered to be a bridge from the gifts to the occupations. *Netzzeichen,* or net draw-ing, was an outgrowth of Pestalozzi's *ABC* that was first mentioned in 1818 and definitively elucidated

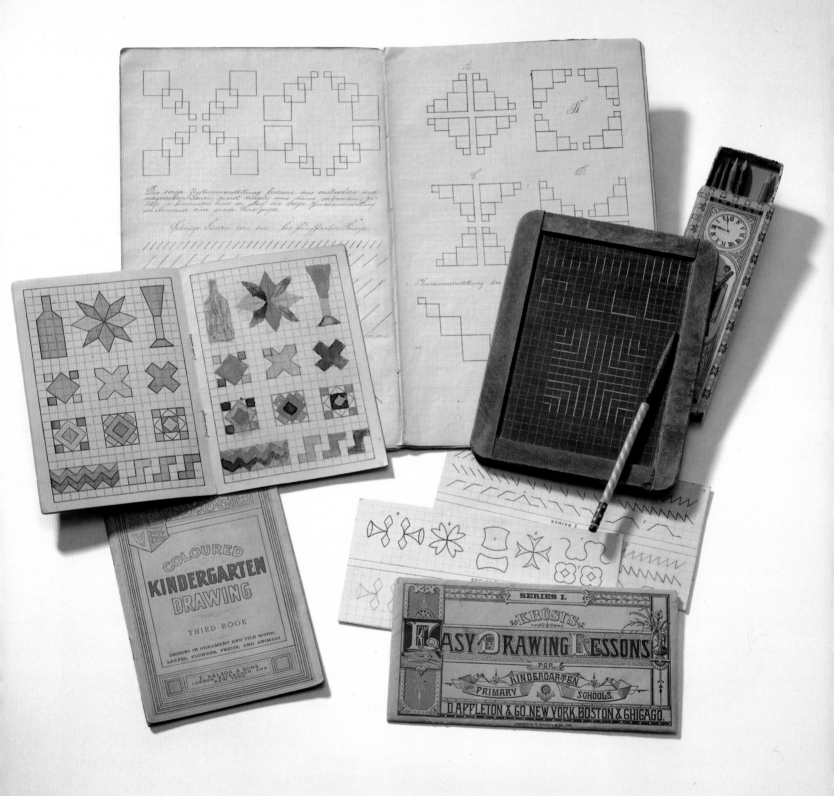

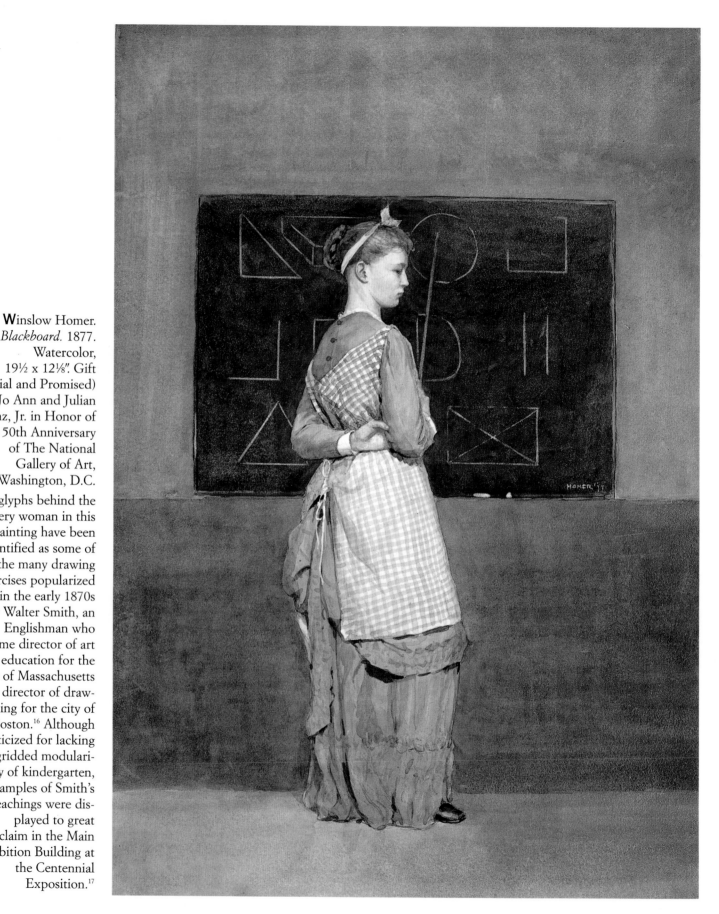

Winslow Homer. *Blackboard.* 1877. Watercolor, 19½ x 12⅛″. Gift (Partial and Promised) of Jo Ann and Julian Ganz, Jr. in Honor of the 50th Anniversary of The National Gallery of Art, Washington, D.C.

The glyphs behind the mystery woman in this painting have been identified as some of the many drawing exercises popularized in the early 1870s by Walter Smith, an Englishman who became director of art education for the State of Massachusetts and director of drawing for the city of Boston.[16] Although criticized for lacking the gridded modularity of kindergarten, examples of Smith's teachings were displayed to great acclaim in the Main Exhibition Building at the Centennial Exposition.[17]

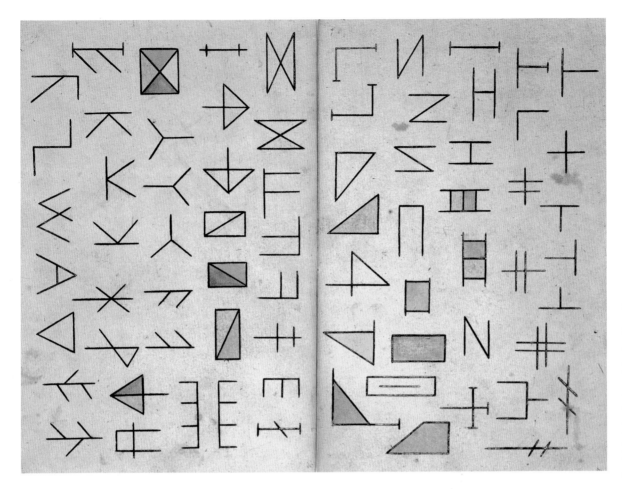

in 1826 in Froebel's *Education of Man.*[14] In a section titled "Drawing in the Net-Work, or In Accordance With Outward Law," Froebel described the importance of the vertical and horizontal axes for human perception and laid the groundwork for the eventual spatial organization of his system.

> However little we may appreciate the fact or be able to account for it, the horizontal and vertical directions mediate our apprehension of all forms. We refer, however unconsciously, all forms to these directions. In our imagination we constantly draw these lines across our field of vision; we see and think according to these; and thus there grows in our consciousness a net-work of lines keeping pace in clearness and distinctness with our consideration of the forms of things.[15]

The grid had long been used by painters to scale up drawings, and Albrecht Dürer (1471–1528) and others employed the camera obscura, which cast an image from nature on a gridded surface, to maintain the accuracy of their compositions, but the Pestalozzian grid that became the Froebelian grid was never a window on the world. Ironically, in spite of their best intentions to clarify objectivity, Pestalozzi (whose drawing book had limited appeal) and Froebel (whose exercises reached an enormous audience) inadvertently provided the tools for penetrating beneath the surface of the known into the perfect reality presumed to reside within. And because this approach was continuously adapted and revitalized by teachers in the nineteenth century and adopted for its formal and philosophical currency by artists in the twentieth, it eventually transcended its humble origins and became a permanent component of the modern mind.

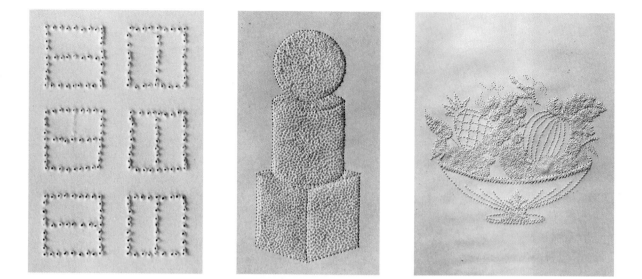

THE 11TH GIFT
Pricking

Top left:
Lettie A. Allen.
Knowledge forms
made by pricking
paper. Chestnut Hill,
Philadelphia, c. 1880

Top center:
Initialed MCB. The
second gift portrayed
by the eleventh.
United States, c. 1895

Top right:
Auguste Cohn.
Nature form made by
pricking paper.
Switzerland, Germany,
or Austria, 1880

Just as drawing in the net found popularity independent of kindergarten, so too did the closely related technique called *Stygmographie,* or drawing on preprinted grids of dots.[18] But whereas one would plot designs on the cross axes of lines in net drawing, or between the points that were their equivalents in dot drawing, in kindergarten pin pricking, lines were no longer the issue. Along with the less common bead, or seed, work, which entailed making designs with seeds on graph paper, perforating, the first of Froebel's occupations, was concerned with the point. It was the end of the logical sequence that began with volumes in space, systematically deconstructed them into planes and lines, and finally existed merely as insubstantial pinholes on white paper. As both an independent exercise and as a practical bridge between drawing and sewing (for by piercing paper at the ends of drawn lines one could replace graphite with colored thread), pricking was another of Froebel's clever adaptations of an existing craft to his course for little children. Paper punch work was a traditional method of Valentine manufacture, and elaborate perforated scenes were also commonly produced, along with sandpaper paintings and theorems on velvet, in American girls' schools before the Civil War. As Paul Klee noted, planes derive from lines, and lines are nothing but points in motion, so a blunt needle and enough patience could transform a sheet of paper into Braille-like "drawings" of great sophistication.[19]

Many pierced-paper examples from each of the "Three Realms" were saved by student-teachers in every country, and some of the old work is truly inspired. But kindergarten was for kids, and the satisfaction of wielding the slightly nasty pricking tool (a pin attached to a wood handle) to create patterns and pictures must have been sublime. Using a felt pad for support, children would punch through a simple drawn or printed image that had been folded over a blank card and then discard the guide to reveal the finished product beneath. These pinhole works could then, as Froebel suggested, be held to the sun or mounted on windows to create sparkling "star" pictures, or be sandwiched with colored tissue for rainbow effects. By creating forms or flowers with masses of pinholes, children would learn Froebel's message of interdependence firsthand—one and all, separate but connected, the individual in community. Like the first gift, the ball, the atoms of the first occupation were simple enough to become the All, and the all was the heart of kindergarten.

Opposite:
Clockwise from top: Perforating cushions, Milton Bradley Company,
Springfield, Massachusetts, c. 1900; Gina (last name unknown). Nature forms
made by pricking paper. United States, c. 1900; Abbie A. Herrick. Beauty
form made by pricking paper. Westfield, Massachusetts, 1875
Herrick was a kindergarten teacher. The work by Gina
comes from a child's album.

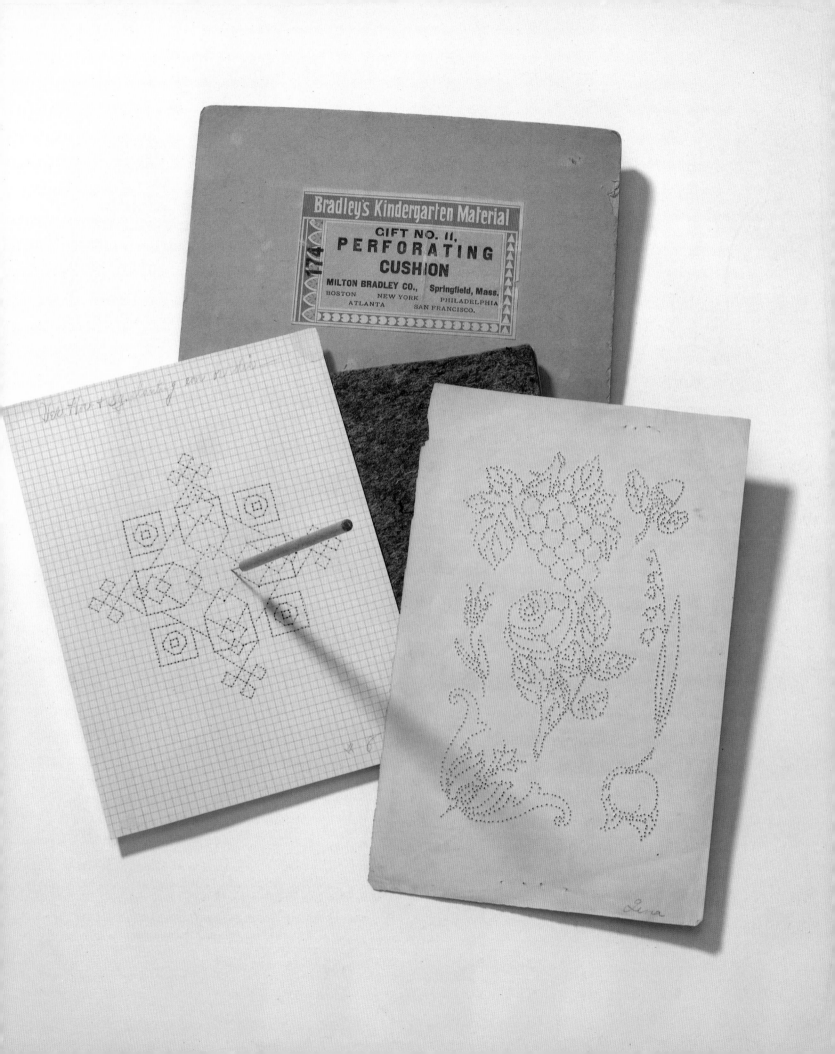

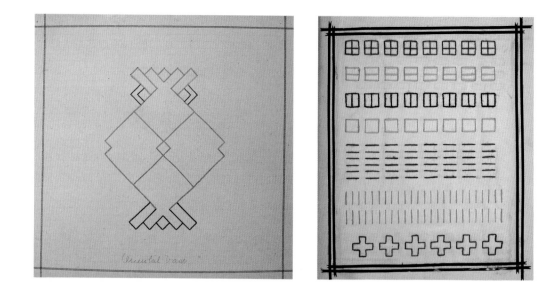

THE 12TH GIFT
Sewing

The remaining "drawing" gift, which was esteemed for its diversity, color, and, presumably, familiarity, was sewing. Kindergarten was an almost exclusively female endeavor and sewing was, and is still, a traditionally female art. But like many of the other occupations that Froebel borrowed from traditional craft activities, kindergarten sewing was to sewing as kindergarten drawing was to drawing—the emphasis in each was not on the thing rendered but in the elements of the work. As a series of short, parallel strokes on gridded paper might have been accomplishment enough in drawing, an overall net of multicolored crosses, squares, or zigzags would often be the finished product in sewing. With silk or wool thread on gridded or prepunched cards, the kind of sewing done in kindergarten was more decorative embroidery than clothes manufacture, and had been a Central European folk art for centuries before it caught the attention of Froebel.

The diversity of iconographic expression in extant trainee sewing albums confirms the occupation's popularity, and hints at the widespread resonance of the kind of abstract symbols that would later appear as formal elements in the paintings of Paul Klee and Piet Mondrian. With their pages of multicolored "letters" forming words in no known tongue, the books passed down through the families of nineteenth-century kindergartners are like mysterious Bibles. But unlike both Old and New Testaments, they avoid the confusion of Babel and withstand multiple interpretations because the primal language in which they are composed is nature's, and God, by definition, is writ large in all their details.

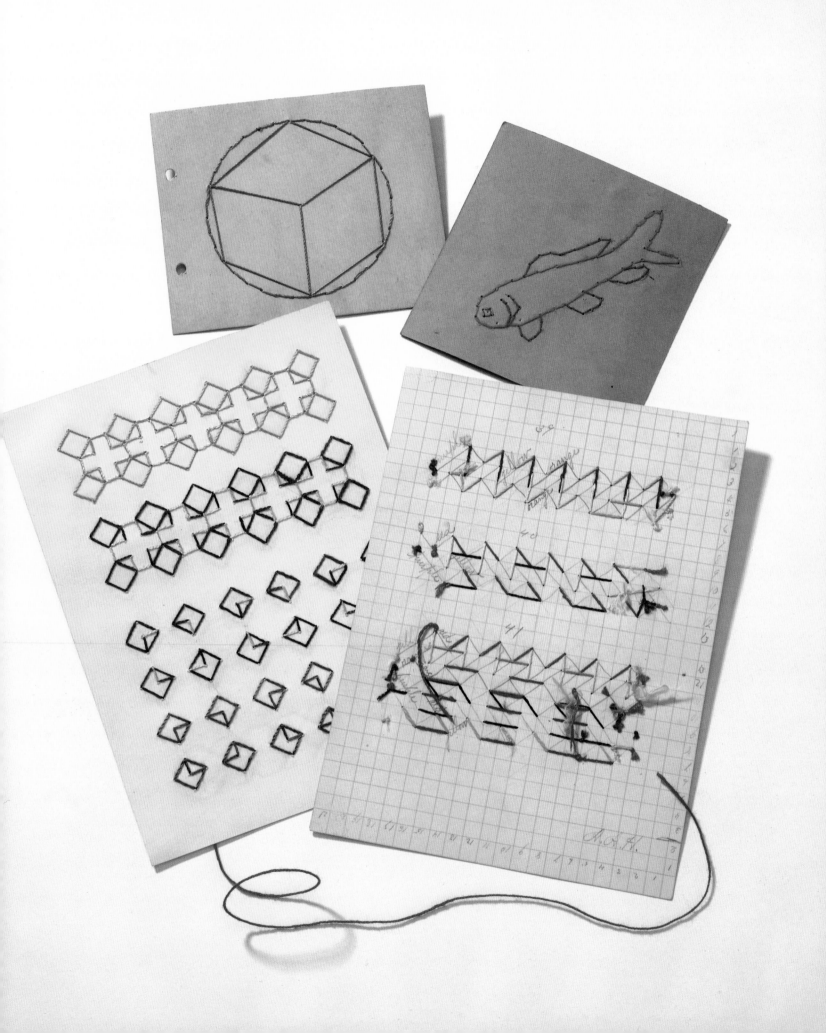

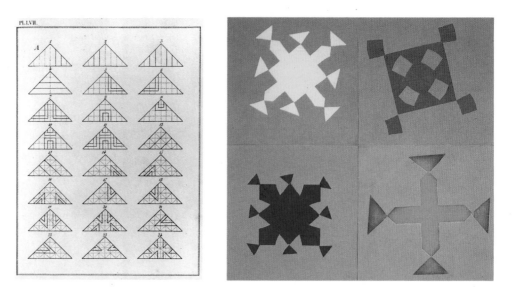

Right:
Folding and cutting techniques for the thirteenth gift. Plate LVII, *Manuel Pratique des Jardins D'Enfants* by J.-F. Jacobs, Brussels 1859

Far right:
John Bryant. Cut paper beauty forms. United States, 1902

This is from a child's album.

THE 13TH, 14TH, AND 18TH GIFTS

Cutting, Weaving, and Folding

Opposite:
From the top: Unknown kindergartener. Paper folding album. Philadelphia, c. 1875; Eighteenth gift (papers for folding). Milton Bradley Company, Springfield, Massachusetts, 1920; J. Hemmelmann. Paper cutting album. Germany, c. 1875; Abbie A. Herrick. Cut paper beauty forms. Westfield, Massachusetts, 1875; Thirteenth gift (papers for cutting). Milton Bradley Company, Springfield, Massachusetts, c. 1920

Although Froebel deemed color so important for infant development that he included it as a feature in the first gift, it was in the paper occupations, cutting (the thirteenth gift), weaving (the fourteenth gift), and folding (the eighteenth gift), where color in the kindergarten really exploded.

The craft of cutting symmetrically folded paper for elaborate baptismal certificates and love tokens began in Germany in the mid-eighteenth century and was quickly transferred to German communities in Pennsylvania.[20] To make a "snowflake," a doily, or a row of paper dolls by snipping the edges of a folded sheet of paper and then slowly unfolding it to discover the geometric magic within is a universal childhood joy certain to remain a favorite kid-craft until the end of time. Although a direct relation, kindergarten cutting was distinguished from these traditional antecedents by the Froebelian notion of transformation. As with the cubic-block gifts, where the project was to use all of the pieces constituting a cube in any design, a piece of paper in kindergarten was never conceived simply as raw material but as a permanent object regardless of superficial metamorphoses. While hard to achieve with the nature forms, forms of knowledge and, particularly, beauty made from single squares of paper usually fulfilled the system's mandate—nothing was discarded, everything was used, unity was maintained.

Paper weaving traces its heritage to weaving itself and, because of its obvious practicality, was the occupation that kindergarten apologists most commonly singled out for the system's economic justification. With pre-slit mattes, colored strips, and flat tin "needles," kindergarten weaving taught counting, progression, method, composition, planning, and creativity.

Paper folding, an old Chinese folk craft that is associated by most people with Japanese origami, entailed making pigs and people, fish and fowl by folding a single piece of paper in a complex sequence of steps. Hats, coats, and sailboats were also part of the folding repertoire in kindergarten, but were no competition for the real focus of the occupation—the folding of paper squares into smaller, and much more elaborate, paper squares. Many of the remaining examples of these rotationally symmetrical and frequently pinwheeling forms are directly descended from designs first described by Froebel, and their obsessive detail does make one wonder at the suitability of this particular activity for the young. But because so much exquisite work of this nature was done by teacher trainees, we can assume many simpler examples were also made by their students. Its introduction near the end of the gift sequence implied that paper folding was recommended for older children. And because kindergarten was designed to play out over several years, it allowed time for the hand skills necessary for this kind of work to develop. By including complex activities in the training sequence, Froebel acknowledged something that educators of his time misunderstood—the young need to move and create, love to be challenged, and are capable of learning and doing almost anything their parents and teachers will take the time to teach.

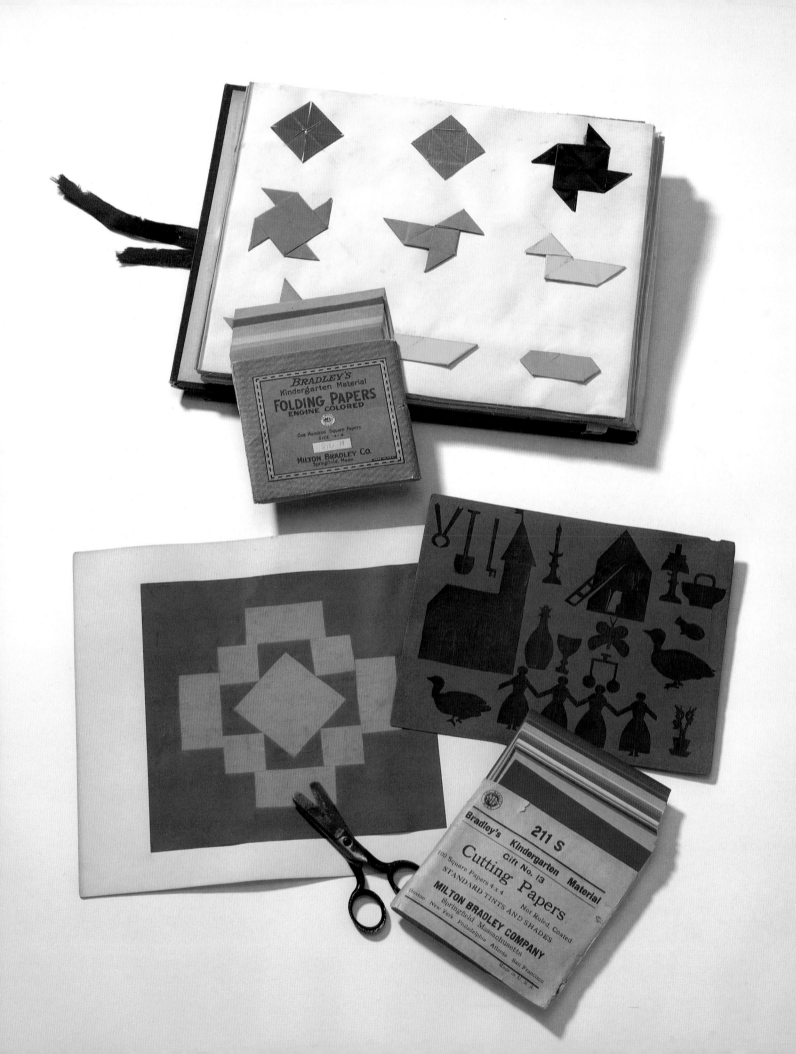

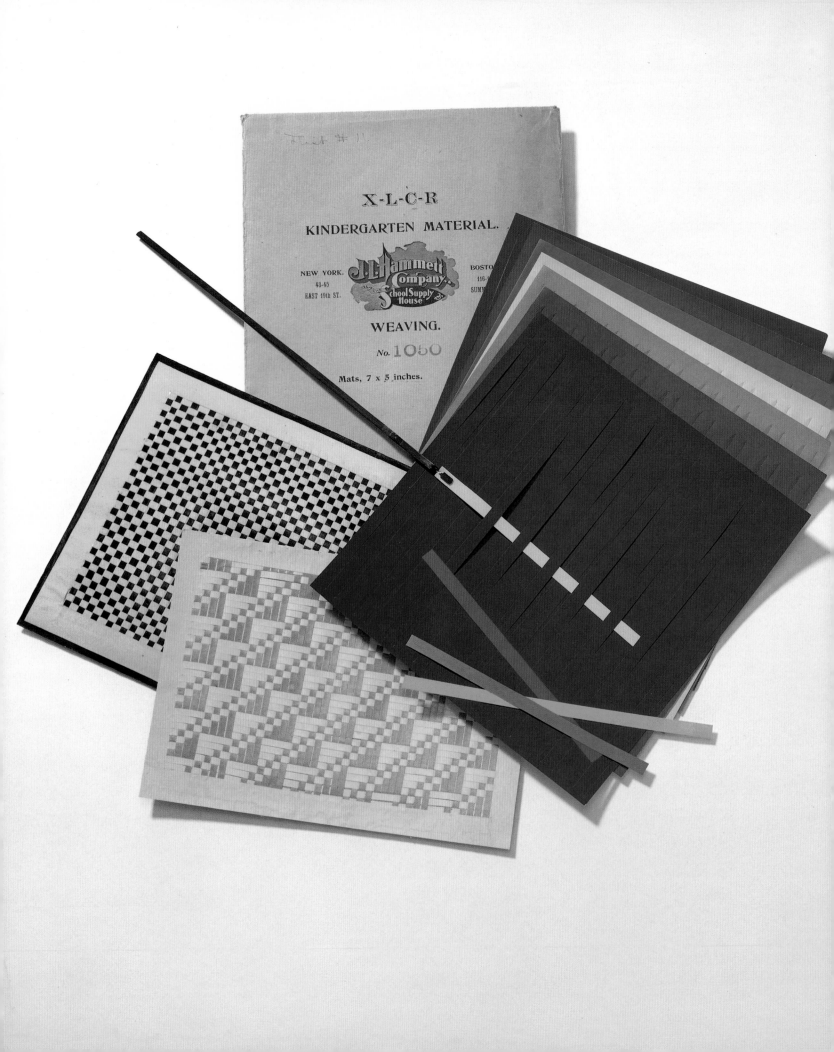

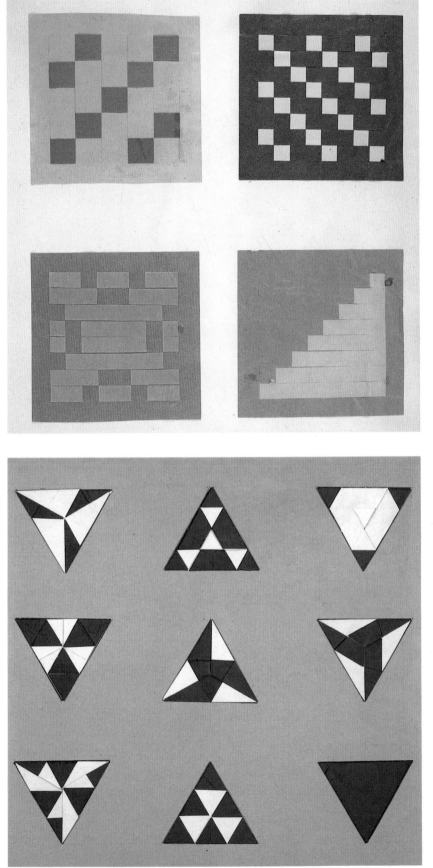

This page, top:
Alice Hubbard.
Woven beauty forms.
Providence, Rhode
Island, 1892–93

These paper-weaving
designs come from a
child's album.

This page, bottom:
Fannie E. Kachline.
Folded beauty forms.
United States, c. 1880

Opposite:
Top: Fourteenth gift
(weaving papers). J. L.
Hammett Company,
New York, c. 1900;
center: Ball patent
weaving needle.
Milton Bradley
Company, Springfield,
Massachusetts,
c. 1900; bottom: Pre-
slit paper weaving
mattes. Milton
Bradley Company,
Springfield,
Massachusetts,
c. 1875. Sold by J. W.
Schermerhorn in New
York City before
Schermerhorn began
marketing kinder-
garten material under
its own label.

This page and
opposite top:
M.H.P. Orr. Nature
forms of the four-
teenth gift. United
States, c. 1890

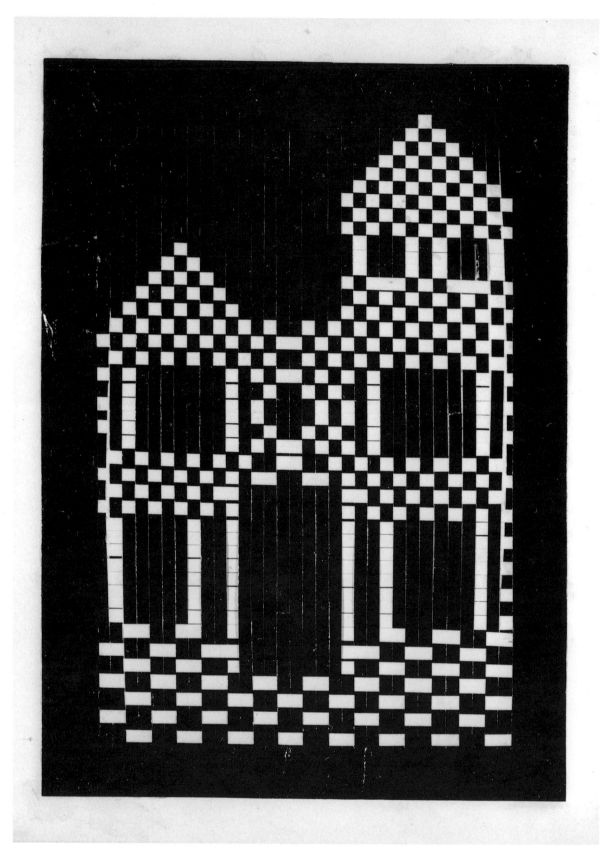

What linked the paper occupations, besides the material of their manufacture, was flatness. They were the planar equivalent of the parquetry tiles with a difference. While the wood triangles and squares of the seventh gift were arranged on the grid of the kindergarten table, the paper gifts were the grid itself transformed. The weavings were orthogonal by definition: warp and weft, x and y. But the squares of paper that were folded into endlessly inventive crystals of color, and those that were sliced and rearranged into jitter-bugging, but still distantly related, versions of their former square selves, were grids as well, with their Cartesian roots disguised. The grid was kindergarten's map, and the paper occupations allowed children to turn it inside out. Used in most of the gifts to plot a geometric voyage, in the paper occupations, the map itself was transformed. The destination remained as always; it was the route that Froebel changed.

Unidentified kindergartner. Cut paper nature forms. United States, c. 1895

Due to the dimensional sine wave of Froebel's kindergarten—solid, plane, line, point, line, plane, solid—the finale of the gift-and-occupation sequence was never a definitive end but always also a return to the beginning. The remaining gifts, peas work, which utilized peas softened in water or balls of wax as connectors for small sticks or toothpicks, and modeling in clay, served therefore as summations of all those preceding, and reintroduced the concept of volume from the system's spherical start.

Peas work combined the previously learned lessons of line and point in brilliantly simple fashion to express volume. The child would first make "flat" shapes like triangles and squares, and then expand them by "drawing" in space until they became pyramids, cubes, or other geometric solids. Christian Weiss's theory of crystal form being an expression of atoms grouped in symmetrical matrices was here adopted by Froebel to make exactly the kind of molecular models used to teach chemical bonding in high schools and colleges throughout the twentieth century. Kindergarten peas work thus anticipated actual developments in science, even as it laid the groundwork for one of the most popular toys of the twentieth century—a kit of sticks and drilled joints that caught on in America as the ubiquitous Tinkertoy.

When peas are soaked in water overnight (the "Philadelphia Early" variety was highly recommended a century ago[21]), and then dried, they become the consistency of dough and may be pierced with thin sticks without crumbling. Although small corks and stiff wires were also marketed for this purpose, peas or seeds gave teachers the opportunity to incorporate the early lessons of growth and nutrition that are still common in kindergartens and preschools today. Peas as structural nodes versus peas as plant embryos allowed teachers to steer the class from architecture to trees, and from geometry to human development, in the kind of multidimensional interconnection Froebel relished.

In a turn-of-the-century Milton, Massachusetts, kindergarten, the nineteenth gift provided the occasion for the first structural experiments of the architect R. Buckminister Fuller (1895–1983), which ultimately led to his invention of the geodesic dome:

One of my first days at kindergarten the teacher brought us some toothpicks and semi-dried peas, and told us to make structures. With my bad sight, I was used to seeing only bulks. I had no feeling at all about structural lines. The other children, who had good eyes, were familiar with houses and barns. Because I couldn't see, I naturally had recourse to my other senses. When the teacher told us to make structures, I tried to make something that would work. Pushing and then pulling, I found that the triangle held its shape when nothing else did. The other children made rectangular structures that seemed to stand up because the peas held them in shape. The teacher called all the other teachers in primary school to take a look at this triangular structure. I remember being surprised that they were surprised.[22]

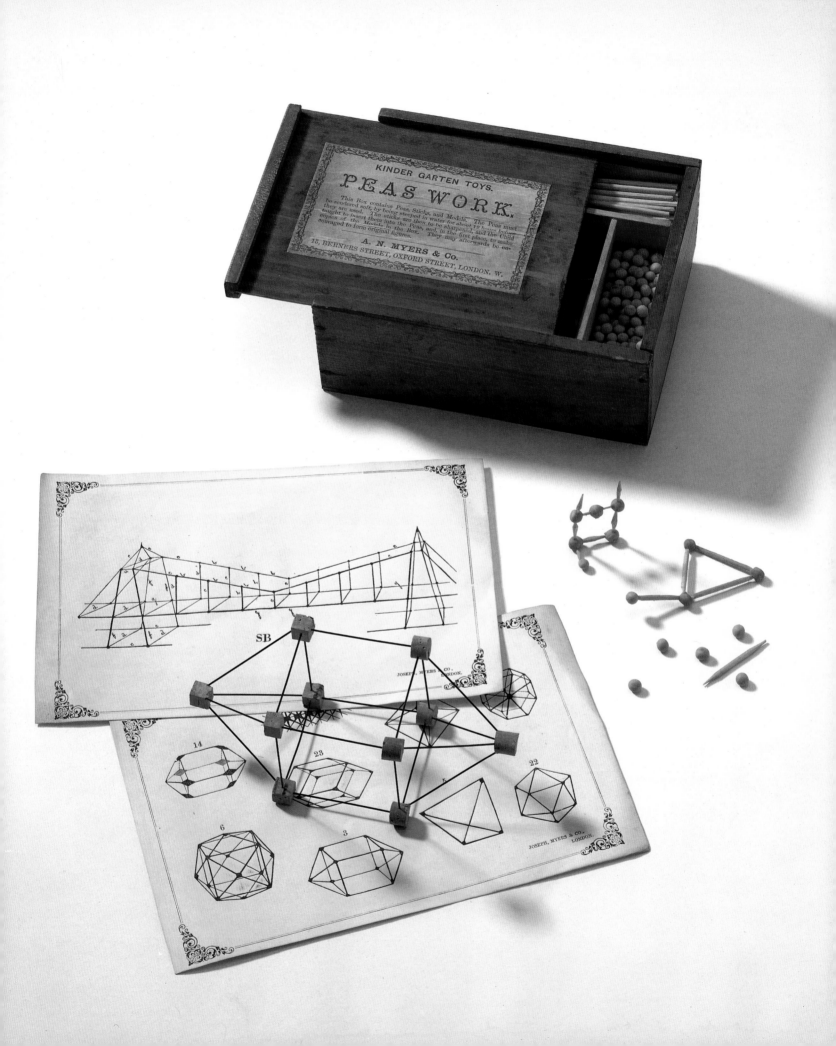

Crystals and letters made with the nineteenth gift. Plate LIV, *A Practical Guide to the English Kindergarten* by Johann and Bertha Ronge, London, 1855

Left:
"Cork- (or Peas-)
Work." E. Steiger &
Company catalogue,
New York City, 1889

Below:
R. Buckminster Fuller.
Geodesic dome for the
United States
Trade Fair Pavilion,
Tokyo, 1957

DRAWN BY OTTO H. BACHER.

MAKING CYLINDERS IN CLAY.

It is incontestable that the forming of shapes in soft material is among the most primitive occupations of the human race, and that it served as the point of departure for all the plastic arts. It is therefore, one of the best means for carrying out Froebel's idea, that the occupations of childhood should run through that of the general development of human civilization.[23]

THE 20TH GIFT
Modeling clay

Top left:
Nature forms for the twentieth gift. Plate LXXIV, *The Paradise of Childhood* by Edward Wiebé, Springfield, Massachusetts, 1869

Top right:
"The Kindergarten Movement. Making Cylinders in Clay." *Century Magazine,* February 1893

The open-work structures of the nineteenth gift were a concise introduction to the weighty mass of the twentieth. Modeling clay, basically natural clay mixed with a little oil to maintain malleability, was a technical spin-off from kindergarten that has since found a wide audience in the realm of fine art. As midnight serves both to end one day and begin the next, modeling, which was typically described as the last gift, was also used at the start of the sequence to clarify the first and second gifts. It was one thing to be given a ball and then a cylinder and cube, but to make a ball, and then, by rolling it on the table, transform it with your own hands into a stubby cylinder, and with a little more work finally into a cube, was a perfect object lesson into the very heart of kindergarten's philosophy, and one that would be difficult to forget. A clay flower might become a clay horse, and then a bug, and then a cube, and then two cubes, and on and on, until it was all things, or at least a model of all things, and as all things a model not only of the entire system but of the entire universe. After working with the rest of the gifts and occupations and experiencing the many ways reality, mathematics, and aesthetics were inspected, the children of the kindergarten were given, via modeling, a chance to practice what they had learned—one thing, and everything.

Opposite:
The second gift made with the twentieth gift

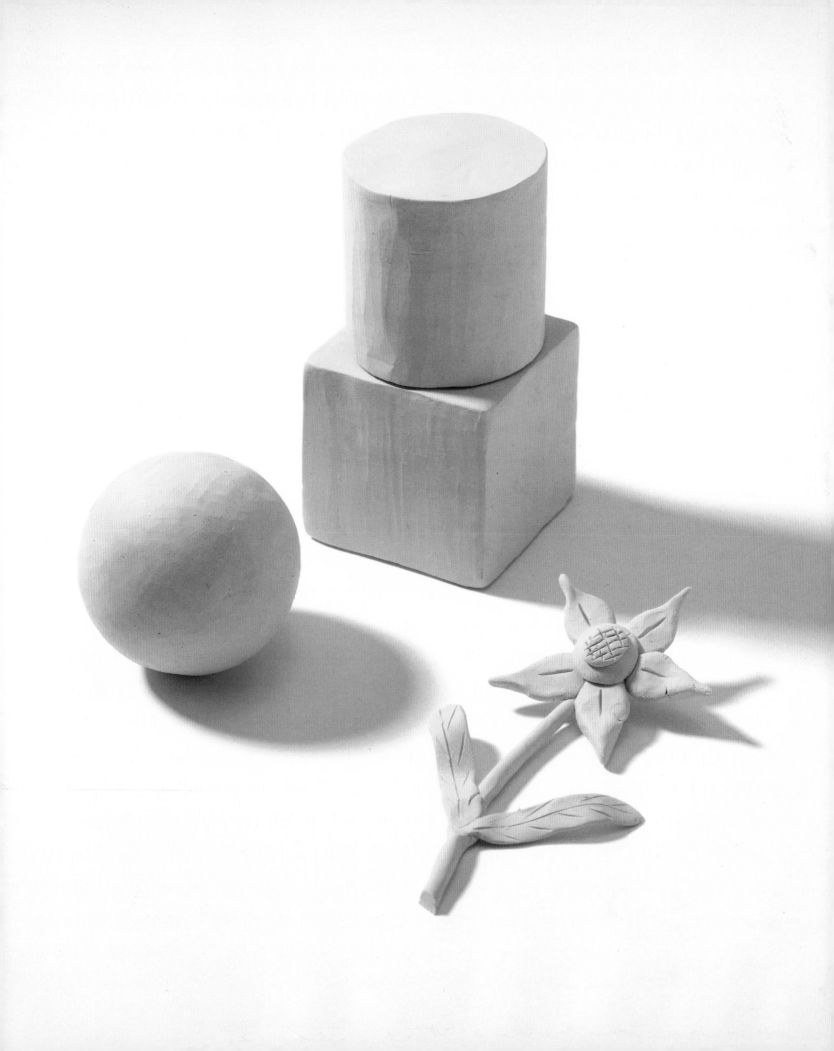

4 SUCCESS

KINDER-
GARTENS
EVERYWHERE

Opposite bottom:
Unidentified New
York kindergarten
classroom, 1899. The
New York Public
Library, Miriam and
Ira D. Wallach
Division of Art, Prints
and Photographs

Complaints that the
kindergarten blocks
were too small for
active youngsters and
that the gridded table
inhibited creativity led
to the development in
the 1920s of the large
floor blocks still in use
today. This view of a
New York City class
in 1899 shows a tran-
sitional attempt at
both activities, with
the empty block boxes
themselves serving as
cubic blocks.

Friedrich Froebel's person and ideas attracted energetic and committed dis-
ciples, mostly women, who did not let the movement's reverses in Germany
deter their crusade. The story of the spread of kindergarten on the European
continent can be told largely by chronicling the travels of the indefatigable
Baroness Bertha von Marenholtz-Bülow from country to country. Like so
many other progressive movements, it came to the Anglo-American world on
the wings of German liberal intellectuals seeking a better future.

Among the latter group, the sisters Bertha and Margarethe Meyer stand
out. As teenagers growing up in a liberal Jewish family in Hamburg, the
Meyers met Froebel in 1849 when he came to that city to give a course of lec-
tures. The elder sister, whose married name was Bertha Ronge, became an
immediate convert, and, with the help of her husband, set out to put Froebel's
ideas into practice. After two years of opening kindergartens in Germany, the
Ronges emigrated to England, where they opened that country's first Infant
Garden at 32 Tavistock Place, Hampstead, in September 1851. Bertha was
soon joined by her younger sister, who worked at the Hampstead kinder-
garten until she met her future husband, Carl Schurz, and emigrated with him
to Watertown, Wisconsin. There, in 1856, Margarethe Schurz founded the
first American kindergarten.[1]

At the beginning of the nineteenth century, the English began providing
schools for working-class children too young to work themselves. The social
reformer Robert Owen (1771–1858), influenced by Pestalozzi's ideas, estab-
lished infant schools connected with his cotton mills at New Lanark,
Scotland, in 1816–24, which specifically promoted singing, dancing, and
object study for the very young. In 1837 the Home and Colonial Society was

Left:
Kindergarten classroom, the Des Peres School, St. Louis, Missouri, c. 1875

The first public kindergarten in America was established in the Des Peres School in 1873. This is one of a group of photographs that was exhibited at the Centennial Women's Pavilion by the school's founder, Susan Blow.

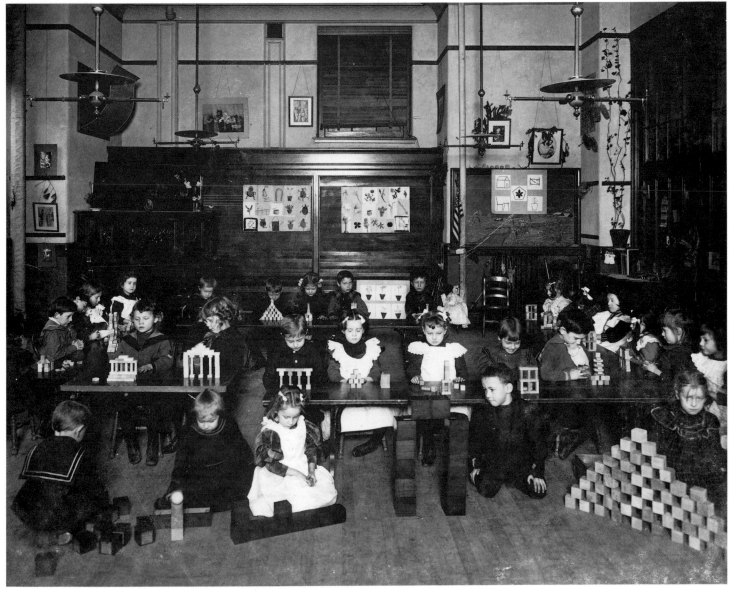

Froebel and his second gift, stained-glass window from the Shepard Kindergarten, St. Louis, Missouri, c. 1904. The Carondelet Historical Society, St. Louis, Missouri

formed to train teachers in Pestalozzi's techniques, and a year later the formerly private infant school system began receiving government aid. By the time the Ronges joined the exodus from Germany to a freer life across the Channel, the groundwork had been laid for kindergarten's acceptance in Great Britain.

Bertha Ronge was a forceful missionary (as we will see, she wrote one of the first popular books about the kindergarten program). In 1854, the London Council of the Society of Arts sponsored tours of Ronge's school as well as a display of kindergarten material provided by Froebel's colleague Charles Hoffmann of Hamburg at the International Exhibition of Educational Systems and Material at St. Martin's Hall. Hoffmann remained in England after the exhibition and both he and Bertha Ronge opened kindergartens in Manchester and Leeds. Maria Boelte, trained by Froebel's widow, Luise, in Hamburg, attended Madame Ronge's school in 1867, returned to Germany in 1872, and then moved to New York to marry John Kraus, another of Froebel's friends. Their New York Normal Training Kindergarten on East Twenty-second Street was the school that began the career of Susan Blow, one of America's greatest kindergartners.

Many of the earliest English translations of Froebel's works were made by German women living in London. Von Marenholtz's own *Women's Educational Mission,* published in London in 1855, was translated by her lifelong companion, Countess Krockow von Wickerode, actually the Irish Elizabeth Micherly. Kindergarten began spreading across the British Isles in the 1860s. Froebel Societies were founded in Manchester and London in 1873 and 1874, respectively, and the latter still exists. Despite its entry into the *Oxford English Dictionary* in 1852, the German word *kindergarten* never found the comfortable place in England that it did in the American colonies and was generally translated as "infant garden" throughout its long history in this, its second home.

The kindergarten exhibit at St. Martin's Hall was particularly intriguing to the American educator Henry Barnard, delegate to the convention from the State of Connecticut. Barnard's enthusiastic 1854 report to the governor of Connecticut was reprinted in his *American Journal of Education* in September 1856. Calling the kindergarten display "one of the most interesting and constructive contributions to the International Exhibition," it opened the way to the realization of Froebel's long-standing dream of exporting modern education to the United States. Froebel had evidently described the United States as, in the words of one of his followers, "best fitted, by virtue of its spirit of freedom, true Christianity, and pure family life, to receive his educational message."[2]

By 1870, there were still fewer than a dozen kindergartens in the United States, all but one established by German immigrants and conducted in the German language. In 1860 Elizabeth Peabody, a member of the New England Transcendentalists, friend of Ralph Waldo Emerson and Herman Melville, and sister-in-law of both Nathaniel Hawthorne and Horace Mann, began an English-language kindergarten in Boston. Among the German-language schools, one was opened in Columbus, Ohio, in

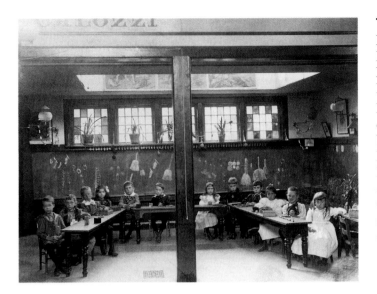

The Caroline Alden Fröbel School and Kindergarten, Providence, Rhode Island, c. 1885

For many years this early Arts & Crafts building was called Froebel Hall. Designed in 1878 by architects Stone & Carpenter, it still stands on the campus of Brown University.

1858; two in New Jersey (in Newark and Hoboken) in 1861; two in New York City in 1864; one in West Newton, Massachusetts, in 1864; one in Louisville, Kentucky, in 1865 (added to the German/English school of Dr. William Hailmann after he visited kindergartens in Switzerland); and one in Detroit in 1869.[3] The first American training school for kindergarteners was opened in Boston in 1868 by Von Marenholtz pupil Matilda Kriege and her daughter Alma. By 1885 there were 565 kindergartens[4] in America, 1,400 teachers, and 29,716 students. That year, St. Louis, which in 1873 had become the first American city to include kindergartens in its public school system, had 60 free kindergartens and 185 teachers.[5] By 1908 there were over 400 different kindergarten *associations* in the United States.

Clearly, the swift conquest of America by kindergarten suggests that Froebel had been correct in his hope that the New World would be his world, and, indeed, the ground had been prepared in advance. In 1861, Dr. E. A. Sheldon, superintendent of schools for Oswego, New York, had opened a department for the training of teachers along Pestalozzian principles that was so successful it was certified as a state normal school two years later. Graduates of the Oswego institution, followers of Pestalozzi who were naturally sympathetic to kindergarten, were among the best teachers America had to offer, and spread respect for the new educational ideals wherever they went. The 1851 Crystal Palace Exhibition in London and its Paris equivalent of 1867 impressed the increasingly worldly middle class with the value of prescribed art education and led directly to the introduction of drawing classes into the Boston Public School system in 1870. The exhibition of drawing and manual-training work from Boston schools at the 1876 Philadelphia Centennial stimulated the introduction of these subjects into schools across the country. The attention received by this display, in close proximity to that of the model kindergarten which had from the start emphasized almost identical activities, helped to stimulate interest in Froebel's ideas.[6]

More generally, kindergarten took hold in the United States because American communities welcomed nonsectarian education. Viewed as a means to nurture ethical, moral, and patriotic values and as a socially responsible method of community organization, the system was quickly adopted by religious organizations of almost every denomination including, among others, Roman Catholic, Lutheran, Jewish, and Friends. As of 1908, the Chinese Presbyterian Mission Church in New York City supported a flourishing kindergarten for Chinese children, and the Women's Christian Temperance Union adopted it as a force for instilling the tenets of clean living in the impressionable young.

While the explicit program of the largely female-led kindergarten movement was to foster cultural enrichment through education, support for the system was also interwoven into one of the primary issues of nineteenth-century feminism: a reevaluation of the institutions that had traditionally supported the physical and intellectual subjugation of both women and children. Inflamed by the democratic ferment of 1848, liberal German women enthusiastically embraced Froebel's idealistic message, recognizing within his spiritual prose straightforward outlets for enlarging the scope of women's fundamental rights and professional opportunities. For feminists in Europe and America, the cooperative promotion

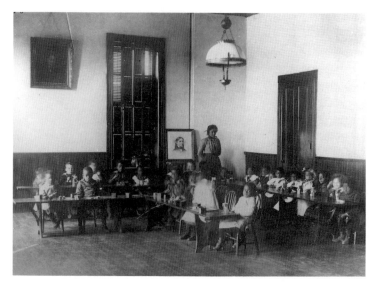

of what they viewed as kindergarten's unassailable benefits provided a focus for community organizing. It was fortunate for the cause that the teaching profession in the United States was, at least where younger children were concerned, largely made up of women. Men were so entrenched as Germany's educators that a convention in 1880 actually passed a resolution opposing the hiring of any female teachers for any grades. By 1900 there were four women to every man teaching kindergarten in America, and almost exactly the reverse proportion in Germany.[7]

Outside of Germany, the spread of kindergarten on the continent in the second half of the nineteenth century was no less spectacular than in America. Von Marenholtz went from country to country, kindling enthusiasm for the new system of education. In 1851, while Froebel was still alive and she was living in Weimar, she had sought to interest the grand duchess of Russia in introducing Froebel's methods into the orphan asylums of St. Petersburg.[8] Although the system's ultimate acceptance in this distinctly undemocratic society was less extensive than in most of Europe, by 1890 there were 130 private infant schools in St. Petersburg, 26 of which were authentic kindergartens.[9]

Her work began in earnest in the mid-1850s. Von Marenholtz journeyed to Paris in 1855 and spent the next three years there crusading for kindergarten. As early as 1771, the French had initiated a national system of *salles d'asile* (infant schools) for children between the ages of three and six years old, a landmark in the evolution toward universal, government-sponsored education. Functioning as day-care centers, preschools, and orphanages, the infant schools expanded throughout the nineteenth century. While French schoolteachers were traditionally men, the infant schools had always been the domain of women. With this preexistent force of young women already caring for the vast majority of its preschool-age children, France must have seemed to Bertha von Marenholtz-Bülow perfectly fertile ground for Froebel's ideas.

By lecturing at all possible venues under any conditions, writing articles for the press, publishing pamphlets, and directing experimental work in a number of infant schools, she managed to garner the attention of some of the key figures of the Parisian intelligentsia. A wide spectrum of France's pedagogical elite provided testimonials, but kindergarten did not immediately take root in French society. Too German, or simply too Romantic for the traditional academic structure of the French education system—where students from the primary school to the university level still sat for lectures in identical semicircular bleachers—the seeds from Von Marenholtz's efforts in the 1850s did not flower on Gallic soil for at least another decade.

Although Von Marenholtz's initial Parisian blitz seemed to her at the time to be less than successful, it ultimately had wide-reaching ramifications for early childhood education in France. Soon after her arrival, the kindergarten gifts and at least some of the system's conceptual underpinnings slowly began to insinuate themselves into the infant schools. In the 1860s and 1870s, the French utilized and altered the Froebelian system according to their needs and in deference to their own traditions. By the 1880s, kindergarten, but definitely not the word *kindergarten,* had become a daily fact of life in French schoolrooms. An 1879 report published under the auspices of the director of primary schools in the Department of the

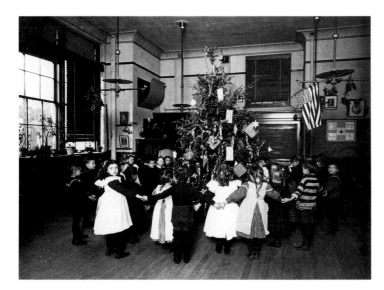

Seine (Paris and its environs) made this clear: "the Salles d'asile of this Department have been divided into two classes: the Salles d'asile proper, or Asylums for the nurture of children from 2 to 4 years of age, and the Froebel class for children from 4 to 6 years of age. The Froebel class is preparatory for the Public Primary School. About 65% of all of the children in Paris and the suburbs are in the Salles d'asile and the Froebel classes."[10] A decree of 1881 that aimed to enhance "intellectual" training in the preschools, which had previously emphasized physical, and particularly moral, instruction, expanded the system of infant schools, renaming them *écoles maternelle*, and further extending, through the very Frobelian association of motherhood and education, the reach of his ideas.[11]

A United States Government report of 1882 suggested that the kindergarten continued to make substantial inroads into the French educational establishment and was by then virtually ubiquitous throughout the country. With data gleaned from interviews with French education officials and on-site inspections, and participation in infant schools before their changeover to the more rigorous, and *more* Froebelian, *écoles maternelle*, the Americans wrote the following: "These institutions can scarcely be styled infant schools in the sense in which we ordinarily use the term. Their aim, besides offering shelter to children too young to attend the primary school, is principally to train the senses according to what is known as the Kindergarten system."[12]

A decade later, an American kindergartner, bemoaning the slow public adoption of the system in the United States, chose the French system as an enviable role model and exclaimed with exasperation, "In France, the écoles maternelle . . . have substantially adopted the Froebelian principle and practice, and had in 1887–88 an attendance of 741,224 between the ages of 3–6 in a population only two thirds that of the U.S., and having a far smaller proportion of young children."[13]

During her sojourn in France, Von Marenholtz paid a hectic five-month visit to Brussels beginning in December 1857. There she addressed conferences of inspectors, teachers, and directors of schools for the very young, and the methods of Froebel were introduced into the country's extensive, preexistent system of infant schools. More importantly, the government decreed in 1860 that all normal schools and training classes for primary-school teachers must include instruction in teaching kindergarten. By the 1870s, kindergarten was recognized as the first grade of all public and private formal instruction.[14]

Kindergarten got an early start in the Netherlands thanks to the influence of Elise van Calcar, a well-known Dutch novelist, who accompanied Von Marenholtz on her initial preaching trip through France in the mid-1850s. In 1858, Von Marenholtz and Van Calcar were successful in establishing Froebel Societies in Amsterdam, The Hague, and other cities in Holland. The Dutch campaign was significantly abetted by the fact that Amélie, daughter of Froebel's close confidant Duchess Ida von Weimar (sister of Queen Adelaide of England and the driving force behind the first Weimar kindergartens), had married Prince Heinrich of the Netherlands and was invaluable in introducing the crusaders to the highest echelon of Dutch society.[15] Van Calcar created the first Dutch kindergarten in Leiden around 1860, and in so doing became, unintentionally, the head of the country's primary-school

reform movement. In 1868, under the direction of the ministry of education, she was assigned to study the feasibility of combining the kindergartens of Holland with the public school system and placing responsibility for their general administration in the hands of women. As of 1883, neither measure had been implemented.[16] Nevertheless, following the lead of Van Calcar in Leiden, and as evidence of the system's near universality, a number of Dutch cities, including Rotterdam, The Hague, Dordrecht, and Delft, had all established kindergarten-teacher training schools by 1880.

In 1875 there were 705 public and private infant schools in Holland with 2,222 teachers (39 male, 2,183 female) and 73,018 students.[17] Except for those operated by the Catholic Church, all of these schools, which had spread throughout the country, employed the kindergarten gifts in some way. Like teachers in every culture, the Dutch reacted to the richness of Froebel and created their own "brand" of kindergarten. They were unlike both the French, who accepted Froebel's gifts but largely ignored his "Germanic" methods, and their doctrinaire opposites in Belgium, who were among the first to integrate the system into their public schools and among the last to relinquish teaching his "three realms." The Dutch closely followed the design activities outlined in contemporary manuals, but generally dispensed with the spiritual foundation that was Froebel's raison d'être.[18]

Von Marenholtz met with educators in Bohemia, Hungary, and Austria in 1856 and succeeded in converting the children's asylums of several municipalities into infant schools with curriculums based on Froebel's methods. In 1857 kindergartens were established in Vienna and Graz "to strengthen and complete the family education for the youngest children, and prepare them for the school instruction which is to follow after the sixth year." By 1872, kindergarten had become compulsory throughout the Austro-Hungarian Empire for all children under six years of age, and instruction in the Froebel method was made obligatory for all students of normal schools and teacher-training classes.[19] In 1909, there were seventy-two kindergartens in Vienna alone.[20]

With Belgium and Austria, Italy was among the first countries to incorporate kindergarten into its public education system. The care and education of preprimary-aged children was well under way there in the early 1860s, and by 1871 there were 130,000 students in over a thousand public and private *asili infantili* (infant asylums) operating throughout the country.[21] Such institutions, more like preschools than the word *asylum* might suggest, had become increasingly important across Europe as a necessary response to the complexity of life during the Industrial Revolution. Serving to teach and occupy the children of the urban lower and working classes, the Italian infant asylums ultimately absorbed many of the forms of kindergarten training and evolved into *giardini d'infanzia*—the introduction to school for all Italians. In the mid-1860s, Von Marenholtz succeeded in getting a model kindergarten established in Venice on strict Froebelian principles. In 1868, George P. Marsh, the American ambassador to Italy, piqued the interest of Cesare Correnti, the Italian minister of public instruction and supplied him with literature on the kindergarten system from New York and Boston. The Italian educator, a progressive

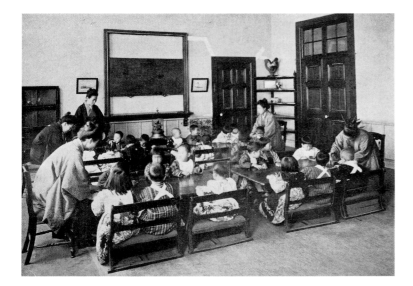

administrator in the newly formed Constitutional Kingdom of Italy, was soon convinced of kindergarten's merits and immediately set out to incorporate Froebel's techniques wherever possible. He sent for the baroness to join him in Florence and help to create a strong beginning for the system there; learning that she was otherwise engaged in establishing kindergarten training schools in Germany, the minister, working largely from printed texts and with an inexact grasp of the subtleties of Froebel's ideas, nevertheless founded over seventy kindergartens "with all external appliances" in Florence and other major cities of Italy. Von Marenholtz did not journey to Italy until late in 1871, when she set up shop in Florence, starting a model kindergarten and lecturing to teacher trainees on the practical and theoretical fine points of Froebel's work.[22] She then opened a rigorously Frobelian kindergarten in Rome, and, in 1872, one of her protégés, Julie Salis-Schwab, introduced the system in Naples and obtained from the administration of the local municipality a promise to make it the first grade of public education when enough qualified kindergartners could be trained for the work.[23]

Froebel's four years in Switzerland had left no tangible results, but in 1860, Von Marenholtz returned to lecture in Zurich, Neuchâtel, Basel, Bern, Lausanne, and Geneva under the auspices of the Swiss Society of Public Utility. Resulting from her efforts was the creation, in Lausanne, of the first Swiss kindergarten, and two years later, in 1862, of another in Neuchâtel. By the mid-1870s the system was adopted as a recognized grade in the public school systems of several (particularly French-speaking) cantons.[24] In 1876, 206 private Swiss *crèches* were converted to kindergartens under government control in several cantons, including St. Gall, Winterthur, and Zurich. In 1883, there were fifty-five in Geneva alone, and the periodical *Swiss Kindergarten*[25] began publication in St. Gall.[26]

Kindergarten may have been introduced to the distant outpost of Japan by a German woman married to a high Japanese official who had served at the Prussian court. This unidentified Berliner apparently started the first Japanese training center for kindergarten teachers with the direct aid of the Meiji empress and helped the wife of the Mikado form an excellent library of Froebel literature.[27] American missionaries to Japan, mostly Presbyterians, including a large contingent from the kindergarten hotbed of Boston, are known to have started many of the early Western-style schools there and may have brought the system with them, as well. In any case, Japan was eager for Western guidance in the field of education: in 1873, the government even hired Dr. David Murray of Rutgers University in New Jersey as the superintendent of the country's school system. In 1876, the first kindergarten in Japan opened in Tokyo. It was operated by the Female Normal School, where, after 1880, a one-year course in the Froebel method was required for all graduating teachers.[28] It is not surprising that the Japanese embraced kindergarten. Froebel's concepts of natural balance, the unification of opposites, and the interdependence of all things, while key features of Western Romanticism, would have seemed familiar to Japanese adherents of Buddhism, Zen, and Shinto's nature-based animism. On a simpler level, the kindergarten occupations—paper folding, of course, but also paper twisting, cutting, slat work, and

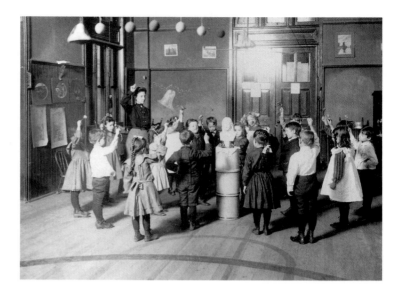

others—had always been prized folk-craft techniques for origami, lantern making, packaging, and kite construction in Japan. By 1911, there were 497 kindergartens in Japan based on the Frobelian model, with 1,535 teachers and 45,202 students.[29]

Finally there was Germany, where the system was born. After Froebel's death, his training institution at Marienthal was relocated to Keilhau. In 1854 the Keilhau school closed and Luise Froebel became the director of the Public Free Kindergarten of Hamburg (a privately funded school), where she began to train kindergarten teachers. The 1851 interdict against state-sponsored kindergarten was officially canceled in 1860, but by then it had permanently sabotaged the support of the most influential members of the Prussian court. The history of the system in Germany before World War I was thus left almost entirely to independently run and financed institutions outside the sphere of the public education system and in frequent conflict with the traditionally powerful church-school establishment. In Germany, where Christianity was more tightly bound with traditional concepts of obedience to the family, the clergy had little interest in upholding Froebel's nonsectarian spirituality and remained hostile to the system's implementation until the second decade of the twentieth century.

In spite of official opposition, however, Froebel's followers were unrelenting in their efforts to disseminate the new teaching, and by 1859 kindergartens were already widespread throughout his homeland.[30] Ten years after he opened the first school for little children, Froebel's labors on behalf of the German kindergarten began to show results. In 1874, kindergarten associations throughout the country joined together into the German Froebel Society,[31] and the Prussian government acquiesced in allowing kindergarten training courses to be added to any girls' school curriculum when requested by local authorities. The previous year, Henriette Schrader-Breymann, Froebel's niece and one of the last students to receive his personal training, opened the Pestalozzi-Froebel House in Berlin, where it still exists today as a school and archive of Froebel literature and historical material.[32] Despite the political, religious, and educational obstacles the system encountered from the start, in 1879 there were 929 active (but mostly private) kindergartens in Germany, and, by 1887, thirty-five years after Froebel died brokenhearted as he witnessed his life's work annulled by the stroke of a pen, no fewer than 2,000.[33]

ESTABLISHMENT AND TRANSFORMATION

It is evident from the publishing industry that grew up around the new institution that kindergarten, like many cultural innovations that catch on, could mean many things to many people. When Froebel died in 1852, the entire printed corpus on the subject consisted almost exclusively of magazines and tracts published by Froebel and his followers. By 1890, the bibliography solely on kindergarten and Froebel-related literature counted almost twenty-five hundred entries,[34] and the outpouring of books on the subject—explanations of its symbology, related pedagogical theses, and especially how-to guides—continued unabated well into the new century. It goes without saying that Froebel would not have agreed with everything perpetrated by these publications in his name.

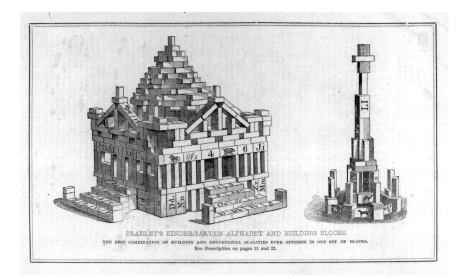

The earliest comprehensive treatment of the system in book form was Bertha Ronge's 1855 treatise in English, *A Practical Guide to the English Kindergarten.* Both it and Von Marenholtz's less graphic but more thoughtful *A Woman's Educational Mission, Being an Explanation of Frederick Froebel's System of Infant Gardens,* which was also published in London that year, attracted the attention of Charles Dickens, who mentioned them positively in an article in *Household Words.*[35] Due to an apparent rivalry that may have stemmed from Von Marenholtz's competitive interference in Ronge's London sphere, neither woman ever acknowledged the other's work in print.

The best early book on the kindergarten system was J. F. Jacobs's *Practical Manual for Frederic Froebel's Kindergarten* of 1859.[36] This volume, originally published in French, appears to have been one of the tangible results of Von Marenholtz's years in France (she sponsored its publication, contributed an introduction, and probably worked closely with Jacobs, whomever he may have been, on the text itself). Between 1838 and 1840, Froebel had published plates of geometric-design ideas, but only for the first five gifts and in his own limited-distribution magazine. He had described most of the remaining gifts and occupations by 1850 but never got around to formalizing their use in diagrammatic form. Ronge's *Practical Guide* and Jacobs's *Manual* were therefore the first widely available sources to include Froebel's own patterns for the first five gifts and the first publications to show all the rest of the kindergarten geometry in pictures (these being created not by Froebel himself but presumably by Ronge and Jacobs with Von Marenholtz). With their hundreds of pages crammed with gridded, geometric designs, these books were true encyclopedias of crystalline form.

In response to criticism from the German kindergarten movement for having sponsored her initial book in French, Von Marenholtz supported the publication in 1869 of *The Kindergarten—A Guide to Froebel's Method of Education, Gifts and Occupations* by Hermann Goldammer.[37] With an introduction and conclusion by the baroness, Goldammer's text on the philosophy and curriculum of the Froebelian system went through several printings in German, French, and English. It also re-created, almost line for line, a great many of the engravings in the earlier book by Jacobs and rendered the forms of the kindergarten into a well-defined lexicon of cubic structures, triangular patterns, crosshatched lines, interconnected semicircles, and other specific designs from what, theoretically, should have been infinite possibilities.

When, later that year, Milton Bradley of Springfield, Massachusetts, published Edward Wiebé's *The Paradise of Childhood,* which liberally reproduced images from Goldammer, kindergarten's crystalline vocabulary became essentially fixed. The forms selected by Froebel and his followers in the 1850s and 1860s thus became a kind of international standard for use in schools of all countries. As most of the later teacher's guides were indirect recapitulations of these first, very similar books, the system of exercises with the gifts that Froebel intended to be creative and open-ended became sclerotic almost from the outset. Ironically, it was in this way that his dream of a universal language, an equalizer to be implanted in children before their inexorable polarization by nationality and religion, came as close as it ever would to actual implementation.

Bradley's Kindergarten Alphabet and Building Blocks. *Catalog of Games and Home Amusements,* Milton Bradley & Company, Springfield, Massachusetts, 1873–74

Just two years after initiating manufacture of the gifts in America, Milton Bradley was manufacturing educational toys like these that began to alter public comprehension of the true nature of Froebel's system.

Signs of the corruption of Froebel's demanding ideal of object-oriented teaching could be seen as early as Ronge's book, which curiously included variations of the kind of ABC spelling blocks that he would certainly have rejected as being too abstract for the preliterate. As the reach of kindergarten spread throughout Europe and North America, object teaching was exploited for commercial gain by textbook and educational-toy companies. Oblivious to the subtleties of the concept as it was formulated by Pestalozzi and refined by Froebel, publishers churned out hundreds of volumes of so-called object lessons that were nothing more than decorative memory exercises, emblematic of the inactive education that Froebel so adamantly opposed. The reductio ad absurdum of this was the proliferation of "ABC books," pairing pictures of things and animals with their printed names. Although the wisest of kindergartners understood the difference between the genuine technique and publishers' fodder, such books found a receptive audience in traditional dogma-bound institutions on both sides of the Atlantic. They directly contradicted Froebel's call for an education based on the comparison and reconciliation of opposites, and their acceptance exemplified the dilution that ultimately affected many aspects of kindergarten's sophisticated philosophy, leading to the eventual abandonment of the original system's central ideas.

Von Marenholtz brought a somewhat different emphasis to the purpose of Froebel's "republic of childhood" with the pet program she advocated throughout her writings and in all her speaking engagements—the value of the system for the manual training of the working class. With elitist aplomb, the baroness emphasized the importance of educating the lower classes with the eye and hand skills that were becoming increasingly needed in the exploding Industrial Revolution. Her lectures to educated, upper-class women never omitted appeals to help the needy help themselves. Philanthropic organizations joined the kindergarten movement in response to the squalor of urban poverty, and in America, Froebel's spirituality was inevitably subordinated to the social good of enculturating the crush of immigrants from Europe. In the settlement houses, public-welfare associations, orphanages, and schools for the poor (including the "Ragged Schools" in England) that were among the system's earliest and most enthusiastic supporters, kindergarten was heavily promoted as a means to adapt young children to life in an industrial society. The weaver of paper would grow up to become a weaver of textiles; the adept manipulator of blocks was a craftsman, machinist, or engineer in the making. Who could dispute that an increased sensitivity to pattern and symmetry in the artisan class would not improve the beauty and quality of everything from silverware to saltcellars? Von Marenholtz, more than anyone, understood the value of kindergarten for creative and spiritual development, but by stressing its practical aspects to the academics and officials that she lobbied so assiduously, she added an important sales pitch for its economic and societal benefits as well.

The original gifts were made by Froebel and his followers or contracted out to local craftsmen in cities like Blankenburg, Hamburg, and Dresden where the first kindergartens were organized. The German toy industry was the most sophisticated in the world in the nineteenth century and the gifts, which were hardly toys in the traditional sense, were simple enough to produce. German publishing companies, including E. Steiger, whose export business was substantial enough to warrant a New York office at 25 Park Place, were exporting kindergarten material to the United States by 1864. Four years later, Elizabeth Peabody and other Boston kindergartners convinced American toy manufacturer Milton Bradley to manufacture the gifts and occupation materials. Almost immediately, Bradley, spotting a new and potentially huge market, began to diversify the line by adding what he considered to be improvements and additions to the original, finite system—and violating the very simplicity of Froebel's conception, which had been made manifestly clear in the excellent text by Wiebé that his own company had published. Bradley and other manufacturers in the United States and Europe started selling "kindergarten" toys of their own creation or ones that had been designed by educators as adjuncts to the twenty or so noted by Froebel. The word *kindergarten* and Froebel's name began to be used to promote "educational" toys like building blocks the way the word *natural* has been used recently to sell everything from mouthwash to frozen food. Boards gridded with holes for colored pegs, pre-punched cards for sewing, and "kindergarten" coloring books soon proliferated, along with kindergarten sets for the home and a new wave of the inevitable ABC blocks. Where one page of prices and descriptions sufficed for trade in 1870, by 1890 catalogs for kindergarten and related materials had become good-sized paperback books. With so much generic "kindergarten" merchandise on the market, it's no wonder the actual system started to get lost in the shuffle. In 1879, only ten years after Milton Bradley began selling kindergarten material, Elizabeth Peabody spoke out against this insidious but inescapable trend. Undoubtedly regretting her initial enthusiasm, she wrote: "The interest of manufacturers and of merchants of the gifts and materials is a snare. It has already corrupted the simplicity of Froebel in Europe and America, for his idea was to use elementary forms exclusively, and simple materials—as much as possible of these being prepared by the children themselves."[38]

Kindergarten had started as a movement, exploded into a fad, and, by the 1890s, was on the verge of becoming yet another of society's many ponderous institutions. By the time popularity made it an essential part of education and daily life, it resembled Froebel's model in outward appearance only. It was in America that this declension of an ideal was most firmly recognized by the educational establishment.

Turn-of-the-century practitioners of the psychology of learning known as Child Study had little use for the untested and untestable metaphysics of Froebel. With a new interest in "scientific" methods, people like John Dewey, G. Stanley Hall, and Edward L. Thorndike redirected early childhood educa-

Trade card, Milton Bradley & Company, Springfield, Massachusetts, c. 1870 Kindergarten was quickly adopted by social reformers as a means to produce better citizens from the immigrant children that were among its first American beneficiaries, an association of patriotism and education that was not lost on Milton Bradley.

tion toward the commonsense reality of the child's environment. The true value of Froebel's idealistic concepts was aggressively debated as teachers questioned the fundamental goals of early education. Where traditional Froebelians defined growth as "the unfolding and awakening of the essential nature of the child," their progressive counterparts asserted it was more a case of "the realization of potential and capacity resulting from interaction with the environment."[39] Edward Thorndike, a student of psychologist William James, considered children's physical health to be the crucial focus of infant education and had moved so far from Froebel's spiritualism that in 1903 he suggested the possibility of substituting a toothbrush for the first gift and sleep for the first occupation.[40] Lackluster and vacant adherence to the gift sequence was rightfully attacked as meaningless and even detrimental, but instead of attempting to enhance what had been lost, the proponents of Child Study steered the system away from Froebel for good.

Anna Bryan, a forward-thinking director of kindergartens in Louisville, Kentucky, was an early proponent of using the blocks simply as building toys rather than components of a symbolic language. She dispensed with many of the occupations, deeming them unnecessarily repetitive, and drew the children closer to reality-based activities like making paper dolls for the chair and bed forms constructed from the third and fourth gifts. One of her teachers, Patty Smith Hill, who is credited with writing for the kindergarten what may be the world's most popular song—"Happy Birthday to You"—worked with Bryan as she experimented with the enlarged gift blocks that ultimately led to the modern kindergarten blocks known today. When she doubled each dimension of the parts of the cubic gifts, the resulting volume became sixteen times as large and the formerly constrained activity of building on the table grid could be transferred to free play on the floor. Patty Hill went on to become the head of the kindergarten-primary department at the Horace Mann School in New York City, the laboratory school for Columbia University's Teachers College, where she exerted considerable influence on the evolving kindergarten debate. She later developed her own system of floor blocks that were so large children could use them to build structures substantial enough to enter. Such model buildings—a house, a restaurant, a store—became convenient springboards to further classwork on domestic activities like cleaning, cooking, or shopping for groceries, and would lead to creative play about families or the occupations of workers in the local community. Ultimately, Hill's construction system proved unwieldy, and its dependence on pegs and holes for stable connections inadvertently eliminated many of the simple lessons on balance and gravity that building blocks could convey.

The smooth, maple blocks that most of us remember from kindergarten were designed in the 1920s by Caroline Pratt, another liberal teacher. Larger than Froebel's but smaller than Hill's, and in a variety of shapes that related more to traditional wood building blocks than the pure forms of kindergarten,

the Pratt Unit blocks are still in standard use today. They are gravity-dependent and hefty enough for floor use, and the addition of scaled wood or rubber people and animals suitable for storytelling and related games promotes symbolic play. Ironically, the Pratt blocks, with their bricks and beams, arches and semicircles, are close cousins to the type of randomly designed toy Froebel specifically reacted against. Lacking strong mathematical modularity, they are fine for free play but less valuable as a conceptual bridge to related planar and linear activities. Thanks to kindergarten, building blocks are universally recognized as one of the most valuable learning tools of early childhood, but by shifting them from the grid of the table to the undefined floor, adding new shapes, and scaling up the size of the parts, twentieth-century educators sacrificed their Froebelian function as the introductory three-dimensional component of a complex overall system.

Considering how much of Froebel's original system had been lost by the early twentieth century, it's surprising to discover that paper folding, weaving, and cutting, along with sewing, slat work, and other kindergarten occupations, were still taught in American normal schools until at least 1930. I know a Cuban man and a Dutch woman who went to Froebel kindergartens in the 1940s, and in Holland newly made gifts were floating around schools into the 1990s. There is a museum devoted to Froebel in Bad Blankenburg, and Froebel research continues in Germany. Modern examples of the block gifts were recently being made in the United States and were available as historical souvenirs at the Frank Lloyd Wright home in Oak Park, Illinois. What may be the only thriving kindergarten and school in the world that still uses the original gifts in the creative fashion directed by Froebel is the Froebel Education Center in Mississauga, Canada. Founded in 1969 by educator and historian Barbara Corbet, the school is close to an authentic kindergarten of about one hundred students from age three to ten. With gifts and occupations made by the teachers themselves, the Froebel Education Center, in spite of its offering religious instruction that inevitably dilutes Froebel's universality, may be the last remaining light of the galaxy that was born in Germany one hundred fifty years ago, burned its brightest in the late nineteenth century, and has since, except in name and influence, basically disappeared.

While it lasted, in every kindergarten, from strictly Froebelian schools in Boston to deliberately academic infant schools in Paris and from 1860 until at least the second quarter of the new century, the youngest and most impressionable members of society were engaged in daily activities that were generally unknown to earlier generations of children. Sitting at tables whose gridded surfaces unavoidably orthogonalized or, simply speaking, "squared" everything they saw and did, all of these tiny blank slates, eager to absorb what their elders saw fit to pass before their eyes and into their hands (but not necessarily learning exactly what their teachers intended) experienced the (il)logic of fragmentation and the language of geometric abstraction before they had learned to read.

5 ART

The artistically cultivated senses of the new generation will again restore pure, holy art.

—Friedrich Froebel[1]

PURE, HOLY ART

Art historians have pointed to many aspects of cultural and material life to explain the abstract art that burst upon the world in the first decade of the twentieth century. So complex was the history of this transitional period that the seminal text on the origins of the abstract era, Alfred H. Barr's *Cubism and Abstract Art,* included a genealogical chart on the jacket of the original 1936 edition. In his foreword to the book's fiftieth anniversary reissue, Robert Rosenblum hailed this clarifying device for providing "an evolutionary pedigree for abstract art that seemed as immutable as a chart tracing the House of Windsor or the Bourbon Dynasty," and, with few alterations, the grand lineage that Barr succinctly illuminated with this "family tree" has remained the standard account of abstraction's birth.[2]

Barr defined two distinct traditions of abstract art, both of which, he suggested, descended from Impressionism. One, presciently called Abstract Expressionist, was intuitional and emotional rather than intellectual, biomorphic rather than geometric, and celebrated the spontaneous and irrational over the classical and structural. The paintings Wassily Kandinsky (1866–1944) produced before his return to Russia in 1914 are among the first and greatest examples in this expressionist vein. The other and, for Barr, writing in 1936, more important current, was based upon logical mutations of crystalline geometry. Rational and Platonic, hard-edged abstraction has had great appeal to both artists and architects throughout the twentieth century and,

Opposite:
Mary L. Fenton.
Flower made with the
fourteenth gift (paper
weaving). United
States, c. 1875

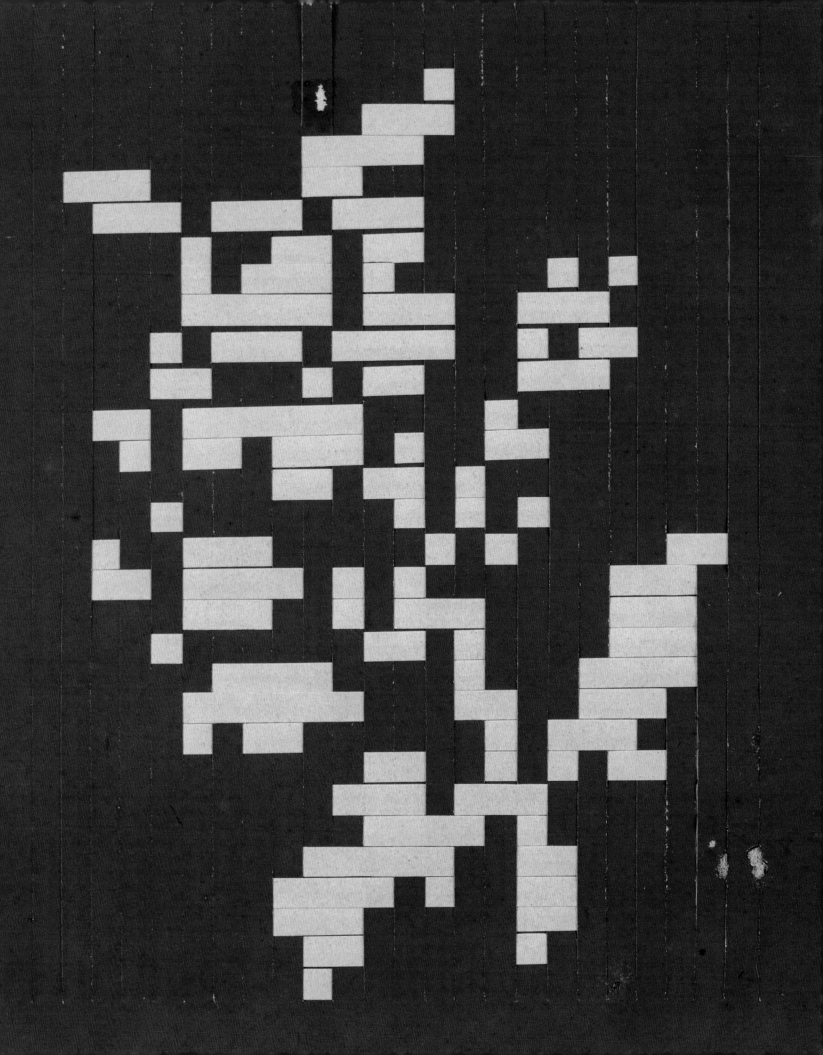

thanks in part to the reach of the Bauhaus, provided a stylistic bridge between the fine and applied arts. Cubism (1908) was the foundation for all the geometry-based "schools" that flourished in the first quarter of the century. Futurism (c. 1909), Suprematism (1913), and Neo-Plasticism (c. 1914), as well as the so-called International Style in architecture, were, to varying degrees, all synthesized from Cubism and would have been unimaginable prior to its advent.

This is not to say, however, that Cubism alone is sufficient to explain the efflorescence of geometric abstraction. Every artist's biography marks his or her own path to vision and expression, and turning points on this path are many, including the brute facts of physical and mental growth and deterioration; the influence of parents, teachers, and other artists; and the zeitgeist itself, the vague pressure of the greater cultural milieu. So, for example, many of the artists who participated in the movements mentioned above acknowledged, in both their art and writing, the impact upon their imagination of new inventions that changed everyday life. Many were friends and colleagues, and their correspondence and travel ensured a quick and continuous dispersal of new ideas, ranging from broad philosophical and literary currents to cultish, quasi-religious movements. Many kept abreast of up-to-date theories and discoveries concurrent in science. The equivalency of matter and energy proposed by Einstein and the relationship of space and time in the new non-Newtonian physics reinforced their belief in a reality beyond observable reality, while more obvious advances in applied technology like flight and radio communication offered a much broader model of the scope of physical existence.

Such are the conventional touchstones for art historians seeking to explain the advent of modern art. In the chapters that follow, I want to explore an entirely different path to the same destination.

In effect, the early kindergartners created an enormous international program designed specifically to alter the mental habits of the general populace, and in their capable hands nineteenth-century children from Austria to Australia learned a new visual language. While focusing on kindergarten's many educational and social benefits, these pioneers overlooked a potentially radical outcome of their efforts that is obvious in retrospect: kindergarten taught abstraction. By explicitly equating ideas, symbols, and things, it encouraged abstract thinking, and, in its repetitive use of geometric forms as the building blocks of all design, it taught children a new and highly disciplined way of making art. Like spokes on a wheel—separate at the rim, but connected at the hub—every lesson of the original kindergarten led from diverse vantage points to a central truth. Simple linear thinking was to be superseded by a more sophisticated, genealogical approach to knowledge that valued relationships as much as answers. The grid of the kindergarten table was symbolic of a type of inquiry that drew from multiple sources, cut across and connected seemingly unrelated data, and had the potential to result in more than one "correct" conclusion. By emphasizing abstraction, kindergarten encouraged the value of unconventional reasoning. If one intended to shakeup Victorian society and effect broad change in the areas of

philosophy, music, science, and art, exposing nineteenth-century preschoolers to the influence of a regime like the Froebelian kindergarten would be a good place to begin.

We are justified, then, in asking whether the great change that occurred after 1900 in visual design and the plastic arts, the cultural domain with which kindergarten's language of form was most closely allied, was related in any way to the spread of kindergarten.

Froebel's published writings provide little in the way of acknowledgment of an abiding artistic interest in his life. He mentions visiting a picture gallery as a young man[3] and seems cognizant that his manual exercises, including drawing, will lead to the development of artistically sensitive children. Although he seriously considered becoming an architect, he rarely comments about features of the built environment, generally limiting himself to exaltations of nature. Yet, thanks to the gift play, the daily activities in kindergarten exhibited affinities with nothing so much as an introductory course in the mechanics of art and architecture. Building, drawing, and color exercises were certainly applicable to an education in the arts, and modeling in clay was itself a standard art technique.

Some of the children who went through kindergarten might have been expected to become artists on the strength of their early training with the gifts and occupations, but the specific forms of the kindergarten were inherently ill-suited for anyone who actually wanted to master the skills required by European art of the late nineteenth century. The cubes, triangles, checkerboards, and line fragments of Froebel's system might resemble art's details but bore no relationship to the art and architecture that we associate with the second half of the nineteenth century: not the art of the Salon or the Barbizon School; not Impressionism; not the architecture of historical revival or the Ecole des Beaux-Arts. Crowding around the grid of the kindergarten table in their lace and velveteens, the first kindergarten generations learned to transform the gifts into the kind of crystalline expressions associated with a new art: the art of their future.

Biographers rarely consider the earliest days of their subjects in detail, and in most cases, interpretable facts about the lives of children are hard to come by. The whole question of the significance of childhood experience for adult achievement is especially complicated in the case of art because, as every parent and teacher knows, everyone is an artist before the onset of puberty. Biographers, therefore, are wise to discount evidence of artistic talent at an early age, as John Richardson does in the famous case of Pablo Picasso, some of whose juvenilia has survived: "It would seem that Picasso—unlike certain composers (Mozart, for instance)—conforms to the rule that no great painter has ever produced work of any serious interest before puberty."[4] An artist's life story really gets going at the point when he or she begins to display an interest or talent for art as a young adult (and sometimes even later), and, were it not for the occasional reminiscence recorded later in life, we would know nothing of what came before.

How do we weigh influences that a biographer never considers and the artist doesn't remember?

What follows is an exercise in "biographical archaeology." Like an archaeologist, I have used whatever evidence is at hand to make my case. I hope that some of my conclusions will be borne out by more extensive research in the future.

CUBISM **A** mutual creation of the brilliant and visually omnivorous Spaniard Pablo Picasso (1881–1973) and the less dazzling but more focused and, during the years of their relationship, more inventive Frenchman Georges Braque (1882–1963), Cubism decisively and permanently altered the course of Western art. Although Cubism has been endlessly dissected for its underlying philosophical, psychological, and symbolic associations, Cubism's creators remained adamant throughout their long lives that the fragmentation, crystallization, and geometrization in their work was less an attempt at creating a new "worldview" (which, when one catalogs its influence, it did) than the result of an essentially visual exploration of art and nature. What experiences in the relatively young lives of Picasso and Braque led them to break with centuries of prior art and invent an entirely new way of seeing? Indeed, from what psychic reservoirs did they draw the confidence that permitted them to attempt such an audacious endeavor? Briefly recapitulating a well-known story, we question once again—from what exactly did Cubism spring, and from what sources and whose influence did Western art become so radically redefined?

In terms of art-historical parentage, Cubism appears to have been a radical elaboration of the paintings and theories of Georges Seurat (1859–1891) and, more directly, Paul Cézanne (1839–1906). Seurat, the "intellectual" Impressionist, supplied the method of paint application that he had invented for his Pointillism. Applying small dots of pigment to control varying levels of contrast, Seurat's work focused on relations of tones (from light to dark), colors (pairs of pure primaries and secondaries), and lines (parallel and perpendicular). His theory, which recognized the viewer's visual cognition and subconscious assimilation of color, was an important influence on the later Orphism (1912) of Robert Delaunay (1885–1941) and Sonia Delaunay (1885–1979), while his painting technique was adopted by Braque and Picasso (who characteristically ignored the theoretical basis for it). According to the standard history, the format of Seurat's paintings—rectilinear color zones in architectonic balance—also influenced the Cubists, although his clear geometry became overlapped and fractured in their paintings. (Orthogonal composition, characterized by intersecting perpendicular lines, soon reappeared as distinctive themes in the Neo-Plasticism of the De Stijl artists and the work of various Bauhaus artists, including Paul Klee and Josef Albers.)

Cézanne's work, especially his later landscape paintings, also provided Braque and Picasso with ideas. The paintings done shortly before Cézanne's death in 1906, particularly his distant views of Mont Sainte-Victoire with their prismatic brushwork, were of paramount interest. Mathematically accurate perspective—one of Renaissance painting's great contributions to world art—began to disintegrate in

Opposite:
Georges Braque.
Mandola. Paris,
c. 1909–10. Oil on
canvas, 28 x 22". The
Tate Gallery, London

109

Standing Man.
Wood engraving from
the mosaic toy Étude
de Parquetage,
Paris, 1849

Dépose

Cézanne's "constructions after nature,"[5] as he utilized what he termed "passage," the blurring of boundaries between the typically simple, angular planes of the foreground and background. The illusion of figures in space was thus replaced by compositions of geometric shapes with less obvious depth. While discernible as landscapes, these proto-abstract pictures were rendered as if they were mosaics of colored facets or puzzles slightly skewed by vibration. Picasso's and Braque's townscapes of 1908–1909 far surpassed Cézanne's work in abstraction of form and denial of perspective. So crystalline was the geometric treatment of these seminal pictures that they elicited the first comments about seeming to have been built up of "cubes."

The classic analytic Cubist paintings of close-toned shades of brown and gray that quickly followed these *plein-air* views may more accurately be described as assemblages of *fragments* of the surface planes of solids in space—two-dimensional semicircles, parallelograms, and triangles. Perhaps heeding the advice Cézanne had included in a letter that was published after his death, where he suggested to Emile Bernard, "you must see in nature the cylinder, the sphere, and the cone,"[6] Braque and Picasso intuitively utilized variations of Plato's basic units of creation to portray their joint version of the physical world. By harnessing the abstraction they perceived in Cézanne's attempts at rendering reality as it actually appears to the eye, without emotional exaggeration or poetic interpretation, the Cubists invented an entirely new strategy for making art that was virtually the antithesis of Cézanne's intent. The portrayal of some form of what the eye sees gave way to creations that were intentionally only vaguely "realistic." Without completely relinquishing representational "motifs" at first, the Cubists and their followers quickly recognized the inherent freedom in abstraction. Worlds other than the visible world, limited only by one's imagination, now became available for artistic plunder.

The painting that seems to have precipitated the break with tradition was Picasso's *Les Demoiselles d'Avignon,* which he completed in the summer of 1907 when Braque was painting in the manner of the Fauves, but from the time of their providential introduction in late November of that year, they contributed equally to the development of Cubism. Many of the seminal advances of Cubism, including *papiers collés* and constructed sculpture, were first attempted by Braque and quickly adopted by the voracious Picasso.[7]

From the start, they spoke the same visual language. This is somewhat surprising considering the different paths they followed to their first meeting. The son of a painter and art teacher, Picasso was accomplished and well known: he had had a number of exhibits and his work had already gone through several distinct "periods." Besides assuring his notoriety in the Parisian art world, the *Demoiselles* is evidence that the "look" of Cubism was already filtering through his consciousness before his meeting with Braque. He had never associated himself with the Fauves and was essentially a realist painter until shortly before his stylistic metamorphosis in early 1907.

Far left:
Flora Christy.
Standing Man made
with the eighteenth
gift (paper folding).
Delhi, Ohio, 1889

Left:
Juan Gris. *Portrait.*
1912. Plate 10,
Les Peintres Cubiste
by Guillaume
Apollinaire,
Paris, 1913

After a thorough study of Picasso in this transformative period, William Rubin places special emphasis on the artist's "embracing primitivism," with its abstracted forms, in explaining the genesis of this visionary work.[8] In June of 1907, having already developed a more than passing interest in ancient Egyptian and Iberian art and African and Oceanic sculpture, Picasso serendipitously entered the Musée d'Ethnographie du Trocadéro where, confronted for the first time with "fetishes" that the French had collected from their colonies in Africa and the South Pacific, he experienced an epiphany: "At that moment, I realized what painting was all about."[9] A month later, he finished the *Demoiselles,* including in it the two revolutionary "African" figures on the painting's right side.

However, as Rubin notes, the *Demoiselles* was, "more a 'breakaway' painting with respect to late nineteenth-century modernism—and post-Medieval Western painting in general—than a 'break-through' painting with regard to Cubism in particular."[10] By 1907, Picasso had been gripped by what Wilhelm Worringer termed "the urge to abstraction."[11] With his complete mastery of technique, and a proclivity toward the "magical" in art and life, Picasso quickly internalized, not the function of the tribal objects, but the intuitive method of their creation. Something of a primitive himself, and perhaps requiring, as Worringer suggested, "resting-points, and opportunities for repose in the face of the bewildering and disquieting phenomena of the outer world," Picasso freed his art of the weight of Western tradition with one painting.[12]

Georges Braque's father was by profession a house painter, and an amateur painter as well, and Georges's boyhood fascination with the paint, varnish, and specialized brushes that were his father's tools in the Parisian suburb of Argenteuil-sur-Seine where he was born in 1882, and later in Le Havre where the family moved in 1890, led to his decision to embark on a career as a painter. Largely trained in the techniques of faux marbling and artificial woodgraining that were the stock-in-trade of the traditional Continental house painter, he was not nearly as well established or recognized as an artist as Picasso was when they met in 1907.

Rubin credits Braque's L'Estaque landscapes of the summer of 1908 as the first Cubist paintings. Prior to the momentous meeting, Cézanne's influence had vaguely begun to infiltrate Braque's own, essentially Fauvist paintings. He had finished a few canvases in which clusters of roofs showed a tentative faceting and had made stabs at replacing the pure colors that marked the work of the Fauves with the earth tones Cézanne had favored, but it wasn't until he entered the realm of freedom opened by Picasso that the thus far unremarkable Braque was able to trigger the dialogue that led to Cubism and create something as original it its own way as the *Desmoiselles.* The accelerated, prismatic deformations that marked Braque's paintings from mid- to late 1908 were, in their almost geologic fracturing, distinct from the more pictorial and curvaceous forms found in Picassos of the same period.

The *Desmoiselles* struck a chord in the soul of the young Braque. Instead of recoiling like most of

Picasso's friends—who were actually avoiding him as one might steer clear of a lunatic—Braque immersed himself in the "monstrosity" as if it were the portrait of a long-lost friend. Were the cubes and crystals that began to crowd the picture plane in Braque's canvases simply a logical response to Cézanne by way of Picasso? Or is it possible that this "cubism" was generated by a more complex mechanism, one that fused visual evaluation in the artist's conscious present with the memory of a similar, deep-seated knowledge from his past? Certainly, a few of his contemporaries sensed the latter. Guillaume Apollinaire said of Braque in the introduction to the exhibition catalog of his first show of his Cubist paintings at the Parisian Galerie Kahnweiler in November 1908, "By taking from within himself the elements of the synthesized motifs which he paints, he has become a creator." Critic Charles Morice wrote, "Visibly, he proceeds from an *a priori* geometry to which he subjects all his field of vision, and he aims at rendering the whole of nature by the combinations of a small number of absolute forms. . .

He has created an alphabet of which each letter has a universal acceptance."[13]

Georges Braque, like most of the children in France (and unlike Picasso and most of the children in Spain[14]), almost certainly went to kindergarten.[15] In 1881, a year before Braque's birth, the *salles d'asile* became the *écoles maternelle.* A contemporary account of part of the curriculum in one of these French "kindergartens" lists the following: "instruction in common things (color, shape, etc.); the rudiments of drawing (stick laying, copying on the slate, easy designs drawn on the blackboard, outline representations of simple objects); arithmetic with the help of blocks and sticks, etc.; manual exercises (plaiting, weaving, folding); gymnastics, singing."[16]

Although the French ignored Froebel's philosophizing, with its spiritual overtones, the Froebelian grid, the normative descendant of Pestalozzi's *ABC der Anshauung,* was ubiquitous in the *écoles maternelle.* If Braque had the average, working-class childhood his biography suggests, he spent most of each day for a year or more playing with the gifts and occupations. Unlike the kindergarten table in use elsewhere, with its continuous grid, the French kindergarten table presented each child with a separate, rectangular gridded area—a pictorial space. The activities that could not be done directly on the gridded wood tabletop (like drawing with pencil or chalk) were performed on equivalently gridded slates that corresponded to the teacher's scored blackboard at the front of the classroom. The gifts, the design tools of the kindergarten, were scaled (in the metric system) to the grid. As the system included triangles, arcs, and lines of different lengths, the structure of the grid was not inviolate but was, in a sense, both there and not there. Abandoning content, teachers put extra emphasis on rendering visual geometries, exalting form for form's sake. So far did the French drift from Froebel's ideas that in 1883, Marie Matrat, inspector general of the nationwide system of *écoles maternelles,* expressed her dismay as follows:

> Even the best headmistresses have *visible form* as their first concern! Rather than resorting
> to a few random exercises, which might even be called improvised, they have made it into

the dominant portion, and the actual objects surrounding the children remain forever forgotten. In a word, these games, rather than being preparation, are the actual teaching.[17]

Matrat doubted that reality could usefully be portrayed with a jumble of geometry:

Braid strips into a diamond shape, and you have a fish! A ball shaken in the cup of one's hand is a bird in a nest, or a race horse! Three little sticks held like a fan is a vase of flowers; a collection of triangles, laid out according to a given pattern, is a factory, a tomb, a log, the mechanism of a windmill, a hundred things the child has never seen, which he cannot represent using these trinkets, except by using fantasy. Such representation so little resembles the real object that even with the best of intentions, for me it was *impossible to ever recognize the object*.[18]

Reality was so confused in French kindergartens that one of the country's leading education experts feared children would lose the ability to distinguish its true nature. Indeed, *"a collection of triangles, laid out according to a given pattern"* may have sown bewilderment and anxiety in some. But for those who would someday become poets of the visual, a second language could become a potent engine for expanding creative expression. After institutionalizing a national program of geometric abstraction, it's no wonder France produced a generation that included Jean Metzinger, Albert Gleizes, Fernand Léger, and Marcel Duchamp. It may have been Picasso who discovered its track and pointed the way, but it was Braque who put the cube in Cubism.

Kindergarten teaches conceptualization through symbols—cubes stand for buildings, triangles for people, and sticks for boats. With the very same materials, it also teaches plastic composition—cubes are planes enclosing volume, triangles are colored shapes, and sticks are lines. After a few months in a real kindergarten, certain children, specifically those who are not only visually adept and sensitive to the look of things but also actively interested in what they see, will learn Froebel's lesson of unity as he intended—with their hands and eyes. At three to six years of age, abstraction is not only comprehensible, as Rudolph Arnheim points out, it's the only imaginable form of expression: "Early stages of development produce highly abstract shapes because close contact with the complexities of the physical world is not, or not yet, pertinent to the task of picture making."[19] Children's drawings are simple not merely because they are produced by the untrained, but because, like any good painting or design, they perfectly fulfill their function with an economy of means. As Pestalozzi and Froebel recognized, children do not need drawing lessons, only guidance if one wants them to draw in a particular way. Georges Braque never became the draftsman that Picasso was, but he always had a profound grasp of how to construct a picture that bears the unmistakable mark of a kindergarten education.

NEO-PLASTICISM

Piet Mondrian (1872–1944) was born in the central Netherlands city of Amersfoort. His conservative Calvinist father was headmaster of the National Christian School, the Dutch Reformed primary school that his son attended. The father was an avid and somewhat accomplished amateur painter who, prior to being appointed administrator of his son's school, was licensed to teach drawing at the primary level. In 1880, the Mondrian family moved farther east to the town of Winterswijk near the German border, where he was appointed head of another Protestant elementary school. It was here that the boy completed his education and, while still a teenager, declared his intention of becoming an artist. Because a career in art was deemed insecure by his parents, Mondrian was urged to follow the example of his father and study for the state-regulated, primary-school drawing license that they felt would provide income assurance if his fine-art career floundered. Heeding their advice, or bowing to their demands, young Mondrian worked at preparing for his examinations with the help of his father and guidance from his uncle, Frits Mondriaan (1853–1932), a professional artist who had studied under the Dutch Impressionist Willem Maris (1844–1910) and become a follower of the Hague School (c. 1870–90) of mostly realist and Impressionist landscape painters. In 1889 Mondrian won his license to teach drawing in primary schools, and three years later, in 1892, the certificate entitling him to teach in secondary schools. Finally, satisfying the requirements of his conservative parents, he registered at the National Academy of Art in Amsterdam later the same year.

Mondrian's artistic evolution was unexceptional. He passed from the academic realism of his uncle to what was by then the acceptability of Impressionism, later flirted with Fauvism, and then joined the swiftly burgeoning ranks of the Cubists. Living in Paris from 1911 until the start of the war in 1914, he turned to abstraction and painted his own "analytic cubist" pictures. His earliest attempts at dissolving reality showed a predilection for the strict orthogonality (in which a ninety-degree relationship of the horizontal and vertical axes is always maintained) that remained a hallmark of all his subsequent work. After returning to Holland, he became associated with the artists Theo van Doesburg (1883–1931) and Bart van der Leck (1876–1958), and together with others, they soon became known as the De Stijl group after the journal they first published in 1917.

While living in Paris, and later in Holland where he was artistically marooned during the war, Mondrian refined a personal aesthetic philosophy that became the theoretical basis for the abstraction of his work. Seeking to portray not the external appearance of things but the universal, elemental motifs that he felt were evidence of a higher reality, he developed a method based upon a dialectical resolution of opposites that would lead to beauty in the perceptual realm. His ideas drew upon a number of independent, yet related, sources. While Hegel hovered over his program to create beauty from a well-balanced synthesis of opposites, he was also acquainted with the pantheistic doctrines of the Theosophists, having joined their society in Amsterdam in 1909.[20] The writings of Rudolf Steiner (1861–1925) are another

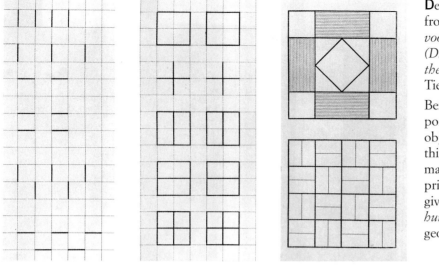

Details of three pages from *Teekenoefeningen voor de Lagere School (Drawing Exercises for the Primary School)*, Tiel, Holland, 1890

Before attempting to portray a single real object, students using this series of drawing manuals for Dutch primary schools were given more than *two hundred fifty* of these geometric exercises.

likely source for his everyday mysticism, inasmuch as they proposed methods for awakening the soul by concentrating one's attention on representations of various abstract forms.[21] As Mondrian's focus was already in transition toward abstraction when Steiner's ideas were published in 1910, it must have gratified him to discover in the Swiss philosopher's theories a sympathetic justification for his own work.[22]

Mondrian's interest in metaphysics and mysticism and his ambition to penetrate to the heart of reality and create an art of unity and equilibrium also found coincidental intellectual justification in the ideas of the Dutch philosopher M.H.J. Schoenmaekers (1875–1944). According to Schoenmaekers, whom Mondrian met in 1915, "Nature, as lively and capricious as it may be in its variations, fundamentally always functions with absolute regularity, that is to say, in plastic regularity." Schoenmaekers postulated a cosmic model defined by the coherence of definite relations, and sought "to penetrate nature in such a way that the inner construction of reality is revealed to us."[23] Mondrian's desire to create an anti-expressionistic art, to eliminate personality from painting and enter the realm of the absolute, was greatly bolstered by his discussions with Schoenmaekers. What he called Neo-Plasticism was an intuitive attempt at portraying the underlying structure of nature and the means by which a visual artist might represent the essential harmonies of the universe. As we already know, this was virtually identical to the intended goal Froebel had set for the similarly geometric kindergarten training more than seventy-five years earlier.

Mondrian sought to transcend the purely visual by portraying what he deemed fundamental about reality. In the decade bracketing World War I he was not alone in this endeavor. As others have previously noted, there were similarities between Schoenmaekers' theories and those expressed by Kandinsky in his *Concerning the Spiritual in Art,* and the philosophy itself was in the air at the time.[24] One wonders, though, at the course that Mondrian (and the rest of the De Stijl group, both artists and architects) took to satisfy this aim. In his very first attempts at deconstructing pictorial reality, Mondrian seems to have immediately identified the governing leitmotif for all of his subsequent works—the right-angle grid of Descartes, Froebel, and, particularly in this case, Froebel's mentor, Pestalozzi.

> Now form, and whatever may depend on form, reveals in various ways inner spiritual energy. To recognize this inner energy is a part of man's destiny; for thereby he learns to know himself, his relation to his surroundings, and, consequently, absolute being. It is, therefore, an essential part of human education to teach the human being, not only how to apprehend but also how to represent form; and, inasmuch as the perpendicular relations (of the vertical and horizontal) aid the development of form-consciousness, the external representation of these relations as a means for the study and representation of form is based on the very nature of man and of the subject of instruction.[25]

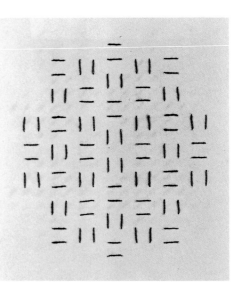

Right:
Abbie A. Herrick.
Beauty form made
with twelfth gift
(sewing). Westfield,
Massachusetts, 1875

Below:
Piet Mondrian.
Composition 10 in
Black and White (Pier
and Ocean).
Domburg, 1915. Oil
on canvas, 33½ x
42½". Kröller-Müller
Museum, Otterlo

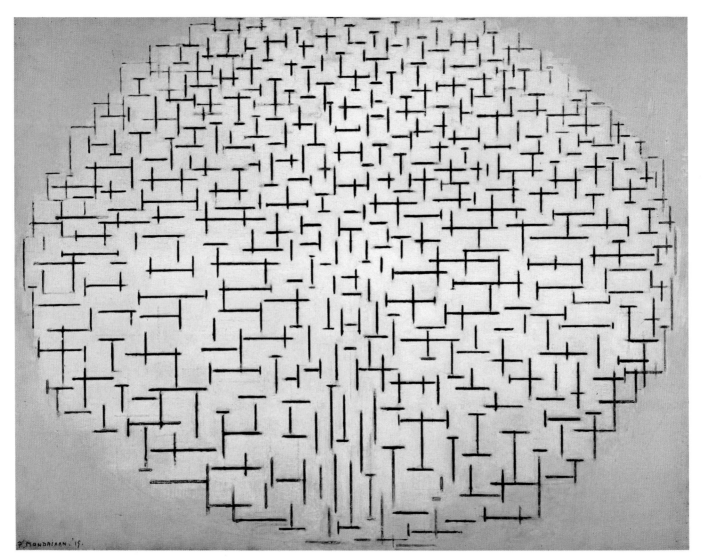

This statement, a virtual manifesto of Neo-Plasticism, was written by neither Mondrian nor van Doesburg after World War I, but by Friedrich Froebel in 1826. Describing the spiritual value in drawing on a network of lines, he was at the time just beginning to formulate the ordered techniques of kindergarten. That it should so exactly anticipate the ideals of Neo-Plasticism suggests that before creating his mature work, Mondrian had early knowledge of kindergarten and, more specifically, that kindergarten's foundation, pedagogical drawing on the Pestalozzian model, formed the basis of his artistic practice.

Kindergarten was well established in Holland, and particularly in Protestant Holland, a decade or more before Mondrian's fifth birthday in 1877.[26] As a primary school headmaster, amateur painter, and drawing teacher, Mondrian's father would surely have recognized the creative value in the occupations (including drawing) and been a likely kindergarten enthusiast regardless of how conservative he was in other areas of life. It is even possible that Mondrian attended a kindergarten in the school his father ran.[27] Living in the very building where his father taught class would have exposed him to the slate grid and net lines of pedagogical drawing from infancy. In kindergarten at age five or six, the already familiar grid would have been reintroduced as a playing field for many other more sophisticated forms and exercises. In addition to using the table matrix to align blocks and sticks and square and triangular parquetry tiles and the gridded slate and pencil for geometric drawing, he would have created his own grids of thread, paper, and colored wood slats.

Even if Mondrian did not attend a Froebelian kindergarten, from age fifteen through seventeen he would have been immersed in the grids and linear exercises while completing the core requirements leading to certification as a primary school drawing teacher. During this period, roughly 1887–89, he would presumably have had to work in schools as a student teacher, and would have had contact with the kindergartens that were, by then, completely established in the national education system. Froebel's colorful geometry could hardly have passed before him unnoticed in the elementary school milieu in which he then functioned.

Twenty years out of normal school and after a long "apprenticeship" of artistic and philosophical growth, Mondrian's first exposure to Cubism was sure to have resonated memories and visual harmonies that were powerfully implanted within him. The abandonment of naturally rendered forms in the paintings of Picasso and, particularly, Braque[28] accelerated his own nascent abstract tendencies, while their edgy geometry and skewed, interpenetrating grids must have struck a chord in the former drawing teacher. Unlike Wassily Kandinsky, who truly composed his works like music, setting themes and moods and working toward their pictorial manifestation with his own complex alphabet of colors, lines, and shapes, Mondrian organized, and quickly reduced, the forms of nature into variations of the severe orthogonal lattice that he knew so well from his past. It was as if having learned the language of geometric abstraction and recognizing its potential, Mondrian then proceeded to throw most of his

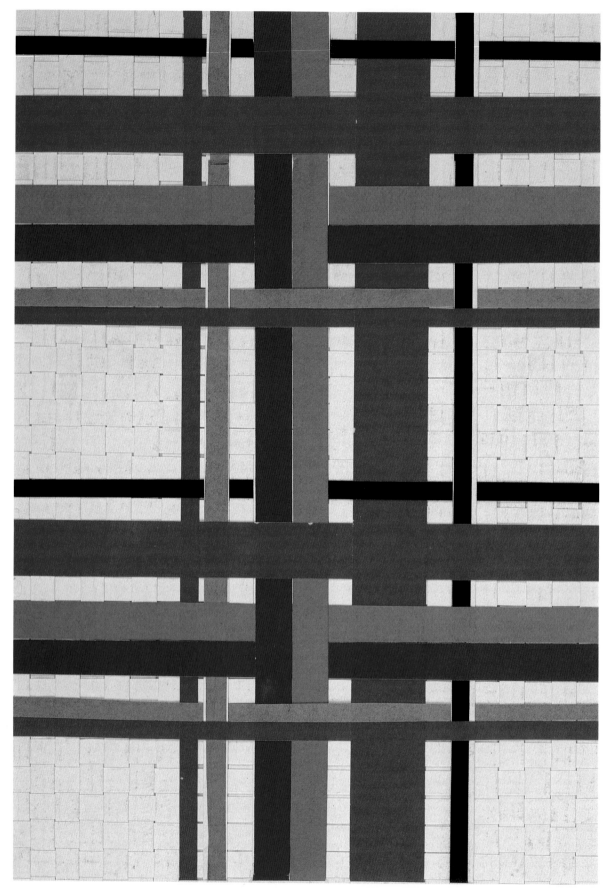

Unknown kindergartner. Beauty form made with four-teenth gift (paper weaving). United States, c. 1890

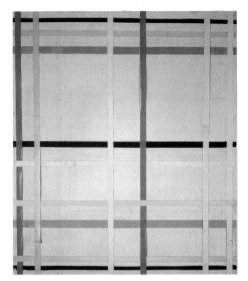

Piet Mondrian. *New York City III* (unfinished). New York, 1941–42. Charcoal and colored paper strips on canvas, 45¼ x 39″. Courtesy Sidney Janis Gallery, New York

pictorial vocabulary away so that he could concentrate on the unifying structure beneath. While Kandinsky relished the infinite diversity of form and color and Braque harnessed those elements that he needed to build his focused and authoritative oeuvre, Mondrian flayed the art of painting so that he could experiment with its very skeleton and pushed structure independently to the fore until it became the salient feature of all his mature work. The grid, Descartes's universal map, thus became all that was essential for Mondrian and, in a real sense, the paradigm for his leap from reality into the abstract sublime. According to this model of Mondrian's development, the training he received as a boy—from his father, in kindergarten, and in normal school—combined with the philosophy of nature that was confirmed by Steiner and Schoenmaekers and the Cubist disregard for pictorial veracity, to form a personal response to the problem of modern painting that remains one of the artistic apogees of the twentieth century.

Certainly, Mondrian was already headed toward geometric abstraction prior to meeting Schoenmaekers, as were some of the other artists and architects who shortly after became aligned as the De Stijl group. The ultimate visual coherence of De Stijl, which, in addition to its theoretical and utopian ethos, very quickly did become a distinct and recognizable style, was not merely a plastic response to the ruminations of the neo-Platonist Schoenmaekers. Writing in 1918 about his fellow Neo-Plastic artists, Mondrian posed a series of questions:

> Was it by chance that they found a most appropriate subject matter through which to express their feeling for determinate relationship in an unforeshortened (without perspective) view of a farmhouse with its mathematical articulation of planes and its primary colors? Was it by chance that they were attracted to straightness and dared to represent a forest simply by its vertical tree trunks? Was it surprising that, once they had abstracted these trunks to lines or planes, they spontaneously came to express the horizontal, thus creating equilibrium with the vertical? Did they do more than exaggerate what all painting has always done? And is it surprising that in the course of their work they abstracted natural appearance more and more, so as to express relationship more and more explicitly? And that the ensuing composition was more mathematical than naturalistic? Was it, finally, by chance that, after abstracting all that was capricious, they abstracted curvature completely, thus achieving the most constant, the most determinate plastic expression of equilibrated relationship—composition in rectangular planes?[29]

Although he implies (after the fact) that the development of De Stijl was a straightforward evolution from nature to complete abstraction that proceeded logically from beginning to "end," his question continues to resound—was it by chance? Was it by chance that so many artists and architects in Holland (and Italy, and Germany, and France)—an entire generation, in fact—almost simultaneously

119

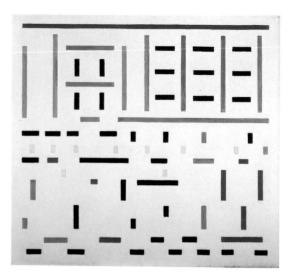

Bart van der Leck. *Composition 1917 No. 4 (End of Day at the Factory).* 1917. Oil on canvas, 37 x 39⅜". Kröller-Müller Museum, Otterlo

invented, and quickly mastered, a visual language without precedent that within a decade had successfully spread throughout the Western world?

The common denominator between Mondrian and the other De Stijl artists was not just Neo-Plasticism but something far simpler. They were European children in the late nineteenth century and came to artistic maturity during the post-Cubist epoch. Bart van der Leck, the painter whose flat planes of primary colors influenced Mondrian after their meeting in 1917, was born in Utrecht in 1876. Theo van Doesburg, the intellectual driving force of the movement, and the one who, with his experiments in painting, architecture, and graphic design, truly sought to forge a new relationship between artists and society, was born in Utrecht in 1883. George Vantongerloo (1886–1965), the most important De Stijl sculptor, whose first abstract works of 1917 can be accurately described as stacks of rectilinear volumes, or, simply put, building blocks, was born in Antwerp, Belgium. Gerrit Rietveld (1888–1964), designer of the iconic Red/Blue chair and the planar and collage-like De Stijl masterpiece the Schröder House, was born in Utrecht. And Robert van't Hoff (1887–1979), the architect who went to Chicago to meet Frank Lloyd Wright in 1914 and immediately after designed his own Wrightian house in Holland, was born in Rotterdam. The artists who created De Stijl, the most abstract, grid-generated, pinwheeling art movement of the early twentieth century, were all graduates of the early kindergarten—the most abstract, grid-generated, pinwheeling educational system of the late nineteenth century—and their parents, the generation just preceding them, were not.

BAUHAUS By 1919, when Walter Gropius (1883–1969) accepted the reins for the new interdisciplinary, art, craft, and design school he called the Bauhaus, kindergarten had been casting its crystalline spell on European culture for more than eighty years. Kindergarten's influence was conveyed on all levels of the experimental school's philosophical and practical coursework. Masters Johannes Itten, Josef Albers, Wassily Kandinsky, and Paul Klee infused the school's revolutionary *Vorkurs* or basic course, a required class of abstract-design activities, with an emphasis that owed a substantial debt to Froebel's system, effectively extending its reach far into the twentieth-century design establishment.

Gropius himself was commissioned in 1924 to design a "national monument for the great friend of children and educator of mankind" in Bad Liebenstein, to commemorate the seventy-fifth anniversary of Froebel's death.[30] Intended to be a combination kindergarten, research center, training school, and historical memorial, Gropius's unbuilt project was a grouping of separate buildings organized by function and expressing in spatial terms Froebelian concepts of life and creation, education and research. With a bridge connecting two of the buildings in the complex, the rationally planned Friedrich Froebelhaus anticipated the influential Bauhaus buildings that Gropius designed and built in Dessau the next year. In a symbolic sense, the new Bauhaus campus could itself be viewed as a kind of monument to Froebel.

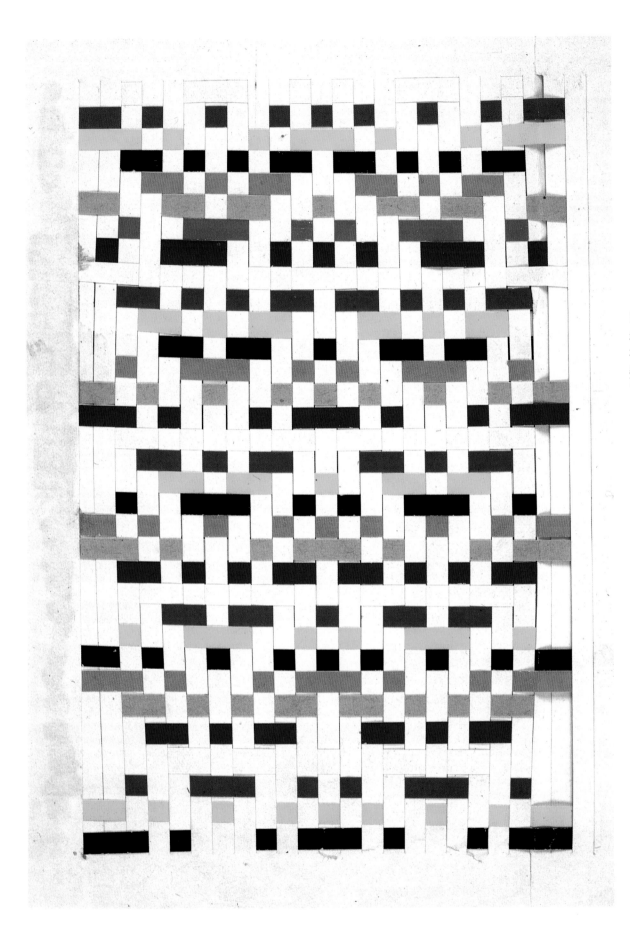

Unknown kindergartner. Beauty form made with fourteenth gift (paper weaving). United States, c. 1900

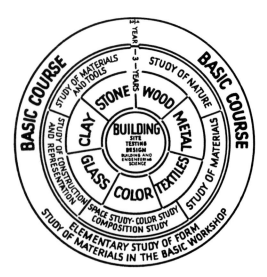

Among the first to be appointed Master of Form by Gropius was the Swiss artist Johannes Itten (1888–1967), an insightful and compelling teacher who had been running his own private school in Vienna when he accepted the invitation to come to Weimar. It was Itten's idea to require the six-month basic course for all new students before they were allowed to proceed to any of the various workshops (including metalwork, ceramics, and weaving) that constituted the bulk of the Bauhaus training.

Itten is famous for causing a stir at the Bauhaus because he was a disciple of Mazdaznan, a religious sect derived from ancient Zoroastrianism and somewhat popular in Europe and California around the time of the First World War. What is less well known is that he was a trained Froebelian kindergarten teacher. The German word *bau* literally means "building" in English, but the word *bauen* also translates as "to grow a crop." Gropius's choice of it for his school that would nurture creativity through every developmental stage was undoubtedly not lost on kindergartner (gardener of children) Itten. Itten's unconventional habits—among other things, disciples of Mazdaznan shaved their heads, wore long, purple robes, and engaged in purification rites that included fasting, enemas, and the puncturing of the skin to eliminate impurities—and charismatic influence over at least part of the student body ultimately led to his dismissal in 1923, but his importance to the early development of the Bauhaus was substantial.

Although other art schools had instituted similar probationary courses prior to its adoption in Weimar, the Bauhaus basic course, which remained in the curriculum through the tenure of each of the various administrations until the school closed in 1933, was distinctive in several ways. It was highly theoretical and concerned less with the making of art than with the development of creativity; it required students to abandon their previous knowledge and traditional skills so they might dig to the root of the artistic process; and by limiting students to the simplest of materials and forms and a finite palette of colors, it demanded an almost childlike resourcefulness that overflowed into all areas of Bauhaus life. The abstraction of reality to its essence was a given in the basic course, as was the conceit that composition of form and color could indeed be taught.

Itten's influence on the Bauhaus is generally measured solely in relation to the ongoing importance of his teaching methods.[31] As a trained kindergarten teacher, however, Itten had assimilated the cruciform and crystalline geometries of Froebel's system—the only characteristic attribute of the kindergarten when he studied it in 1908 that had remained essentially unchanged from Froebel's original conception.

Itten designed the basic course along Froebelian principles. People learned by doing, and experimentation was an end in itself; nothing stood in isolation, but rather every texture, color, and form was paired with its antithesis to increase comprehension of both; design exercises were mingled with physical exercises as students stretched and flailed their arms to loosen up before work; reality was exposed in "play" with simple materials. Like all good kindergarteners, Itten would have had his own set of gifts

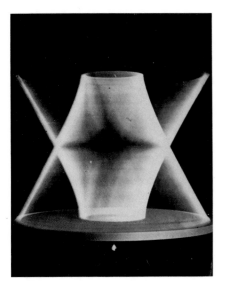

and would have retained examples of his original training exercises, and it is likely that the work of the kindergarten (already familiar to most of the students) was shown or used in some way. Unity was as popular a word at the Weimar Bauhaus as it was in the Bad Blankenburg kindergarten.

Itten's departure from Weimar was accelerated by the arrival in 1921 of Theo van Doesburg. Recognizing affinities in the vaguely utopian programs of the Bauhaus and De Stijl group, van Doesburg had come seeking some sort of linkage between them. His vociferous and outspoken personality acted as the catalyst that ended the school's Expressionist phase and swayed Gropius to embrace the disciplined purity of *Neue Sachlichiet* (New Objectivity, 1923), which had recently overtaken all the arts in Germany. The gulf between Itten and Gropius widened as the Swiss mystic's continued insistence on the creation of individualistic artworks fell out of synch with van Doesburg's dream of a socially unifying style and Gropius's new emphasis on maintaining the school's economic independence by designing products for mass production.

Van Doesburg's influence at the school was largely manifested in the areas of typography and furniture design. He began to publish the magazine *De Stijl* from his new base in Germany, and his *Principles of Neo-Plastic Art* was released in 1925 as the sixth volume of the school's series of Bauhausbücher. The strict orthogonality that Mondrian developed (and van Doesburg adopted), by crossing kindergarten, pedagogical drawing, and neo-Platonic philosophy, was thus transferred to Weimar as the logic of technological form was shunting the romance of Expressionism aside—exactly the moment it was likely to take root.

Itten's departure coincided with the arrival of his far different replacement in charge of the basic course, the Hungarian László Moholy-Nagy (1895–1946). Moholy, a follower of the Constructivists Vladimir Tatlin and El Lissitzky, was the antithesis of Itten. With his worker's jumpsuit and fetishistic embrace of modern technology, he had little patience for the monkish habits and hocus-pocus of his predecessor. Moholy became master of the metal shop and focused the work there and in the formerly intuitive basic course toward the solving of real problems, such as designing electric lighting with basic materials like steel and glass. Unpopular as he was with many of the painters, including Klee and Kandinsky, Moholy's influence during his three years at the school was long-lasting, and the products created during his tenure are among the first with the geometrically pure look that is often still associated with the word *Bauhaus.* Moholy never taught the basic course alone, however, but shared duties with Josef Albers (1888–1976), who taught the first of the course's two semesters. Albers had started at the Bauhaus as a student in 1920 and became a "Young Master" in 1923, staying on until the school's last gasp in Berlin in 1933. His innovative use of materials was especially impressive and remained the focus of his classes.

After Moholy's departure, Albers was put in charge of the basic course and continued to teach and

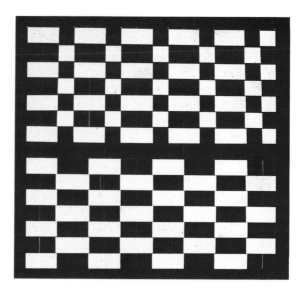

Unknown kindergartner. Knowledge forms made with fourteenth gift (paper weaving). United States, c. 1900

administer the program until the school's demise. While Moholy's course was primarily concerned with sensitizing students to the sculptural relationships of volume, balance, and tension, the work produced in Albers's classes focused more on the exploration of the nature of materials. He was particularly enamored of paper and the structural transformations it undergoes through the simple acts of cutting and folding. The diversity of results from these introductory classes is testimony to the success of his experimental method. Paper sculpture, paper structures, paper pictures, and paper patterns—in the 1920s, with the Beaux Arts still very much alive, the production from Albers's classes was extremely basic and rigorously modern. Anticipating ideas ranging from precast concrete architecture to economical cardboard packaging, the basic course under Albers was a true design laboratory.

Cutting pre-folded paper, of course, was the most striking and colorful of Froebel's occupations. It immediately afforded the satisfaction of artistic creation to every little child and was virtually foolproof in its simplicity. In 1855, Charles Dickens had written after observing a kindergarten in London, "By cutting paper, patterns are produced in the Infant Garden that would often, though the work of very little hands, be received in schools of design with acclamation."[32] Seventy years later in Germany, Albers's sophisticated use of paper and scissors was doubtless due to the related training and years of practice he had received while engaged in his primary profession before joining the Bauhaus: in 1908, after three years' study in preparatory teachers' training school and another three years in teachers college, Albers began teaching at the elementary level and continued to do so for most of the next decade. Throughout his tenure as a teacher of little children, Albers was an avid follower of contemporary art and frequently visited museums and galleries in Munich and Berlin. A painter in his spare time, he obtained a certificate to teach art in 1915, but he continued to teach elementary school until 1919 when he enrolled in his first official painting class at the Munich Academy.

As Bertha von Marenholtz-Bülow and other pioneer kindergartners had envisioned as early as the 1850s, the handicraft aspects of the kindergarten system—the "fancy work"—filtered out from Froebel's conceptual course and developed a life of its own in craft schools and art programs for all grades. The history of art education is too large a digression for the present study, but it can be said with confidence that besides drawing in the grid, which was standard in some form in most countries throughout the last quarter of the nineteenth century, elements of the gifts—paper and raffia weaving, sewing and embroidery, paper cutting and folding—had by 1900 been isolated as school and home craft occupations for a burgeoning independent market. In spite of the preponderance of young women in the field, there were always male kindergarten teachers, beginning with Froebel himself. It is not clear if Albers trained to teach kindergarten, but there is no question that he would have been completely familiar with the workings of the system. Intimately involved as he was for over ten years with the education of the very young, highly attuned to all the visual arts, and ultimately himself a teacher of art on

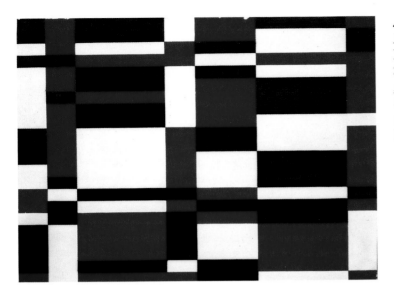

Josef Albers.
Dominating White.
Dessau, 1927.
Sandblasted flashed
glass with paint,
8½ x 11½". The Josef
and Anni Albers
Foundation

the primary level, Albers transferred more to the Bauhaus basic course than his obvious skill and charisma as a teacher, and the form language of the class was enhanced beyond measure by his prior mastery of creative exercises from a different world—the child world, the world of the kindergarten.

For most of the duration of the basic course, through the tenure of Itten, Moholy, and Albers, basic art theory was taught by the school's two most important independent artists, Paul Klee (1879–1940) and Wassily Kandinsky (1866–1944). Both spent many years with the school, during which they developed compulsory courses in color and form that resulted in the publication of seminal texts: Klee's *Pedagogical Sketchbook* (1925) and Kandinsky's *Point and Line to Plane* (1926).

Of all the form givers of modern art, Paul Klee, who joined the staff of the Bauhaus in 1920, was perhaps the most diversely brilliant. The second Bauhausbücher, his famous *Pedagogical Sketchbook*, served as both a text for students and an introduction to his own hermetic working method, yet it represented only the tiniest fraction of the thousands of pages of course lectures, diagrams, diary entries, and poetry left at his death. He was a concert violinist, accomplished mathematician, and adored teacher whose eleven years at the Bauhaus were among the most fruitful of his career. His complete oeuvre, nine thousand finished artworks and many more preliminary drawings produced over thirty active years, is almost unimaginably extensive.

The content of Klee's works is superficially simple—birds, fish, people, architecture, steps, stars, and arrows. Nature was his muse and he rarely abandoned her, but Klee was more metaphysician than natural philosopher. Like an alchemist, or Hesse's Magister Ludi, Klee claimed everything known and imagined, physical and spiritual, visual, psychological, and sensual, as the raw material for his visual poetry and spun a giant web of intimate masterpieces.

During his early days at the Weimar Bauhaus, before there were painting classes per se, Klee was Master of Form in the stained-glass workshop and an active participant in the weaving workshop. As he had previously painted on glass, the rich color and structured organization of stained glass must have had great appeal to Klee, but the artist took a more particular interest in the rhythmic logic of textile work.[33] Given his characteristic inventiveness, it was inevitable that Klee would transform the warp and weft of the textile looms into theoretical lessons for the basic course, and evidence of interwoven "chessboard" patterns indeed appears near the beginning of the *Pedagogical Sketchbook*. Klee's own work includes numerous examples of bold color "weaving," as well as a kind of calligraphic "embroidery" that has also been compared to musical notation.[34] Because these motifs emerge naturally as a mechanical consequence of loom work, one might assume that the importance of Klee's relationship with the Bauhaus weavers was their influence on him. But there is evidence that Klee's enthusiasm for clothlike "chessboards" had been smoldering in his artistic arsenal for years and reemerged in his paintings and coursework as a result of his own independent explorations.

Klee had painted assemblages of colored squares as early as 1914, apparently as a result of his association with Robert Delaunay, whom he had met in 1912. Certainly, Gropius and Itten also had an influence on Klee when he arrived at the Bauhaus. What is less well known is that in conjunction with his duties to the weaving students, Klee repeatedly met with a woman who was a Froebelian kindergarten teacher during the four years he spent in Weimar.[35] Whether Itten was the link between the two is not known, but the fact that Klee was directly involved with Froebel's techniques while teaching at the Bauhaus suggests a hitherto unrecognized level of general acceptance for the system in intellectual milieus that were entirely unrelated to the education of little children.

Under his musician father's influence, Klee became a masterful violinist but decided in his twenties to pursue art over music. Like his friend Kandinsky, who "composed" his abstractions as swirling symphonies, Klee approached painting with a musician's eye. But whereas the romantic Russian attempted to paint sound, the mathematical Swiss seemed to aim more at portraying the layered logic of musical scores. While some of his paintings do resemble pages of written notation, many more are organized with an intuited Euclidean structure. Knowing music, art, and mathematics equally well, it was as if Klee remained a musician even while painting and succeeded in inverting music to coax from it the hidden geometry that is its conceptual mirror image.

Klee was highly rational in his spirituality and habitually used the word "crystalline" to describe both his work and himself.[36] He shared with Froebel a taste for the equally crystalline Romanticism of Novalis (1772–1801), and both the pedagogue and painter acknowledged the German poet's paeans to spontaneous creativity and natural artistic instinct.[37] The mélange of essential characteristics embodied in Klee—nature lover, metaphysician, geometer, musician, and artist—are just what one might expect in an astute and sensitive graduate of a good kindergarten.

A native of Bern, Klee began attending the local public primary school in the spring of 1886 and, after four years there, continued on at the municipal Progymnasium.[38] Kindergarten came to Switzerland early and was widely established there before Klee's birth. Bern was not an immediate hotbed like nearby Neuchâtel, which had its first kindergarten in 1862, but was won over to Froebel's ideas soon enough. By the mid-1870s, kindergarten had become a recognized grade in the school system of many of the Swiss cantons. Around the same time, the cantonal administration of Bern began requiring all of its teacher-trainees to attend special classes on the Froebel method at government expense and soon after provided "in-service training for practicing teachers who were given three months' leave every two years" for the same purpose. Most importantly, by 1880 both the Swiss Ministry of Education in Geneva and the Bernese government had officially adopted Froebel's philosophy and principles for use in the public schools for students up to the age of ten.[39] Along with actually financing intensive supplemental coursework for all of their elementary school teachers, the Swiss adapted

126

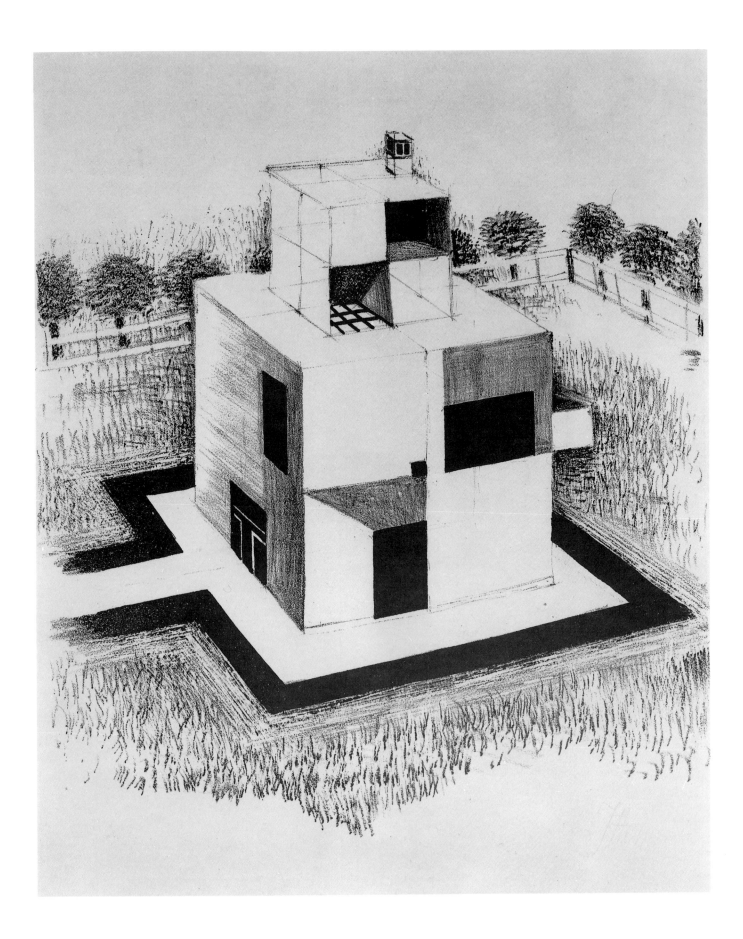

127

Paul Klee. *Suspended Fruit.* Weimar, c. 1921. Watercolor and pencil on textured paper, 9¾ x 6″. The Metropolitan Museum of Art, The Berggruen Klee Collection, 1984

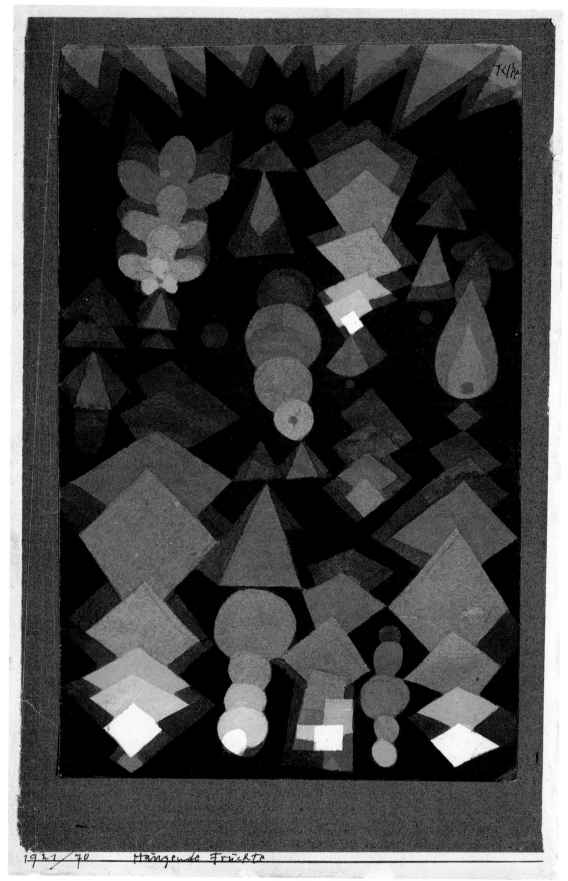

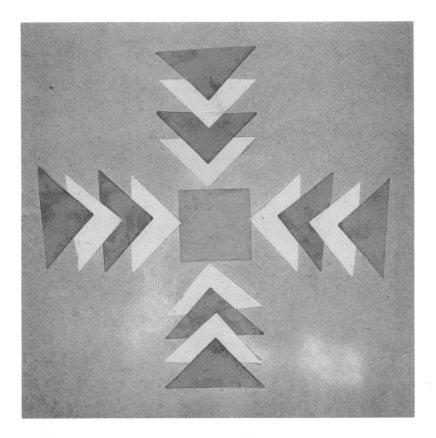

Gladys Eloise Edwards. Beauty form made with the seventh gift (paper parquetry). Willink, New York, 1902

Gladys Edwards was a four-and-a-half-year-old student at the East Aurora High School Kindergarten when her mother (presumably) assembled the endearing scrapbook of letters, drawings, and kindergarten work that includes this original design.

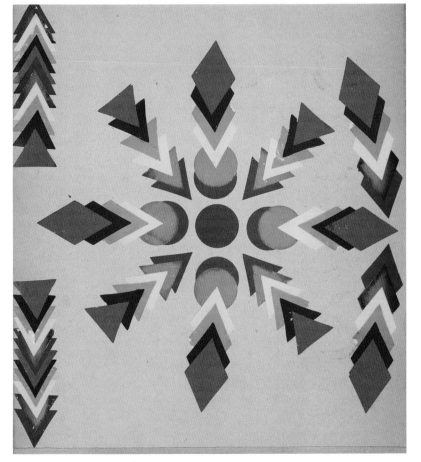

Irma H. Crawford. Beauty form made with the seventh gift (paper parquetry). United States, 1909

Froebel's concepts and manual work for inclusion in standard primary education during the period that Paul Klee spent in public school.

Interaction with colleagues and visitors who espoused the ideas of Russian Constructivism and De Stijl, research into the methods of Froebel, and his own background in Swiss public school resulted in Klee's many "constructive" works made during and after his Bauhaus years.[40] His distinctly Froebelian "Magic Squares," the archetypal, multicolored "chessboards" that were among Klee's only totally non-representational works, first appeared in Weimar and he returned to them at least once a year until his death. If these gridded images relate directly to the paper weaving and parquetry kindergarten gifts, other characteristic Klee works seem to derive from the daily coursework with the linear gifts—sewing, drawing in the net, stick laying, and work with the jointed slats.[41] Ultimately, so many visual and theoretical parallels exist between the paintings of the crystalline Swiss artist and the teachings of the German crystallographer that it seems not unreasonable to call Klee one of Froebel's greatest pupils. Paul Klee loved nature and recognized his place within her grand tapestry. And he understood the relationship between life, science, and beauty to an extent, and with a grace, that few ever attain.

Wassily Kandinsky, who came to the Bauhaus in 1922, was a late bloomer as an artist. Although he had art lessons as a child in Moscow and was given his first oil paints when he was fourteen or fifteen, he only became serious about painting in his thirtieth year after first studying and practicing law. At an 1896 exhibition of French art in Moscow, one of Monet's ethereal haystack paintings greatly impressed him, and soon afterward he turned down a law-school teaching post in favor of two years of study at a private art school in Munich. Beginning around 1900, he painted landscapes and cityscapes of Germany and Russia that recapitulated the styles of recent art movements, ranging through pre-Impressionism, Impressionism, illustration, and Fauvism, and culminating, in 1911, in the high-pitched colors of the *Blaue Reiter*. Entering into the discipline of art somewhat abruptly from that of law, his empathy for the tried-and-true styles of the recent past is no surprise. He may, in fact, have been the first important painter whose development began not in the traditional mastery of academic representation, but in the proto-modernism of late-nineteenth-century France. What is remarkable about the early Kandinsky is the speed in which he discovered in these colorful, and sometimes decorative, views the confident abstraction that marked him as one of the greatest and most original artists of his time.

From the beginning, color was Kandinsky's road map. His earliest memories were tethered to color, and color became the foundation for all his theoretical and practical work. A two-month, backcountry research trip that he undertook in 1889 to study punishment in peasant courts and the pagan beliefs in a traditional Finno-Hungarian tribe left him with a permanent fascination for the brilliant colors of Russian folk art. Memories of those pure hues that he later translated into Jugendstijl-like images of Russian traditional tales became one of the inspirations for his journey into pure painting. In 1904, still

years away from his definitive breakthrough, he penned the first theoretical notes on color that led to his personal manifesto on abstraction's importance for the new age: *Concerning the Spiritual in Art* (1912).

In 1911, acknowledging parallels between his approach to painting and the atonal music of composer Arnold Schoenberg (1874–1951), the musically trained Kandinsky initiated a correspondence between the two that would last for several years. Kandinsky consciously modeled his progression away from realism on music's inherent abstraction: "He [a painter] naturally seeks to apply the methods of music to his own art. And from this results that modern desire for rhythm in painting, for mathematical, abstract construction, for repeated notes of color, for setting color in motion."[42]

Kandinsky's early abstractions may be termed "expressionistic," particularly as it compares to the distinctly "geometric" nature of his paintings after he became a teacher at the Bauhaus. The reasons and timing of the transition from the former to the latter have long been debated, but always inconclusively. The nature of abstraction itself in the work of Kandinsky has also been a matter of art-historical contention for decades, ranging from scholarly theories about Theosophy, Russian folk art, and musical composition, to reflections on the painter's love of hiking in nature and ideas about his reliance on glasses to see properly. With due respect for the many rigorous studies of the life and work of Kandinsky, the present author would like to propose a new approach to the genesis of Kandinsky's abstraction, particularly in its later, geometrically defined incarnation.

When Kandinsky joined his old acquaintance Paul Klee at the Bauhaus, they began a productive friendship that marked a number of their paintings with a kind of geometric parallelism. The highly organized but expressive brushwork that distinguished his first forays into abstraction disappeared from Kandinsky's work shortly after he reached Weimar and rarely reemerged in the precise forms of his later paintings. For regardless of his years back in Russia during the heyday of Constructivism, Kandinsky's adoption of hard-edge geometry largely coalesced at the Bauhaus. Despite the odds against it, Kandinsky's path to this international locus of almost a century of kindergarten culture began exactly where it did for most of the Bauhaus masters: kindergarten.

At the end of 1869, to the surprise of their son's nurse, who felt there were more than enough "broken-down buildings and old stones" to be appreciated right in Moscow, the Kandinsky family traveled south for an extended stay in Italy. From the months, or more likely years, that they remained there, Wassily, who was only three years old when they arrived, retained a small number of surprisingly vivid memories. In a brief autobiographical statement first prepared in 1910, Kandinsky's mention of the massive Bernini colonnade in the forecourt of St. Peter's verified a trip to Rome, while a spooky, nighttime ride on "black water . . . in a black, long boat with a black box in the center"[43] confirmed a journey to Venice. The only other recollection of Italy that Kandinsky deemed important enough to include was of crossing over a bridge in Florence in a carriage with his mother, and then, upon reaching their

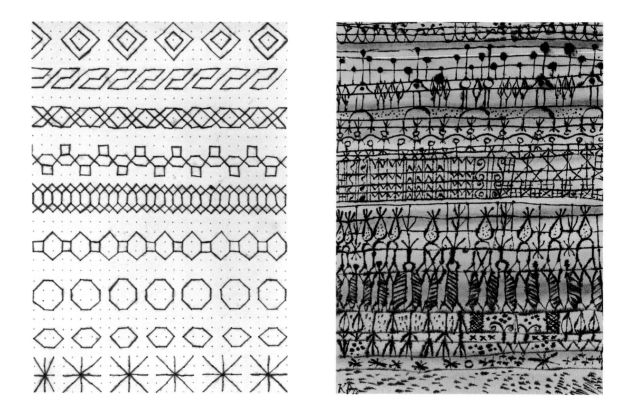

destination, of entering a kindergarten. By the end of 1871, if the generally recognized chronology of Kandinsky's youth is correct, the family had returned from the Mediterranean to Moscow, and subsequently, for the sake of his father's health, resettled in Odessa on the Black Sea.

Thus, fate decreed that Kandinsky would be among the earliest initiates into the symbolic geometry of kindergarten. In light of his position in the development of twentieth-century art and as teacher at the Bauhaus, the coincidental intersection—at life's most impressionable age—of the future abstract painter with child-sized *models* of the forms that would later reemerge as the very building blocks of his mature paintings commands attention.

The kindergarten movement blossomed in Italy in 1868, and Florence was immediately well supplied with the new experimental classes.[44] Kandinsky's parents, well-heeled and German-speaking, liberal and artistically curious, were the kind of people who had supported Froebel's work, and the likelihood of his having been left in a traditional Italian *asilo,* which mingled orphans, the poor, and the children of the working class, is improbable. Incapable of communicating in Italian, the young Kandinsky's experience of kindergarten would have been essentially nonverbal and, by necessity, almost entirely visual and tactile. Kandinsky's memory was admittedly almost entirely eidetic, that is, the success of his recollections hinged upon their "photographic" association with a scene or even a color.[45] Thrust into intimate, daily contact with the clear geometries of Froebel's system at the age of four and isolated from the other *ragazzi del giardino* by language, Kandinsky almost certainly assimilated a mental storehouse of forms that emerged in his painting when he joined the staff of the Bauhaus.[46]

It would not be entirely farfetched to speculate about Kandinsky's abstraction stemming, at least partly, from the lessons of pictorial disintegration he received as a child in a Florentine kindergarten. It is clear that while he developed as an artist, the actual forms of nature in his paintings receded in importance and were replaced by simplified suggestions of their former selves, a process that recapitulates in reverse kindergarten's curriculum.

That Kandinsky's work ultimately coalesced into compositions of discrete forms should come as no surprise considering geometry's prototypical importance both to philosophy and psychology. Eccentrically balanced fields of swirling, interpenetrating color may be viewed as an embryonic state of

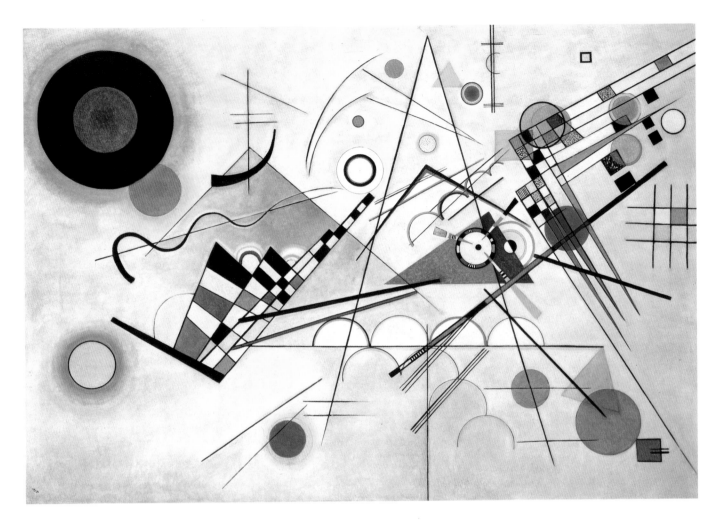

actual reality but do not compare in utter simplicity to a yellow triangle. Plato's forms became Kandinsky's forms because they were a further refinement of the visual discourse in which he was already engaged. Evidence also suggests that geometry is a natural response from people who, for artistic, cultural, or medical reasons, step away from observable reality to dwell more directly in the realm of what Kandinsky called "internal truth."[47] Having started down the path toward pure abstraction, he brilliantly utilized all the tools with which he might achieve his goal of revealing "the spiritual in art."

When he felt the need to simplify his work, that is, substitute universal geometry for what had previously been infused with too much "personality," Kandinsky had a ready reference imbedded deep within him. The arcs, lines, triangles, squares, and grids that constituted his canvases after 1922 when he arrived at the Bauhaus first appeared indistinctly in his paintings from the late teens when he last lived in Russia. For this reason scholars have speculated about the possibility of his having been influenced toward geometry by the work of Kasimir Malevich. Recent scholarship not only contradicts this notion but suggests that the reverse might even be true—that after reading a translation of *Concerning the Spiritual in Art,* Malevich quickly hit upon the direction for his Suprematism.[48]

When Kandinsky arrived at the Bauhaus, the artistic nexus for Froebel's theoretical and stylistic descendants, his work changed forever. In Weimar, the animated crescendos of color that had rent the fabric of Western art by rejecting the portrayal of observable reality in favor of intuited emotional harmony were permanently transformed into eccentrically balanced assemblages of distinct geometric forms. Like the pedagogical tools of his new colleague Joseph Itten, the childlike forms of his old friend Paul Klee, and the primary creations of the narrowly focused basic course, Kandinsky's paintings returned to their roots.

Wassily Kandinsky. *Composition 8.* Weimar, 1923. Oil on canvas, 55⅛ x 79⅛″. The Solomon R. Guggenheim Foundation, New York

6 ARCHITECTURE

"The ultimate aim of all visual arts is the complete Building."[1]

GEOMETRY AS TRUTH **A**rchitecture was the "bull's-eye" of the Bauhaus curriculum, and all the related arts and crafts surrounded and served it as subjects to a king. Because it straddles an intersection of the environment, mathematics, and aesthetics (or nature, knowledge, and beauty), and is the sum of all the plastic arts, architecture, particularly after 1900 (and half a century of kindergarten) ought to have displayed evidence of the impact of Froebel's unified training in any number of ways.

Modern architecture was made possible by a series of revolutionary advances in construction technology, particularly structural building framing (first of iron and later steel) that eliminated the required load-bearing capacity of traditional walls and led inexorably to the towering "curtain wall" buildings that now constitute the downtowns of every large city. Glass, previously used solely for windows, was now available as walls. Reinforced concrete, which can be cast into large, monolithic forms of any shape, expanded the vocabulary of both architecture and engineering, making possible bridges, dams, and building cantilevers that were impractical or inconceivable with the unit construction of traditional masonry. And electric power and elevators, perfected simultaneously with these structural breakthroughs, ushered in skyscrapers and the environmental controls they required, as the internal-combustion engine and the automobile began to redefine cities and concepts of urbanity that were first formulated in the Middle Ages.

The manner in which these inventions were deployed, however, is part of the history of ideas. Whether they came from the intellectual wing of the

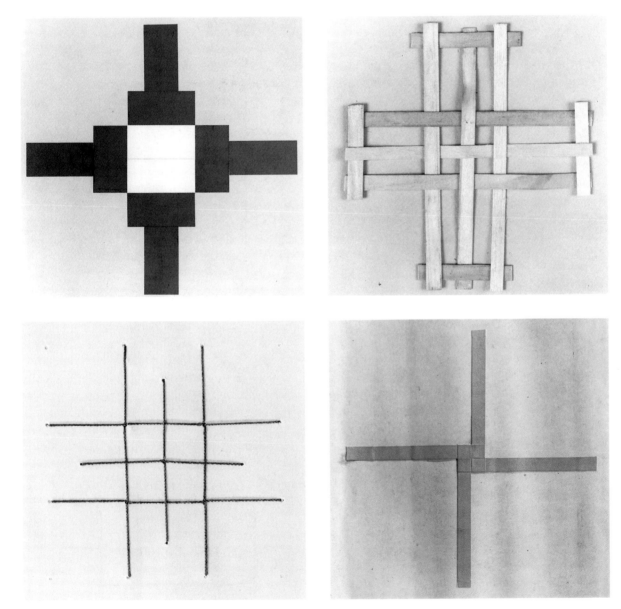

Top left:
Unknown kindergartner. Beauty form made with paper parquetry. United States, c. 1895

Top right:
Rose A. Craigan. Beauty form made with slatwork. United States, c. 1910

Bottom left:
Helen Howard Whitman. Beauty form made with sewing. New Britain (Connecticut) Normal School, c. 1900

Bottom right:
Jessie Georgina Barker. Beauty form made with paper lacing. United States, c. 1895

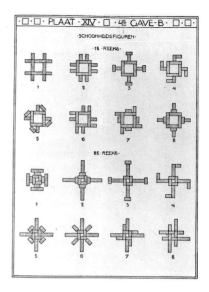

Cruciform and pinwheeling beauty forms for the fourth gift. Plate XIV, *De Kindertuin* by Joha. Wierts Van Coehoorn-Stout, Amsterdam, 1904

French Academy or were raised on the pared-down aesthetics of English Arts and Crafts or the German Werkbund, the proto-moderns reacted against the backward-looking, Romantic tradition of the nineteenth century that had its final flourish in the tendrils of Art Nouveau and began to shift their vision from historical precedent to intellectual order. The "modern" in modern architecture owed a major debt to new concepts of spatial organization and avant-garde design strategies that were touted as Rationalist, Functionalist, or Elementarist in their conscious expression of structure and abandonment of ornament, an intellectual tradition that traced its roots to the subversion of Baroque synthetic space by eighteenth-century visionaries like Giovanni Battista Piranesi (1720–1778) and Claude-Nicolas Ledoux (1736–1806). French academics in particular reinvigorated Cartesian rationality by emphasizing clarity of structural and spatial expression. In a basic, almost primary, pedagogical reorientation, Rationalist theorists like Auguste Choisy (1841–1909) began to argue at the turn of the century that architectural form is a logical consequence of construction techniques. To such thinkers, glass walls, exposed structures, functionally based asymmetrical plans, and the rejection of unnecessary ornament required new concepts of design, and the age-old reliance on geometry as truth gained in renewed importance.

But while the pioneer modernists proudly wore their anti-traditional theories on their sleeves, their new architecture, which certainly generated buildings unlike any previously known, was hardly the simple embodiment of "truth to materials" or "form following function" that its boosters sometimes claimed. With technological tools of recent sophistication but no tradition for their employment, much of what developed into modern architecture was thus supplied by architects' involvement with the theories and practitioners of the allied discipline of abstract art. The triumph of Cubism and geometric abstraction came just as architects were searching for new modes of expression. Their simultaneous adoption by architecture, which was recently untethered from classical models and possessed a grab bag of nifty new technologies, was assured. Kindergarten, which had become an important ingredient in art, was thus implanted into the architecture equation not only by the architects themselves (every one of whom was born during the system's heyday), but via contemporary art as well. Architecture was not, generally speaking, an influence on art, but Cubism, Futurism, and Neo-Plasticism found their way into architecture, and all brought kindergarten along for the ride.

Even more direct connections can be drawn, however, between kindergarten and the profound shift in architectural expression that occurred in the early twentieth century. If, as a kind of case study, we look at the work and writings of the two architects conventionally thought to be the century's greatest, Frank Lloyd Wright and Le Corbusier, we can find suggestive evidence pointing to a fact that has been confirmed by their biographies: both were children of the original kindergarten.

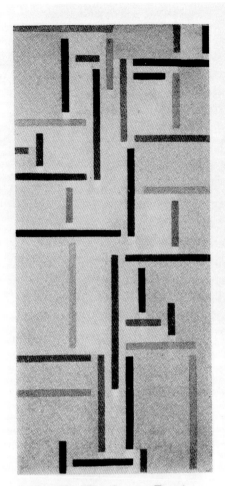

162 (52) **Doesburg: Russian dance, 1918** (*not in exhibition*); *cf.* Picasso, fig. 27

163 (305) **Miës van der Rohe: Project for a brick country house, plan, 1922**

In 1936 Alfred Barr traced the influence of Cubism on German architecture via the Neo-Plasticism of Mondrian and van Doesburg. Kindergarten, a primary influence on most of the protagonists of these movements, was not part of the equation. Page 157 from *Cubism and Abstract Art* by Alfred Barr, New York, 1936.

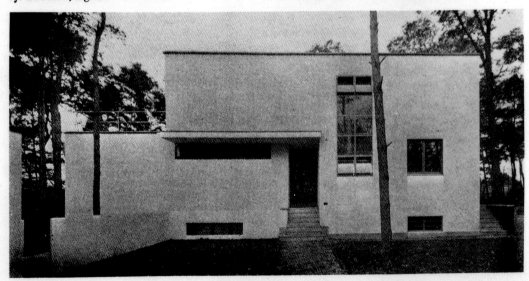

164 (290) **Gropius: Professor's house, Dessau, 1925-26;** *cf.* Doesburg, fig. 144, *lower right*

All is unity, all springs from unity, strives for and
leads up to unity, and returns to unity at last.
—Froebel, 1827[2]

UNITY was their watchword, the sign and symbol
that thrilled them, the UNITY of all things.
—Wright, 1932[3]

FRANK LLOYD WRIGHT

Friedrich Froebel died in Germany fifteen years before Frank Lloyd Wright (1867–1959) was born in Wisconsin. Comments by the nineteenth-century crystallographer-turned-educator and the twentieth-century architect-turned-design-deity echo one another harmoniously because, as Wright always claimed and historians have sometimes grudgingly acknowledged, Froebel invented a system and Wright made it his own. In 1900, before the Larkin Building (Buffalo, 1904–5), Unity Temple (Oak Park, Illinois, 1905–7), and his Prairie Houses had garnered him his first fame, the influence of kindergarten on Wright was already discussed in the architectural press.[8] Wright himself placed great emphasis on his kindergarten experiences, alluding to them frequently in his Taliesin lectures.[9]

Mother learned that Frederick Froebel taught that children should not be allowed to draw from casual appearances of Nature until they had first mastered the basic forms lying hidden behind appearances. Cosmic, geometric elements were what should first be made visible to the child-mind.

Taken East at the age of three to my father's pastorate near Boston, for several years I sat at the little kindergarten table-top ruled by lines about four inches apart each way making four-inch squares; and among other things, played upon these "unit-lines" with the square (cube), the circle (sphere) and the triangle (tetrahedron or tripod)—these were smooth maple-wood blocks. Scarlet cardboard triangle (60°–30°) two inches on the short side, and one side white, were smooth triangular sections with which to come by pattern—design—by my own imagination. Eventually I was to construct designs in other mediums. But the smooth cardboard triangles and maple-wood blocks were most important. All are in my fingers to this day.

Also German papers, glazed and matte, beautiful soft color qualities, were another one of the "gifts"—cut into sheets about twelve inches each way, these squares were slitted to be woven into gay colorful checkerings as fancy might dictate. Thus color sense awakened. There were also ingenious "constructions" to be made with straight, slender, pointed sticks like toothpicks or jack-straws, dried peas for the joinings, etc., etc. The virtue of all this lay in the awakening of the child-mind to rhythmic structure in Nature—giving the child a sense of innate cause-and-effect otherwise far beyond child-comprehension. I soon became susceptible to constructive pattern *evolving in everything I saw.* I learned to "see" this way and when I did, I did not care to draw casual incidentals of Nature. I wanted to *design.*[10]

The stones in my hand and under my eyes turned to living, speaking forms.

—Froebel, 1827[4]

The smooth shapely maple blocks with which to build, the sense of which never afterward leaves the fingers: so form became feeling.

—Wright, 1932[5]

In his autobiography, published in 1932, more than fifty years after the event, Wright remarked that his mother discovered the gifts for the first time at the Centennial Exposition in Philadelphia in 1876, but it is more likely that her associations brought her into the kindergarten orbit much earlier.[11] A carriage ride of an hour or less from Anna Lloyd Jones's girlhood home in Spring Green, Wisconsin, would have deposited her on the doorstep of the first kindergarten in America, founded in 1856 in Watertown, Wisconsin, by Margarethe Schurz. While the Welsh Lloyd Jones family and the German Schurzes may have had little reason to expand beyond their respective immigrant communities, the proximity of the progressive Unitarian forebears of Wright and the American landfall of Froebel's philosophy lends credence to speculation that Anna, the eldest of three sisters who all became teachers, knew about kindergarten even before the birth of her son.

The Wright family moved in 1870 when Frank was three to Weymouth, a suburb of Boston, one of America's few active kindergarten centers. At some point in the 1870s, Anna Wright commuted from Weymouth to Boston to take a kindergarten training course so that she could teach her children at home. In 1860, Elizabeth Peabody had opened America's first English-speaking kindergarten at 15 Pinckney Street in Boston after meeting Margarethe Schurz's clever little son in Roxbury, Massachusetts (where they had recently relocated from Wisconsin). In September 1868, Von Marenholtz pupils Matilda and Alma Kriege took charge of the kindergarten and teacher-training school, relocating it to 52 Chestnut Street. One of Matilda's kindergartners, Mary J. Garland, took over the Chestnut Street school with her assistant Rebecca J. Weston when the Krieges returned to Germany in 1872. After 1874, the Krieges returned to Boston and started a new school that existed concurrently with the one they had left in their former students' hands. At either school, Anna Wright would have received a thorough grounding in Froebel's ideas and the use of the gifts and occupations, which had recently been codified for an American audience by Edward Wiebé in his popular *Paradise of Childhood* of 1869.

Ruth Burritt, the woman who supposedly introduced Anna Wright to the system in Philadelphia, started her teaching career in Wisconsin before chancing upon a kindergarten in the Appleton (Wisconsin) Collegiate Institute in 1872; training with Anna Ogden in Worthington, Ohio, and then with Garland in Boston, Burritt was living and teaching in Boston in 1874–76 when she was chosen by the city's Froebel Society to run the Centennial Exposition's Kindergarten Cottage in Fairmount Park.[12] The strong probability that Anna Wright and Ruth Burritt were acquaintances or even friends years before 1876 is the likeliest explanation for the connection of kindergarten and the fair in the memory of Frank Lloyd Wright.

Wright recalled sitting "at the little kindergarten table" for "several years." Even though Froebel recommended that his training extend into the primary grades, is it really likely that Wright worked at the gridded table (which, having been designed for the very young, was very low—only twenty-one

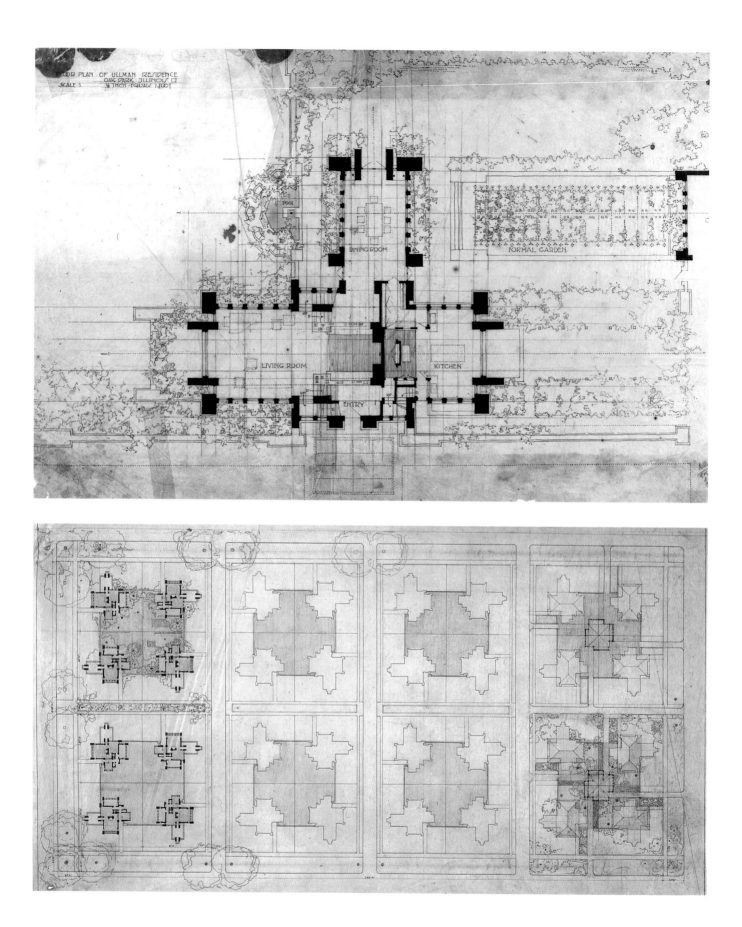

FLOOR PLAN OF ULLMAN RESIDENCE
OAK PARK ILLINOIS
SCALE ⅛ INCH EQUALS 1 FOOT

POOL

DINING ROOM

FORMAL GARDEN

LIVING ROOM

KITCHEN

ENTRY

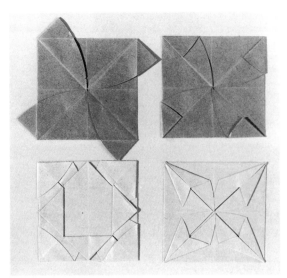

Left:
Unidentified kindergartner. Beauty forms made with the eighteenth gift (paper folding). United States, c. 1880

Below:
Frank Lloyd Wright. Price Tower—typical floor plan. 1952. Ink, 35½ x 36″. © 1996 The Frank Lloyd Wright Foundation

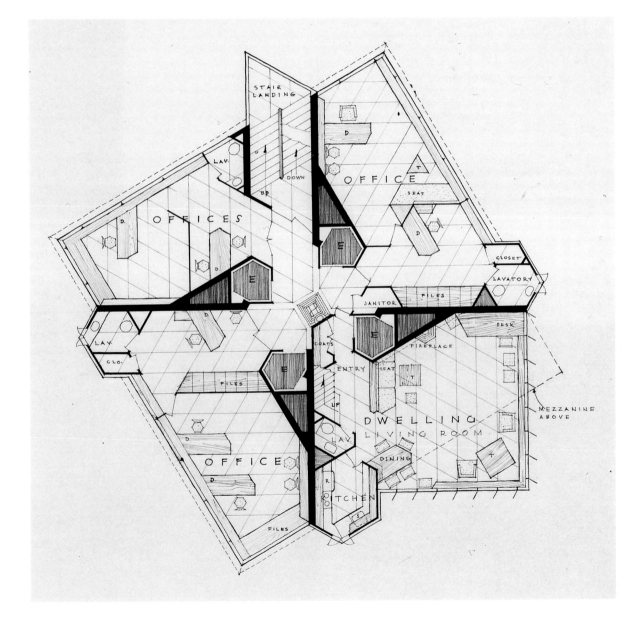

Opposite top:
Frank Lloyd Wright. H. J. Ullman residence—plan. 1904. Ink, 18 x 28⅜″. © 1996 The Frank Lloyd Wright Foundation

Wright utilized many different square and rectangular grids, often combining several on the same plan.

Opposite bottom:
Frank Lloyd Wright. Roberts Quad Housing—plan of block development. c. 1903. Ink, 15 x 27″. © 1996 The Frank Lloyd Wright Foundation

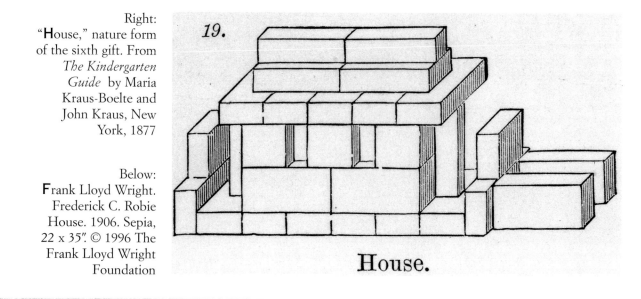

19.

House.

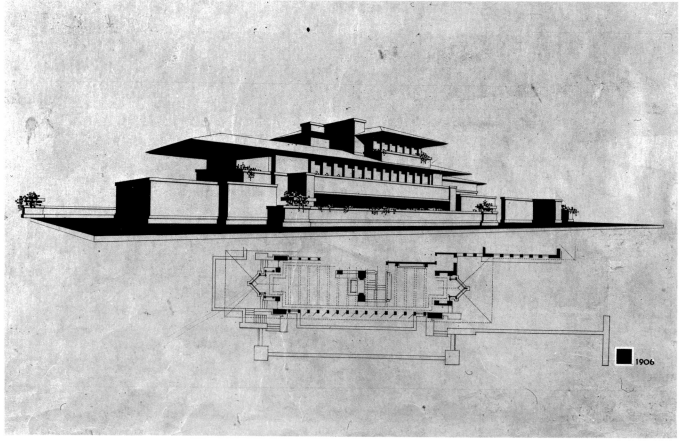

1906

Left:
"Bath," nature form of the sixth gift. From *The Kindergarten Guide* by Maria Kraus-Boelte and John Kraus, New York, 1877

Below:
Frank Lloyd Wright. Larkin Company Administration Building. 1902. Sepia, 14 x 12". © 1996 The Frank Lloyd Wright Foundation

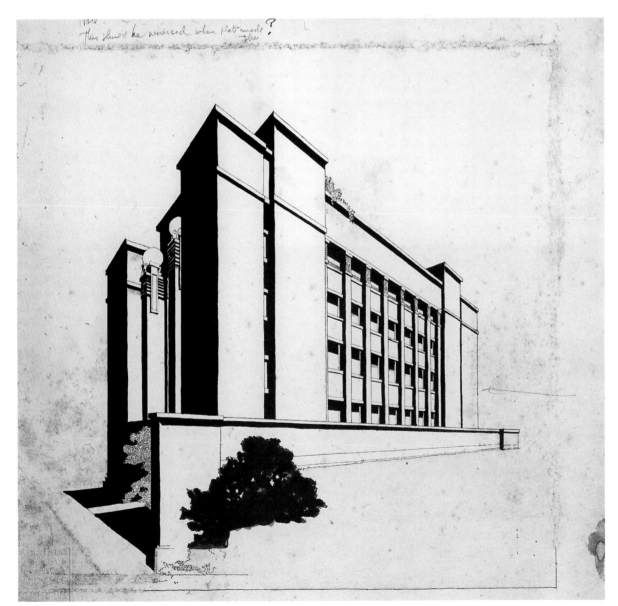

Right:
Katherine R. Torrey.
Beauty form made
with the seventh gift
(paper parquetry).
United States, c. 1890

Below:
Frank Lloyd Wright.
Beth Shalom
Synagogue—main
floor plan. c. 1953.
Colored pencil,
32 x 36". © 1996 The
Frank Lloyd Wright
Foundation

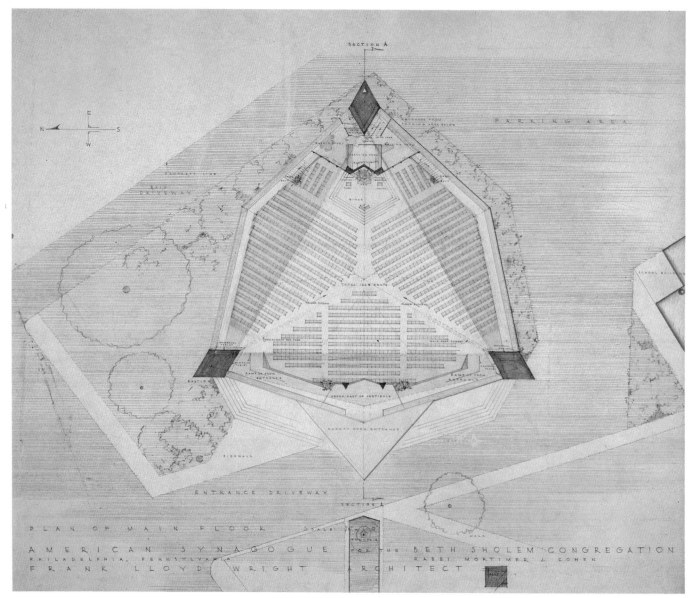

I can still see my hazel buds, like angels, opening for me the great God's temple of Nature. I now had what I needed: to the Church life was added the Nature-Temple; to the religious life, the life of Nature.

—Froebel, 1827[6]

Encouraged by my early training at the kindergarten table and subsequent work on the farm in the valley, I came to feel that in the nature of Nature—if from within outward—I would come upon nothing not sacred. Nature had become my Bible.

—Wright, 1957[7]

inches high) past his tenth birthday? Is it not more plausible that Anna Wright began training her son years earlier and that his memories of her visit to the Centennial Exposition became intertwined with the ongoing experience because his mother excitedly returned to Weymouth with fresh materials or heady with the knowledge that the system was so well represented at the fair?[13]

What did kindergarten mean to Frank Lloyd Wright?[14] It would be wrong to conclude that because Wright never mentioned Froebel's advanced mathematical or philosophical concepts, his fundamental approach to design was not shaped by his experience in kindergarten. Kindergarten was play, and a good kindergartner made certain her little sprouts never thought otherwise—the theoretical underpinnings of the education were kept from children just as they are in any classroom situation. Wright remembered the activities of kindergarten rather than its pedagogy because he absorbed them so effortlessly. More than any of his influential contemporaries in the arts, Wright was a child of Froebel's kindergarten, and while he may still have gone on to become an architect without it, he would certainly never have developed into the one we know.

The measure of kindergarten's influence on Wright can be taken by comparing his own approach to design with that of his "Lieber Meister," Louis Sullivan (1856–1924). Wright worked for Sullivan for five years and considered the training he received from the great skyscraper designer as intrinsic to his development. Sullivan, whose *Kindergarten Chats* of 1901 actually had nothing to do with kindergarten except inasmuch as "the ideas underlying the work are simple and elementary,"[15] is famous both for the vertical aesthetic that he developed for the skyscraper and the lushly organic terra-cotta ornament he created for that purpose. Sullivan never went to kindergarten, but to some extent his approach to design and Froebel's were complementary. In 1918, while Sullivan was working on his last project, the Farmers and Merchants Union Bank in Columbus, Wisconsin, the wife of the bank's president, Mrs. J. R. Wheeler, who was then studying at the Chicago Kindergarten Training School, recognized the similarities in their views. In one telling incident, Mrs. Wheeler apologized to Sullivan for not being capable of fully understanding his design philosophy. To set her at ease, he responded in Froebelian fashion, "I am a gardener. I recognize good ground."[16]

Whatever ideas they shared, however, the eleven years in age that separated Wright and Sullivan marked a generation gap. Sullivan's thickly draped, terra-cotta facades expanded upon the twenty-five-hundred-year-old classical tradition that typically reserved plant forms for key architectural junctures, like the acanthus leaves on Corinthian capitals. Wright, while a student of Sullivan's, was much more definitively a student of Froebel's, and like him came to understand through the gifts that everything in nature is reducible to its primary atomic units. He learned to recognize the "building blocks" at the heart of all natural systems and the logical way in which they were related, so that, while formulating his concept of "Organic Architecture"—the harmonious integration of forms and forces resolved to

145

unity—geometry, the ancients' and Froebel's choice as the ideal system to represent these "atoms," became Wright's as well. If the decorative panels of Wright's early houses mimicked Sullivan's intertwining plant and sea forms, they soon crystallized into the geometric designs that he used for the rest of his life, and his architecture possesses a unity of conception, from point (ornament), to line (plan), to plane (elevation), to volume (space), that betrays more than a passing knowledge of the forms of nature, knowledge, and beauty.

It is haunting to imagine the young Wright, seated at a kindergarten table in Boston in the 1870s, using the gifts to build miniature structures that possessed the earmarks of his mature work to come: structures that were grid-based, rotationally derived, and generated by the systematic juxtaposition of simple triangular and orthogonal units on a modular field.

LE CORBUSIER

Architecture is the masterly, correct and magnificent play of masses brought together in light. Our eyes are made to see forms in light; light and shade reveal these forms; cubes, cones, spheres, cylinders, or pyramids are the great primary forms which light reveals to advantage; the image of these is distinct and tangible within us and without ambiguity. It is for that reason that these are *beautiful forms, the most beautiful forms.* Everybody is agreed as to that, the child, the savage and the metaphysician. It is of the very nature of the plastic arts.

—Le Corbusier, 1923[17]

Not in pursuit of an architectural idea, but simply guided by the results of calculation (derived from the principles which govern our universe) and the conception of A LIVING ORGANISM, the Engineers of today make use of the primary elements and, by co-ordinating them in accordance with the rules, provoke in us architectural emotions and thus make the work of man ring in unison with universal order.

—Le Corbusier, 1923[18]

Charles-Édouard Jeanneret (1887-1965) was born at La Chaux-de-Fonds in the French-speaking canton of Neuchâtel, Switzerland. He was thus twenty years younger than Frank Lloyd Wright and most of his important work dates from after World War I, by which time Wright's "first golden age" had already passed.[19] As Le Corbusier, the pseudonym he adopted in 1920, Jeanneret is remembered for an encompassing and peripatetic career in architecture, art, theory, and city planning, and for the design of many of the twentieth century's iconic buildings. Except perhaps for Mies van der Rohe, whose refined aesthetic was too easily parodied into the bland glass boxes that plague the modern city, the built

work (and voluminous published writings) of Le Corbusier has had more direct influence on the created environment in this century than that of any other figure.

Le Corbusier became one of the twentieth century's greatest architects, yet his training was distinctly atypical inasmuch as he never went to an architecture school. Until recently, all that was known of his education was that his father, a second-generation watch-face enameler in a town whose economy rose and fell with the watchmaking industry, enrolled young Édouard in the La Chaux-de-Fonds *école d'art,* the school of applied arts, in 1902 to be trained as a watchcase engraver. Three years later, Charles L'Eplattenier, Jeanneret's teacher of design and decorative composition, concluded that the boy, who was in any case too poorly sighted to continue on in the exacting field of watchmaking, would be better off turning his attention to architecture. In the same school, which lacked practical courses (such as physics, statics, or structures) and was thus ill-equipped for educating architects, the eighteen-year-old refocused his attention from the decoration of watches to the decoration of buildings.

Under the tutelage of the idealist L'Eplattenier, who discovered in the forms of nature the basis for every important historical architectural style, Jeanneret was trained to seek design inspiration in the trees and stones of the Jura region of western Switzerland. L'Eplattenier directed his students to develop simplified interpretations of alpine plant and mineral forms in their work and was fascinated by the possibility of creating localized styles that could represent, symbolically more than empirically, the distinctive environment of any particular region.[20]

Jeanneret spent the years 1907–11 traveling and sketching throughout Europe, continuing his "schooling," which was entirely divorced from traditional academic concerns. He returned to La Chaux-de-Fonds at the end of 1911 to begin seriously in his chosen career, but only after years of wide-eyed exploration and at least one critical architectural experience—his well-known visit to the Carthusian monastery in Galluzzo, on the Ema River near Florence.

Le Corbusier acknowledged the influence of the *"chartreuse d'Ema"* throughout his life, and its square ring of monk's residences, each with a small garden and all surrounding a central cloister, resurfaced in many different guises in his later work, culminating in Ste. Marie-de-la Tourette (Eveux-sur-l'Arbresle, 1957–60), his own design for a rectangular monastery. The concept of stacking and/or interlocking self-contained houses, or "machines for living in," as he wrote in 1921, was a direct result of his early exposure to the Italian monastery, and the way its discrete units were treated—as giant, multiform building blocks—profoundly affected his career at all levels.[21] The independent home, including double-height living room and walled garden, that he displayed as the Esprit Nouveau Pavilion (Exposition des Arts Décoratifs et Industriels, Paris, 1925) had made its first appearance ganged in his multistoried Immeubles-villas project of 1922 and was still on his mind in 1947 when he designed the Unité d'Habitation in Marseilles. He was as much a carver of space as a linker of spaces, yet the snaking

Right:
Le Corbusier. Block
plans for attached
housing. Plate VR 1,
La Ville radieuse,
Paris, 1935

Below:
Euphenia Feir. Beauty
form made with the
twelfth gift (sewing).
Cobourg, Ontario,
c. 1895

chains of clustered housing and isolated, but regularly distributed, towers in his many city-planning projects often appeared as if they were selected from a kit of ideal parts and then arrayed in strict patterns on a giant, tightly controlled chessboard.

Jeanneret began in architecture as a devotee of the medieval and spent part of 1909 writing on the historical growth of cities, but nothing in his study of Camillo Sitte's analyses of ancient town squares, which credited their plans to the concretization of traditional cart tracks and pedestrian ways, hinted at the stylistic transformation through which he was about to pass. Within a few years, he rejected all ornament that might interfere with the geometric purity of his designs, settled on white stucco as architecture's most appropriate facing material (visually at least, since his adoption of jointless skins for northern Europe led to inevitable cracking problems), and repudiated Sitte's concept of the organic growth of cities in favor of his own orthogonally ordered designs.

Although he managed to meet some of Europe's most important modern architects, including Josef Hoffmann (1870–1956), Tony Garnier (1869–1948), Auguste Perret (1874–1954), and Peter Behrens (1868–1940), nothing specific in their work clearly presaged the geometric coherence of Le Corbusier's extensive oeuvre. Working for Perret sensitized him to concrete, or, at least, its smooth, planar look, as the flat walls of Le Corbusier's first important villas were not cast, but built up of old-fashioned brick hidden by stucco. Like the earlier Italian Futurists he glorified the machine, and his relation of cars and planes to buildings in his influential book *Vers une architecture* (1923) might have been in response to Behrens, who designed everything from fans and lamps to the hangerlike Turbinenfabrik building (1908–9) for the German utility AEG. The Behrens office may also have first exposed the young Le Corbusier to a far more important influence—the use of *tracé regulateur*, or regulating lines, to "tune" his work. These simple mathematical scales for creating proportionally coherent rhythms in the design of buildings, or composition of paintings, were adopted as critical tools by Le Corbusier; his use of them approached obsession during the years he spent perfecting the Modulor (1942–48), his proportional system based on the average dimensions of human beings and the golden section.

Even in his earliest projects, historical precedent meant little to Le Corbusier, and his repudiation of "style" led to the modern style he largely invented. More a product of experience than academia, he nevertheless embodied academic concerns like classical symmetry and order in much of his work. He was a functionalist in his many prototypical schemes for efficient living, but in his architecture, elegance of proportion often took precedence over his intention to satisfy basic human desires and sometimes interfered with the quality of life he hoped to provide. In a career of extreme diversity that included designs for single houses and giant apartment blocks, churches, world's fair pavilions, government offices, and entire cities, one of the few things that tied all of his disparate ideas together was his life-long reliance on geometry:

149

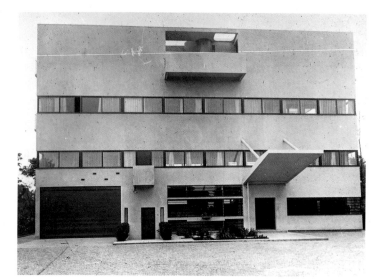

Above left:
Le Corbusier. Villa
Stein. Garches,
France, 1927

Above right:
Le Corbusier. Villa
Stein—elevation.
c. 1927. Ink.
Fondation Le
Corbusier

One feels very clearly that the precision required of any act that arouses a superior quality of emotion is based on mathematics. The Result can be expressed by the single word *harmony*. Harmony is the happy coexistence of things; coexistence implies duality or multiplicity and consequently calls for proportions and consonances. What sort of consonances? Those existing between ourselves and our environment, between the spirit of man and the spirit of things, between mathematics as a human invention and mathematics as the secret of the universe.[22]

This fixation on geometry as a language that unites the works of nature and the works of man will be familiar to readers of this book, but it was not until historian Marc Solitaire published a paper in 1993 that the architectural world was to discover what Solitaire had astutely suspected.[23] Kindergarten first came to La-Chaux-de-Fonds in 1878, and got a tremendous boost from an academic decree of 1889 requiring the implementation of the system cantonwide. Coincident with the new regulation was the founding of a state-mandated Neuchâtel Frobelian Normal School and the immediate enrollment of seventy previously trained teachers for instruction in Froebel's methods. On September 1, 1891, even before his fourth birthday, Charles-Édouard Jeanneret began his studies in the *école particulaire* of La Chaux-de-Fonds run by one of the new college's first graduates, Louise Colin. After three years in this private kindergarten, Jeanneret took the equivalency examinations that allowed him to enter the public primary school, which was also structured along Froebelian lines. All told, before his entry into the *école d'art,* the future Le Corbusier spent almost ten years in programs based solidly on Froebel's techniques, and during the very period when Froebelianism in his hometown was the purest and most rigorous it would ever be.

In 1911, Charles-Édouard Jeanneret, aged twenty-four, described the Parthenon as "a sovereign cube facing the sea."[24] In 1959, aged seventy-two, Le Corbusier wrote a *Poème de l'angle droit* (Poem to the Right Angle). His kindergarten training, reinforced by his years with L'Eplattenier, blossomed in controlled diversity. Le Corbusier had little patience with architecture schools and directed those who sought to learn the discipline to visit natural-history museums and compare classes of seashells, or walk through forests to draw leaves and trees, or prowl beaches to observe spreading waves and the formations of clouds. His own work tended toward the orthogonal, yet he would cleave his perfect rectangles with eccentric curves as necessary to fulfill programmatic requirements and at will to enhance their spatial poetry. He created the Modulor not because he wanted to shoehorn people into unforgiving geometric grids but because he hoped to link the patterns of human design to the Music of the Spheres. Froebel's creative approach to geometry was explicit in all of Le Corbusier's buildings, but it was Froebel's philosophy that was the most important thing Charles-Édouard Jeanneret learned in kindergarten.

Left:
Le Corbusier.
Villa Stein—elevation.
c. 1927. Ink.
Fondation
Le Corbusier

Below:
Mildred Smith.
Nature form made
with the twelfth gift
(sewing). United
States, c. 1890

151

UNITY AND HARMONY

Wright was already known in Europe by 1901, when he was visited by the English architect C. R. Ashbee, but discussions in Chicago with German philosopher Kuno Francke, who was lecturing locally in 1908, led to his early fame there. On Francke's recommendation, the elaborate and expensive *Ausgeführte Bauten,* the so-called Wasmuth portfolio, with its elegant Japanese-inspired prints of the Larkin Building, Unity Temple, several important Prairie Houses, and unbuilt projects, was published in Berlin in 1910. Ernst Wasmuth's cheaper and more compact second edition of 1914, with an introduction by Ashbee that included many quotes from Wright's own *In the Cause of Architecture,* achieved much wider distribution than the deluxe original, and its influence, particularly in Holland, was profound. The copy Robert van't Hoff received as a gift from his father induced him to travel to the United States in 1914, when he visited with Wright and viewed his Oak Park work and the Larkin Building in Buffalo.[25] Although the second edition included photographs of some of Wright's buildings, the starkly geometric aspect of the drawings in both folios tended to abstract his rectangular forms into large-scale versions of the kindergarten gifts that inspired them. Published in Europe after the birth of Cubism but before a definitive Dutch response to it, the Wasmuth pictures thus served to reintroduce Froebel's geometries into the zeitgeist just before Mondrian and the philosopher Schoenmaekers defined an almost identical impulse as Neo-Plasticism. Mondrian's work had already begun to coalesce into the grid when Van't Hoff returned to Holland with extensive graphic documentation on Wright's architecture, and when the group formed in 1917, the prints and photos served to reinforce the members' fascination with "the centrifugal spatiality that was to become the touchstone of De Stijl."[26] Years later, when Van Doesburg moved to the Itten-dominated Weimar Bauhaus, another dose of kindergarten, via American architecture, Dutch architecture, and Dutch painting, returned like a cultural boomerang to within a few miles of Froebel's home.

When Henry-Russell Hitchcock and Philip Johnson subjectively defined the International Style in their 1932 Museum of Modern Art show, "Modern Architecture: International Exhibition," they made no attempt to conceal their loyalties as to the relative merits of the work of Wright and Le Corbusier. Wright was included in the exhibit, but is referred to in the catalog as a "half modern," whose importance to the new architecture was mostly as a crucial, but no longer significant, "artistic ancestor."[27] At age sixty-five, with few commissions due to the Depression and at a point when his second major creative period was about over, Wright was stung by this neglectful treatment at the hands of the architectural avant-garde and publicly criticized the International Style and its hero Le Corbusier. Fallingwater (Mill Run, Pennsylvania, 1935–39) was designed and built in the years following the New York exhibit and, while Wright never admitted it, was almost certainly an attempt to "out-modern" Le Corbusier and the rest of the International Style propagandists he had come to loathe. Harnessing his creative powers

This page and opposite: **T**he *garderie d'enfants* (nursery school) on the roof of Le Corbusier's Unité d'Habitation (Marseilles, 1947–52), a single apartment block containing shops and other community services

with a vengeance, it became Wright's most famous building and the one that was largely responsible for launching his "third golden age." Le Corbusier, for his part, claimed never to have seen any of Wright's work and, from 1932 on, after the completion of his first tentatively "Cartesian Skyscrapers," the Pavillon Suisse (Cité Universitaire, Paris, 1930–32) and the Cité de Réfuge (Paris, 1932–33), both in Paris, spent much of his time until after World War II designing speculative projects and theorizing about the organized planning of cities.

In their respective careers after the war, both Wright and Le Corbusier relied more than ever on overtly geometric proportional systems. After decades mastering the right angle and cube, Wright rediscovered the triangle and circle and utilized these kindergarten geometries in the curving and beehive structures of Usonia (1936–56). Le Corbusier published the patented Modulor in 1948 and used its system of natural harmony on every building, painting, and publication he produced until the end of his life. In 1957, when Wright described "The Modular of the Kindergarten Table,"[28] directly commenting on his perceived antagonist's much ballyhooed publication, which had first appeared in English in 1954, he had no way of knowing that their mutual love affair with the magic of geometry derived from identical roots.

For Wright, the goal was unity; for Le Corbusier, harmony. Although less obvious in Wright's earth-caressing hearth-homes than Le Corbusier's hovering white abstractions, a reliance on proportional systems and almost religious adherence to the power of geometry linked the two practically and psychically, and, as harnessed by the genius of each, resulted in the creation of an inordinate amount of what is definitive about modern architecture. Wright transformed aspects of Froebel's system into the regulating grids upon which his plans were always organized and the interpenetrating rectangular solids that were their three-dimensional equivalent; he scored the regular rhythm of his houses' deeply overhung fenestration on related proportions and decorated the whole with stained glass, wood reliefs, and concrete designs of similar coherence. Le Corbusier enlarged the Platonic solids to building size and ornamented them with nothing but their own shapes and shadows; he overlaid everything from house plans to cities "formally structured like an oriental carpet"[29] with organizing grids scaled to the natural proportions of people and, from at least 1916 onward, carefully ordered every one of his projects, including the idiosyncratic masterpiece, Notre-Dame-du-Haut (Ronchamp, 1950–54), with golden-section modules, right-angle composition, or regulating diagrams of his own invention, to guarantee the harmonious relationship "between the spirit of man and the spirit of things."

ACKNOWLEDGMENTS

It was Ben Apfelbaum who brought me to Abrams and who mentioned my kindergarten collection to Paul Gottlieb, president and publisher. I want to thank both of them for the opportunity to write this book. Even earlier, John Spencer sold me my first kindergarten workbooks and thereby changed the course of my life; J. Abbott Miller first suggested a link between kindergarten and the origin of European modernism.

I am grateful for the generous assistance I received at the many different research facilities I visited in the past five years. In particular, I want to thank Rosemary Haddad at the Canadian Centre for Architecture; David Ment and Betty Weneck at Teachers College, Columbia University; Barbara O. Natanson at the Library of Congress; Susan Pine at the New York Public Library for her crocheting skills; Peter Gittleman at the Society for the Preservation of New England Antiquities; Lois Waninger at the Carondelet Historical Society; and Brooke Hodge at the Harvard Graduate School of Design for her help through the years in the cause of building blocks.

Thanks to drawing historian Diana Korzenik, building-block historian George Hardy, and lightbulb historian John Wenrich. Thanks to specialist on childhood development Kathleen Berger; to H. Allen Brooks for information about Le Corbusier; to Robert Peabody Emlen for the location of Froebel Hall on the Brown University campus; and to Sophie Nagiscarde for her valiant effort searching for Georges Braque's youth.

For important pictures reproduced herein I want to thank in particular Peter Henrici and Peter Hanousek, both of whom showed up out of the blue. And Eve Kahn and David Winter.

For reading sections of my manuscript at different stages and suggesting changes that I may or may not have had the sense to comply with, thanks to Barry Bergdoll, Prentice Rollins, and Jan Avgikos. Special thanks also to the ever-insightful Larry Kagan; to fellow collectors Nancy Rosin and Rick Gallagher; to Fred Sharf for his advice; and to my agent Irene Skolnick. For specific information on kindergarten history I want to thank Professor Helmut Heiland of Gerhard Mercator University in Duisburg, Germany, and Harriet Cuffaro of the Bank Street School here in New York. For volunteering as foot soldiers in the search for kindergarten material and evidence of Mondrian's youth in Holland, thanks to my neighbors Yvonne Simons and Max Spoerri.

Very special thanks to Jeanne S. Rubin for being more knowledgeable about kindergarten's importance than anyone else, and for allowing me publish some of her research. And to my editor, Eric Himmel, and to Sam Antupit and Liz Trovato, who designed the book.

Finally I want to thank my parents Dorothy and Seymour Brosterman for the love that got me here; Mel and Linda, who gambled on me during the lean times; Robbin for her unflagging enthusiasm; and my wife, Noelle (La Magnificenza), whom I met just as this project started and with whom I will have the great pleasure of sharing all my futures.

Norman Brosterman

NOTES

PROLOGUE

1. Virginia Wolfe, "Mr. Bennett and Mrs. Brown," in *The Virginia Wolfe Reader*, ed. Mitchell A. Leaska (San Diego: Harcourt Brace & Company, 1984), p. 194.

INTRODUCTION

1. Amazingly, at a time when the telegraph was a highly profitable, international success, with urban streets literally webbed with humming, multitiered wires, Bell found no interest from the business community in his invention and would not for years to come.
2. The giant, upraised arm of Lady Liberty, France's birthday gift to the United States, would later also be displayed in New York's Madison Square as a lookout tower, before all of the funds for the enormous, Richard Morris Hunt-designed base were raised for the statue's erection in 1886.
3. There were at least seven separate kindergarten displays at the fair, including two exhibits mounted by the E. Steiger Company of New York showing their German-made kindergarten wares along with a line of mostly German textbooks for kindergarten and other grades. Along with their offerings in the Main Exhibition Building and the U. S. Government Building, E. Steiger also supplied the materials and furniture for the model class in the Kindergarten Cottage. The Pennsylvania Educational Department exhibited "Kinder Garten" materials in their octagonal pavilion. A reporter for the *New York Tribune* noted that in an extensive display on education in the Japanese building, "The whole Kindergarten system was in use, with an odd Asiatic flavor added to Froebel," and that the Canadian Pavilion also showed Froebel's gifts. Finally, there was the "American Kindergarten," a highly religious bastardization of the kindergarten ideal, which was cooked up by one Emily M. Coe and had its own building next to the Swedish Schoolhouse. See Thompson Westcott, *Centennial Portfolio* (Philadelphia: Thomas Hunter, 1876); *Historical Register of the Centennial Exposition* (New York: Frank Leslie's Magazine, 1876); *Kindergarten Material and Occupations at the Centennial Exhibition* (New York: E. Steiger, 1878); *The American Book Trade at the Exhibition*, reprinted in an E. Steiger flyer from the *New Yorker Handels-Zeitung*, 1876; "Guide To The Exhibition," *New York Tribune. Extra, No. 35* (New York, 1876); Emily M. Coe, *American Kindergarten Magazine*, vol. 2 (New York: The American Kindergarten Society, 1880).
4. "The smooth shapely maple blocks with which to build, the sense of which never afterward leaves the fingers: so form became feeling. These primary forms were the secret of all effects . . . which were ever got into the architecture of the world." Frank Lloyd Wright, *An Autobiography* (New York: Duell, Sloan, and Pearce, 1943), p. 34; "Along with the gifts was the system, as a basis for design and the elementary geometry behind all natural birth of Form." Frank Lloyd Wright, *A Testament* (New York: Horizon Press, 1957), p. 19.

CHAPTER ONE

1. Friedrich Froebel, *Autobiography of Friedrich Froebel*, translated and annotated by Emilie Michaelis and H. Keatley Moore (Syracuse, N.Y.: C. W. Bardeen, 1889), p. 6.
2. Ibid., p. 25.
3. Ibid., p. 32.
4. Ibid., p. 49.
5. Jean-Jacques Rousseau, *Émile*, trans. William H. Payne (New York: D. Appleton, 1892), p. 1.
6. Ibid., p. 90.
7. Robert Owen, co-founder of the utopian community at New Harmony, Indiana, in 1824, was an early, enthusiastic observer at Yverdon. He later persuaded a disciple of Pestalozzi, Joseph Neef, who had opened America's first Pestalozzian school in Philadelphia in 1806, to initiate another along similar lines at his short-lived, socialist experiment on the American frontier.
8. Originally published as *Die Menschenerziehung, die Erziehungs—Unterrichts—und Lehrkunst, angestrebt in der allgemeinen deutschen Erziehungsanstalt zu Keilhau, dargestellt von dem vorsteher derselben, F.W.A. Froebel. I. Band bis zum begonnen Knabenalter (The Education of Man, the Art of Education, Instruction and Training, as practiced in the Educational Institute at Keilhau, written by its principal, F.W.A. Froebel. Volume I, to the beginning of Boyhood)* (Keilhau: Verlag der Astalt, 1826). I have consulted two English translations: Friedrich Froebel, *The Education of Man*, translated by Josephine Jarvis, introduction by Elizabeth Peabody (New York: A. Lovell, 1885) and Friedrich Froebel, *The Education of Man*, trans. William N. Hailmann (New York: D. Appleton, 1887). The Jarvis translation is more accurate; the Hailmann translation is simplified and has more commentary for American audiences.
9. Heinrich Pestalozzi, *ABC der Anschauung, oder Anschauungs-Lehre der Massverhältnisse* (Tübingen, Germany: J. G. Cotta, 1803).
10. For Froebel, "those great discoveries . . . through which the great manifold external world was seen to form a comprehensive outer unity . . . fitted in exactly with my own longings and endeavours." Froebel, *Autobiography*, p. 88.
11. The development of crystallography and Weiss's role in its modern genesis may be found in John G. Burke, "The Concept of Crystal Symmetry," in *Origins of the Science of Crystals* (Berkeley: University of California Press, 1966).
12. Froebel, *Autobiography*, p. 87.
13. Originally published as *Mutter und Koselieder* (Rudolstadt, Germany, 1844). I have consulted Friedrich Froebel, *Mother's Songs, Games and Stories*, trans. Frances and Emily Lord (London: William Rice, 1885).
14. *Ein Einigungsblatt für alle Freunde der Menschenbildung.*
15. *Zeitschrift für Friedrich Fröbels Bestrebungen.*
16. Bertha von Marenholtz-Bülow, *Woman's Educational Mission—Being An Explanation of Frederich Fröbel's System of Infant Gardens* (London: Darton, 1855), p. 7.
17. Bertha von Marenholtz-Bülow, *Reminiscences of Friedrich Froebel*, trans. Mrs. Horace (Mary) Mann (Boston: Lee and Shepard, 1891), p. 97.

CHAPTER TWO

1. J. F. Jacobs, *Manuel Pratique des Jardins d'Enfants* (Brussels: F. Claassen, 1859), p. 21.
2. Froebel, *Education of Man*, trans. Jarvis, p. 30.
3. Susan E. Blow, *Symbolic Education: A Commentary on Froebel's "Mother Play"* (New York: D. Appleton, 1894), p. 105.
4. Variations of many of the activities Froebel selected as gifts already existed as traditional toys or handicrafts. The seventh gift, tablet laying, was derived from a fairly common type of parquetry toy used for creating decorative designs and abstracted flowers, which was itself a child's version of the ancient arts of stone mosaic and wood marquetry. The eighth and fifteenth gifts, stick laying and slat interlacing, have affinities to the very old game of jackstraws, or pick-up sticks, while the thirteenth gift, paper-cutting, is a likely relative of the traditional German silhouette scissors-craft called *Scherenschnitt*. The first gift, a soft knit ball on a string, makes sense as the beginning of the system in that it may be used with infants. Gifts two through six, the wood blocks, were distantly related to building toys first made in Germany in the eighteenth century.
5. *Ein Sonntagsblatt für Gleichgesinnte.*

6. Froebel, *Education of Man*, trans. Hailmann, p. 287.
7. Von Marenholtz, *Reminiscences of Friedrich Froebel*, pp. 269–70.

CHAPTER THREE

1. Friedrich Froebel, *Pedagogics of the Kindergarten*, trans. Josephine Jarvis (New York: D. Appleton, 1896), p. 33.
2. Froebel, *Pedagogics*, p. 60.
3. Von Marenholtz, *Woman's Educational Mission*, p. 21.
4. Von Marenholtz, *Reminiscences of Friedrich Froebel*, p. 225.
5. Froebel, *Pedagogics*, p. 118.
6. See Elisabeth S. Hirsch, *The Block Book* (Washington, D.C.: National Association for the Education of Young Children, 1984).
7. Froebel, *Pedagogics*, p. 122.
8. Maria Montessori (1870–1952), an Italian physician and educator, developed a program for educating preschool children at the turn of the century that borrowed from Froebel's (and Pestalozzi's) educational philosophy. She opened her first *casa dei bambini* (children's house) in Rome in 1907. Montessori schools in the United States and Europe have had periods of growth and of decline since then, but they have never commanded more than a small, specialized niche among preschools.
9. Froebel, *Pedagogics*, p. 136.
10. Kate Douglas Wiggin and Nora Archibald Smith, *The Republic of Childhood—Froebel's Gifts* (Boston: Houghton, Mifflin, 1895), pp. 139–40.
11. *Anschauung* is a German noun derived from the verb *anschauen* (to see or perceive). See Ellen Lupton and J. Abbott Miller, *The Bauhaus and Design Theory* (New York: Princeton Architectural Press, 1991) and Clive Ashwin, *Drawing and Education in German-Speaking Europe, 1800–1900* (Ann Arbor, Mich.: UMI Research Press, 1981). Ashwin identifies Buss as Christoph, while in Henry Barnard, *Pestalozzi and Pestalozzianism* (New York: F. C. Brownell, 1859), he is listed as Johannes.
12. Schmid was Pestalozzi's mathematics teacher at Yverdon and later achieved some measure of fame on his own. Froebel's heavily annotated copy of Schmid's later general geometry book is housed in the Froebel Museum in Bad Blankenburg and contains hundreds of original drawings of mathematically derived patterns that Froebel penned into the margins. See Kristina Leeb-Lundberg, "Friedrich Froebel revisited," *The New Era Journal of the World Education Fellowship* (London) 57, no. 1 (Jan.–Feb. 1976).
13. Ashwin, *Drawing and Education*, p. 16.
14. Ibid., p. 128
15. Froebel, *Education of Man*, trans. Hailmann, p. 288.
16. Diana Korzenik, *Drawn to Art* (Hanover, N.H.: University Press of New England, 1985).
17. Nina Moore, *The Kindergarten Manual of Drawing* (London: W. Swan Sonnenschein & Allen, 1879). Although this book was published in London, Moore wrote it in the Boston suburb of West Newton.
18. Ashwin, *Drawing and Education*, p. 127.
19. See Paul Klee, *Pedagogical Sketchbook* (London: Faber and Faber, 1968).
20. Starr Ockenga, *On Women and Friendship* (New York: Stewart, Tabori & Chang, 1993), p. 95.
21. Wiggin and Smith, *Republic of Childhood—I*, p. 244.
22. From the video "Buckminster Fuller: Thinking Out Loud," produced and directed by Karen Goodman and Kirk Simon (New York: Zeitgeist Films, 1996).
23. Hermann Goldammer, *The Kindergarten* (Berlin: Charles Habel, 1882), Part II, p. 147.

CHAPTER FOUR

1. S. Quam, *First Kindergarten in the United States* (Watertown, Wisc.: Watertown Historical Society, 1988). The first attempt to introduce kindergarten to America was unsuccessfully made about 1853 by two of Froebel's disciples, Louisa Frankenberg and her brother Adolph. In 1854, some small interest in the system was awakened when a supply of kindergarten material was sent from Germany to the Pennsylvania Institute for the Feeble Minded. Cora L. Stockham and Emily A. Kellogg, eds., *Mothers' Portfolio* (Chicago: Alice B. Stockham, 1889), p. 332.
2. Froebel, *Education of Man*, trans. Hailmann, n.p. According to Hailmann, the citation came from an 1836 essay by Froebel on "The Renewal of Life."
3. Nina Vandewalker, *The Kindergarten in American Education* (New York: Macmillan, 1908), p. 13.
4. Of these, 423 were English-language schools, 142 German-language schools. One hundred were connected with public schools.
5. Friedrich Froebel, *Froebel's Letters on the Kindergarten*, translated, edited, and annotated by Emilie Michaelis and H. Keatley Moore (London: Swan Sonnenschein, 1891). The original German edition of 1887 was edited by Hermann Poesche.
6. Vandewalker, *Kindergarten*, p. 6.
7. Ann Taylor Allen, "'Let Us Live With Our Children': Kindergarten Movements in Germany and the United States, 1840–1914," *History of Education Quarterly* 28 (Spring 1988): pp. 42-43.
8. Henry Barnard, ed., *Kindergarten and Child Culture Papers* (Hartford, Conn.: Barnard's American Journal of Education, 1884), p. 151.
9. *Kindergarten Review Magazine* (1890–91), p. 207. In 1887, there were kindergartens not only in St. Petersburg (which also had a Froebel Society and a teachers' training college), but also Moscow, Kiev, Omsk, Riga, and Dorpat. Froebel, *Froebel's Letters on the Kindergarten*, p. 200.
10. Barnard, *Kindergarten and Child Culture Papers*, p. 157.
11. *Report of the Commissioner of Education 1890–91* (Washington, D.C.: Government Printing Office, 1891), p. 730.
12. "French Shelter Schools (Salles D'Asile)," *U.S. Bureau of Education Circular 1882 no.6—Technical Instruction in France* (Washington, D.C.: Government Printing Office, 1891), p. 11.
13. "The Kindergarten of America," *Kindergarten Review* (March, 1893): p. 77.
14. In regulations drawn up in 1879, the Belgian infant schools, or *écoles gardiennes*, were renamed *écoles maternelles;* two years later the French followed suit. Barnard, *Kindergarten and Child Culture Papers*, pp. 157, 490.
15. Froebel, *Education of Man*, trans. Hailmann, p. 28.
16. *Report of the Commissioner of Education 1890–91.*
17. *Report of the Commissioner of Education 1877* (Washington, D.C.: Government Printing Office, 1877), p. CLXVII.
18. Marie Matrat, "Les Écoles Gardiennes de La Hollande," *Revue Pédagogique* (Paris, 1883): pp. 306–25.
19. Barnard, *Kindergarten and Child Culture Papers*, pp. 6, 157.
20. Lupton and Miller, *Bauhaus and Design Theory*, p. 18.
21. *Report of the Commissioner of Education 1890–91*, p. 321. In 1871 there were 1,099 schools with 130,806 students. In 1881 there were 1,741; in 1891 there were 2,218 with 256,423 students.
22. "The Kindergarten," *U.S. Bureau of Education Circular of Information July 1872* (Washington, D.C.: U.S. Government Printing Office, 1872), p. 12. Contents includes "Kindergarten in Italy—introduction by Elizabeth P. Peabody, Philosophy and Methods of the Kindergarten, for Teachers in Italy by Baroness Marenholtz Bülow."
23. Barnard, *Kindergarten and Child Culture Papers*, p. 6.
24. Ibid., p. 157.
25. *Schweizerische Kindergarten.*
26. Froebel, *Froebel's Letters on the Kindergarten*, p. 196.
27. Ibid., p. 209.
28. *Report of the Commissioner of Education 1890–91*, p. 290.
29. *Education in Japan*, pamphlet prepared for the Panama-Pacific International Exposition 1915 (Tokyo: Department of Education, 1914), n.p.
30. Jacobs, *Manuel Pratique*, p. 10.
31. Deutscher Froebelverband.
32. Ann Taylor Allen, "Spiritual Motherhood: German Feminists and the Kindergarten Movement, 1848–1911," *History of Education Quarterly* 22 (Fall 1982), p. 329.
33. Froebel, *Froebel's Letters on the Kindergarten.*
34. Helmut Heiland, *Bibliographie Friedrichfröbel Primär und Sekundärliteratur 1820–1990* (Hildesheim, Germany: George Olms Verlag A. G., 1990).
35. Charles Dickens, "Infant Gardens," *Household Words* 278 (July 21, 1855), p. 582.
36. *Manuel Pratique des Jardins D'Enfants.*
37. Originally published as *Der Kindergarten. Handbuch der Fröbelschen Erziehungsmethode, Spielgaben und Beschäftigungen* (Berlin, 1869). The English-language translation, by William Wright, was of the third German edition. It was published in Berlin by Charles Habel, in London by Williams & Norgate, and in New York by E. Steiger, in 1882.
38. Barnard, *Kindergarten and Child Culture Papers*, p. 15.
39. Harriet Cuffaro, "A View of Materials as the Texts of the Early Childhood Curriculum," *Yearbook in Early Childhood Education 2* (New York: Teachers College Press, 1991), p. 69. An expanded history of the changes to kindergarten wrought by Child Study may also be found in Evelyn Weber, *Ideas Influencing Early Childhood Education* (New York: Teachers College Press, 1984).
40. Edward L. Thorndike, "Notes on Psychology for Kindergartners," *Teachers College Record* 4 (November 1903), quoted in Weber, *Ideas Influencing Early Childhood Education*, p. 6.

CHAPTER FIVE

1. Wiggin and Smith, *Republic of Childhood*, p. 112.
2. Alfred H. Barr, Jr., *Cubism and Abstract Art* (New York: Museum of Modern Art, 1986), p. 2.
3. Froebel, *Autobiography*, p. 40.
4. John Richardson, *A Life of Picasso*, vol. 1 (New York: Random House, 1991), p. 29. Richardson goes on to make a different point about Picasso's childhood artwork that is more in the spirit of my argument. He suggests that the child's much commented upon skill at *papier découpé*, which he made with his aunt's embroidery scissors, influenced his later experiments with Cubism and *papier collé*.
5. Herbert Read, *A Concise History of Modern Painting* (London: Thames and Hudson, 1985), p. 18.
6. Richard Verdi, *Cézanne* (London: Thames and Hudson, 1992), p. 147.
7. William Rubin, *Picasso and Braque: Pioneering Cubism* (New York: The Museum of Modern Art, 1989), pp. 21, 30–41.
8. William Rubin, "Picasso," in *Primitivism in 20th Century Art*, vol. 1, ed. William Rubin (New York: The Museum of Modern Art, 1984), pp. 241–343.
9. Françoise Gilot and Carlton Lake, *Life with Picasso* (New York: McGraw Hill, 1964), p. 226. William Rubin discusses this episode in detail in "Picasso," in *Primitivism.*
10. William Rubin, "Picasso," p. 253.
11. Wilhelm Worringer, *Abstraction and Empathy* (New York: International Universities Press, 1980), p. 14.
12. Ibid., p. 34–35.
13. Edward F. Fry, *Cubism* (London: Thames and Hudson, 1966), p. 52. Morice's review was published in the *Mercure de France*, December 16, 1908.
14. In 1883 a kindergarten training college opened in Madrid. There were then two kindergartens in Madrid and one in Bilbao. Froebel, *Froebel's Letters on the Kindergarten*, p. 200.
15. This statement is based upon the likelihood that Braque received a typical French primary education in state-run schools. I am not aware of any source that gives details about Braque's early education.
16. *Report of the Commissioner of Education 1890–91*, p. 730.
17. Marie Matrat, "Les Écoles Gardiennes de La Hollande," p. 312 (emphasis in original).
18. Ibid., p. 312 (emphasis in original).
19. Rudolph Arnheim, *Art and Visual Perception* (Berkeley: University of California Press, 1974), p. 146.
20. The credo of the Theosophical Society reads: "1. To form a nucleus of the Universal Brotherhood of Humanity, without distinction of race, creed, sex, caste, or color. 2. To encourage the study of comparative religion, philosophy, and science. 3. To investigate the unexplained laws of Nature and the powers latent in Man." Carel Blotkamp, *Mondrian: The Art of Destruction* (New York: Harry N. Abrams, 1994), p. 35.
21. Steiner's ideas, which Mondrian would have encountered in his *Het occultisme in groote trekken* (1910), are recounted in Carel Blotkamp et al., *De Stijl: The Formative Years* (Cambridge, Mass.: MIT Press, 1986), p. 49.
22. Steiner developed his own course in what he called Form Drawing, a pedagogical system designed to develop in children an ability to experience forms and reconcile their opposites into harmonious, abstract patterns. Unlike Mondrian's paintings, which were based on an orthogonal grid, the Steiner Form Drawing course, like everything else in the Steiner system, used virtually every shape *but* the square. The right angle, Mondrian's perverse response to Steiner's theories, is anathema to the Steinerites' vision of nature, and is studiously avoided in all of their activities, furniture, and even architecture. See Hans R. Niederhäuser and Margaret Frohlich, *Form Drawing* (Spring Valley, N.Y.: Mercury Press, 1984).
23. Hans L. C. Jaffé, *De Stijl: 1917–31: The Dutch Contribution to Modern Art* (Amsterdam: J. M. Meulenhof, 1956), p. 57.

24. Read, *Concise History of Modern Painting,* p. 200.
25. Froebel, *Education of Man,* trans. Hailmann, p. 288.
26. Although there were schools that did not accept the system, they seem to have been run by the Catholic church, in the area south of the rivers in what was formerly the northernmost fringe of the Spanish empire.
27. Without specific records of the curriculum of Mondrian's first school year, we cannot be certain of his kindergarten exposure *at that time.* We can, though, state with confidence that inasmuch as Amersfort lies close by Utrecht in the north, the odds are greatly in favor of his having attended kindergarten as a boy.
28. William Rubin points out that although Mondrian held Picasso in the highest esteem, "his Cubism was much closer to the reductive, abstracting spirit of Braque's." See William Rubin, *Picasso and Braque,* p. 23.
29. Blotkamp, *De Stijl,* p. 40. The passage originally appeared in Piet Mondrian, "Het bepaalde en het onbepaalde," *De Stijl* 2, no.2 (1918): p. 17.
30. See Winfried Nerdinger, *Der Architekt Walter Gropius* (Berlin: Gebr. Mann, 1985), p. 66. Gropius included the model of his design for the Friedrich Froebelhaus in *Internationale Architektur* (1925), the first of a series of informational texts (Bauhausbücher) published during the life of the institution.
31. A romantic and expressionist painter throughout his years at the Bauhaus, Itten's almost antimodern attitude in his own work did not impinge on his teaching.
32. Charles Dickens, "Infant Gardens," p. 7.
33. "What was more important, however, was his influence on the weaving workshop and above all his general educational activities which he carried out in conjunction with the preliminary course." Hans M. Wingler, *The Bauhaus* (Cambridge, Mass.: MIT Press, 1969), p. 265.
34. Will Grohmann, *Paul Klee* (New York: Harry N. Abrams, 1955), p. 257.
35. This information from Dr. Eugene Glaesemer, former Curator of the Klee Kunstmuseum in Bern, was transmitted to Froebel scholar Jeanne S. Rubin in 1981. It, and other information on the connection between Klee and kindergarten, including historical research on kindergarten in the Canton of Bern, are from an unpublished manuscript by Jeanne S. Rubin tentatively titled "Frank Lloyd Wright's Froebel Kindergarten: Architecture of Molecules," and were graciously provided by her.
36. Grohmann, *Paul Klee,* pp. 57, 192.
37. Froebel, *Autobiography,* p. 45.
38. Klee's father Hans, a music teacher at the Cantonal Teachers' College at Hofwyl near Bern, and his father's father, were, like Froebel, born in Thuringia.
39. Jeanne S. Rubin, "Frank Lloyd Wright's Froebel Kindergarten." Froebel had always intended the kindergarten training to continue into the primary school and beyond, and there is at least one instance where it was used (philosophically at least) right up to the university level.
40. Grohmann uses the word "constructive" to describe Klee's geometrically ordered works. See, for example, Grohmann, *Paul Klee,* pp. 205–6.
41. "Paul Klee (1879–1940) liked certain motifs—among them, colored squares, stripes, latticework patterns, pictographs—and used them throughout his career." From a wall label in the Metropolitan Museum of Art, New York, 1994.
42. Wassily Kandinsky, *Concerning the Spiritual in Art* (Mineola, N.Y.: Dover Press, 1977), p. 19.
43. Wassily Kandinsky, *Kandinsky 1901–1913* (Berlin: Der Sturm, 1913), p. 23.
44. In the winter of 1871, Von Marenholtz, who knew Froebel's ideas better than anyone alive, arrived in Florence to start a kindergarten and teacher-training school that became a model of Froebelian purity. Although the Kandinsky family may have left the city just before her arrival, there is little reason to doubt that Kandinsky spent at least a year in an actual, if not strictly Froebelian, kindergarten when he was three or four years old. The chronology of these years of Kandinsky's life, however, is far from clear, and it is possible that the family was still in the city when Von Marenholtz made her appearance. Kandinsky stated in his *Reminiscences* of 1913 that the family journeyed to Italy when he was three years old. If this is true, unless their trip took place in the few weeks of 1869 that remained after his birthday on December 4, the Kandinsky family's Italian sojourn really began in 1870, and not 1869 as is commonly recorded. In

the second version of the *Reminiscences,* published in Moscow in 1918, Kandinsky implied that he was closer to seven when the family returned to Russia, although there is some evidence that he may have purposely blurred the facts to avoid speaking of his parent's divorce in the intervening years. But if this accounting were correct, Kandinsky may still have been in Italy as late as 1873, leaving plenty of time for him not only to attend kindergarten, but the rigorously Froebelian kindergarten begun by Von Marenholtz at the end of 1871. If this was true, then like Frank Lloyd Wright, whose mother trained with a woman who trained with Froebel, Kandinsky's life may also have begun with a direct line to the kindergarten source. See Kandinsky, *Kandinsky 1901–1913,* for the *Reminiscences* of 1913 and Hilla Rebay, ed., *In Memory of Wassily Kandinsky* (New York: Solomon R. Guggenheim Foundation, 1945) for the second version of 1918.
45. "I never had a so-called good memory: I was particularly always unable to memorize numbers, names and even poems. The tables of multiplication always offered me insurmountable difficulties, which I have not overcome to this date [1910] and which got my teachers desperate. From the very start I had to utilize the optical memory. Then it went better. In the state examination in statistics I quoted an entire page of figures only because in the excitement I saw this page in front of me. Thus, already as a boy, I was able to, at home, paint by heart paintings, which had particularly fascinated me in exhibits, as far as my technical abilities permitted. Later I often painted a landscape better "by heart" than from nature." Kandinsky, *Kandinsky 1901–1913,* p. 28.
46. Memory, particularly in and of early childhood, is an enigmatic and imprecise faculty. The purely sensorial memories of youth, programmed directly and lacking reinforcement from an intellectual bridge of spoken language, may be more deeply seated than most and consequently more difficult to decode and describe later. For this reason, adults often have difficulties expressing their earliest memories and find themselves describing incidents and images by way of comparison or metaphor. Nonverbal memories, which are difficult to dredge up, often remain hidden unless activated by an unexpected shock, but once "discovered" are harder to change or erase. Images imprinted in the mind, particularly before the age of seven during the stage Piaget termed "pre-logical," may not erupt until late in life, and often only if triggered by a related sight, smell, or taste. See Kathleen Stassen Berger, *The Developing Person Through the Life Span* (New York: Worth, 1994). Information on learning and memory from the above and from interviews with the author.
47. "When by some circumstance the mind is freed from its usual allegiance to the complexities of nature, it will organize shapes in accordance with the tendencies that govern its own functioning. We have much evidence that the principal tendency at work here is that toward simplest structure, i.e., toward the most regular, symmetrical, geometrical shape attainable under the circumstances." Arnheim, *Art and Visual Perception,* p. 145.
48. Jelena Hahl-Koch, *Kandinsky* (New York: Rizzoli, 1993), p. 242. Although few things look as much like kindergarten as the work of Malevich, and the genesis of his Architectons seems straight from a kindergarten teacher's drawing book, there is nothing to support speculation of his having attended kindergarten in the small Ukrainian agricultural centers where he grew up. According to one source, there were, in Russia in 1887, kindergartens in St. Petersburg (which also had a Froebel Society and a teachers' training college), Moscow, Kiev, Omsk, Riga, and Dorpat. Froebel, *Froebel's Letters on the Kindergarten,* p. 200.

CHAPTER SIX

1. Wingler, *The Bauhaus,* p. 31. This is the first line of Gropius's so-called "Bauhaus Manifesto."
2. Froebel, *Autobiography,* p. 69.
3. Frank Lloyd Wright, *An Autobiography* (New York: Duell, Sloan, and Pearce, 1943), p. 36. Wright is writing about the Lloyd Joneses, his mother's family.
4. Froebel, *Autobiography,* p. 112.
5. Wright, *Autobiography,* p. 34.
6. Froebel, *Autobiography,* p. 12.
7. Frank Lloyd Wright, *A Testament* (New York: Horizon Press, 1957), p. 21.

8. See Robert C. Spencer, Jr., "The Work of Frank Lloyd Wright," *Architectural Review* (Boston, 7 June 1900), pp. 61–72. Critical commentary since that time has alternated between complete skepticism or, at best, shallow acknowledgment of the link between the gifts and the architecture, to fairly recent explorations of significant value. The best early insights appear in Grant Carpenter Manson, *Frank Lloyd Wright to 1910: The First Golden Age* (New York: Van Nostrand Reinhold, 1958), pp. 5–10, although the author inaccurately describes some early kindergarten circles. In the 1980s, two articles by fortunates with first-hand living experience of Wright's work were published that furthered the Wright/Froebel dialogue. The first, by Edgar Kaufmann Jr., who was lucky enough to grow up in Fallingwater, one of Wright's most sublime houses, recapitulates prior information, includes a valuable chunk of old kindergarten history, but nevertheless contains several inaccuracies and many specious conclusions. Edgar Kaufmann Jr., "'Form Became Feeling,' A New View of Froebel and Wright," *Journal of the Society of Architectural Historians* (May 1981). Reprinted in Edgar Kaufmann, Jr., *Nine Commentaries on Frank Lloyd Wright* (New York/Cambridge, Mass.: The Architectural History Foundation/MIT Press, 1989). The second, a small portion of thirty-odd years of kindergarten research by Jeanne S. Rubin, Professor Emeritus of Music at Kent State University and Wright Usonian client from 1951, clarifies the Wright/Froebel/crystallography connection so definitively that reading it would have made Froebel dizzy with joy. Jeanne S. Rubin, "The Froebel-Wright Kindergarten Connection: A New Perspective," *Journal of the Society of Architectural Historians* (March 1989). Kaufmann questions the efficacy of American kindergarten before the Centennial Exposition because, as he notes, most of Froebel's own writings were not translated into English at that time, but as we have seen, the vast majority of kindergartners were taught, like their pupils, not by reading, but by doing. Furthermore, after 1869, when Edward Wiebé's *Paradise of Childhood* was published, a good American introduction to the system was widely available. Kaufmann also denies the spatial and volumetric value of the block gifts, claiming that "they were not presented as building blocks, but as regular geometric solids said to underlie the complex shapes of nature," and that "Froebel could not help in concepts or relationships of space." Froebel himself, however, referred to the cubic gifts as *baukasten,* or building blocks, and his emphasis on their use for the creation of architectural models began in 1838 even before he coined the name *kindergarten.* In the original plates of the first five gifts published in his weekly *Sontagsblatter,* Froebel took a liberty in the representation of the nature forms that many later publications ignored—in spite of their being built from blocks, he deliberately deleted the seams from between the pieces. The "buildings" and "facades" were thus rendered as actual constructions, and because no blocks were ever left unused, each new structure was a variation of an equivalent volume in three dimensions, in other words, a relationship of space. Kaufmann's approach to the gifts, which it seems he may never actually have seen, ignored Froebel's multilevel system where not only the blocks, but also the flat parquetry tiles, sticks and peas, and even modeling clay, are used to describe the concept of volume, even as they remain planar, or linear when approached with a different emphasis. See Kaufmann, *Nine Commentaries on Frank Lloyd Wright,* pp. 1–6.
9. That Wright spoke often about the kindergarten was confirmed for the author by former Taliesin student and self-described Wrightian, architect E. Fay Jones.
10. Wright, *Testament,* pp. 19–20.
11. Wright's recollections are not precisely accurate. For example, he wrote that after "discovering" the kindergarten in Philadelphia, his mother "Could hardly wait to go to Boston as soon as she got home—to Milton Bradley's." In fact, in 1876 there was no retail outlet in Boston exclusively for Milton Bradley toys and kindergarten material. Like most manufacturers of a similar ilk, Bradley's products were distributed through private toy, book, and "fancy goods" stores. E. Steiger, the importer that was so well represented at the fair, would also have sold their materials in Boston, which might explain Wright's comment about "German papers, glazed and

matte." Boston's own J. L. Hammett Company, which advertised in 1876 that they handled school supplies, school furniture, and school books at their shop at 37–39 Brattle Street, ultimately sold kindergarten gifts under their own label and might have filled Anna Wright's orders as well. See Wright, *Autobiography*, p. 32.

12. The Committee of Nineteen, *Pioneers of the Kindergarten in America* (New York: Century, 1924), p. 137.

13. Historians have also speculated that Wright accompanied his mother to Phildelphia in 1876, which would account for his combined memories of kindergarten and the Centennial. I think that this is unlikely.

14. Richard MacCormac argued that Froebel's system gave Wright a philosophy, a design discipline, and a characteristic style. See Richard C. MacCormac, "The Anatomy of Wright's Aesthetic," *Architectural Review* (London, February 1968).

15. Louis Sullivan, *Kindergarten Chats and Other Writings* (New York: George Wittenborn, 1947), p. 15.

16. John Szarkowski, *The Idea of Louis Sullivan* (St. Paul: University of Minnesota Press, 1956), p. 3.

17. Le Corbusier, *Towards a New Architecture* (Mineola, N.Y.: Dover, 1986), p. 29. This is a reprint of the English edition originally published by John Rodker, London, in 1931, translated from the thirteenth French edition and with an introducton by Frederick Etchells. The original French edition of *Vers une architecture* (1923) was a compilation of writings by Le Corbusier for his own magazine, *L'Esprit Nouveau*.

18. Ibid., p. 31.

19. See Manson, *Frank Lloyd Wright to 1910*.

20. See H. Allen Brooks, "Le Corbusier's Formative Years at La Chaux-de-Fonds," in *Le Corbusier*, ed. H. Allen Brooks (Princeton: Princeton University Press, 1987).

21. Le Corbusier, *Towards a New Architecture*, p. 4.

22. Jacques Guiton, *The Ideas of Le Corbusier* (New York: George Braziller, 1981), p. 60.

23. Marc Solitaire, "Le Corbusier et l'urbain: la rectification du damier froebelian," in *La Ville et L'Urbanisme après Le Corbusier*, conference proceedings edited by H. Allen Brooks (La Chaux-de-Fonds, Switzerland: Editions d'En Haut, 1993). Solitaire's paper is highly detailed as to Jeanneret family history and the implementation of kindergarten in Switzerland.

24. Le Corbusier, *Journey to the East* (Cambridge, Mass.: MIT Press, 1987), p. 212.

25. Blotkamp, *De Stijl*, p. 210.

26. Kenneth Frampton, "Neoplasticism and Architecture: Formation and Transformation," in *De Stijl: 1917–1931 Visions of Utopia*, ed. Mildred Friedman (New York: Abbeville Press, 1982), p. 100.

27. Henry Russell Hitchcock and Philip Johnson, *The International Style: Architecture since 1922* (New York: W. W. Norton, 1932), p. 27.

28. "Kindergarten training, as I have shown, proved an unforeseen asset: for one thing, because later all my planning was devised on a properly proportional unit system." Wright, *Testament*, p. 220.

29. Kenneth Frampton, *Modern Architecture 1851–1945* (New York: Rizzoli, 1983) p. 266.

BIBLIOGRAPHY

I. BOOKS BY FROEBEL AND ORIGINAL KINDERGARTEN TEXTS

Barnard, Henry, ed. *Kindergarten and Child Culture Papers*. Hartford, Conn.: Barnard's American Journal of Education, 1884.

Blow, Susan E. *The Songs and Music of Froebel's Mother Play*. New York: D. Appleton, 1895.

—. *Symbolic Education: A Commentary on Froebel's "Mother Play."* New York: D. Appleton, 1894.

Douai, Adolf. *The Kindergarten*. New York: E. Steiger, 1872.

Froebel, Friedrich. *Autobiography of Friedrich Froebel*. Translated and annotated by Emilie Michaelis and H. Keatley Moore. Syracuse, N.Y.: C. W. Bardeen, 1889.

—. *The Education of Man*. Translated by Josephine Jarvis, introduction by Elizabeth Peabody. New York: A. Lovell, 1885. (Originally published as *Die Menschenerziehung, die Erziehungs—Unterrichts—*

und Lehrkunst, angestrebt in der allgemeinen deutschen Erziehungsanstalt zu Keilhau, dargestellt von dem vorsteher derselben, F.W.A. Froebel. I. Band bis zum begonnen Knabenalter. Keilhau: Verlag der Astalt, 1826.)

—. *The Education of Man*. Translated by William N. Hailmann. New York: D. Appleton, 1887.

—. *Friedrich Froebel's Education by Development*, vol. 2 of *Pedagogics of the Kindergarten*. Translated by Josephine Jarvis. New York: D. Appleton, 1899.

—. *Froebel's Letters*. Edited by Arnold Heinemann. Boston: Lee and Shepard, 1893.

—. *Froebel's Letters on the Kindergarten*. Translated, edited, and annotated by Emilie Michaelis and H. Keatley Moore. London: Swan Sonnenschein, 1891.

—. *Mother's Songs, Games and Stories*. Translated by Frances and Emily Lord. London: William Rice, 1885. (Originally published as *Mutter und Koselieder*, 1844.)

—. *Pedagogics of the Kindergarten*. Translated by Josephine Jarvis. New York: D. Appleton, 1896.

Goldammer, Hermann. *The Kindergarten*. Berlin: Charles Habel, 1882. (Originally published as *Der Kindergarten*. Berlin: Habel, 1869.)

Hughes, James L. *Froebel's Educational Laws for All Teachers*. New York: D. Appleton, 1897.

Jacobs, J. F. *Manuel Pratique des Jardins d'Enfants*. Brussels: F. Claassen, 1859.

"The Kindergarten." *U.S. Bureau of Education Circular of Information July 1872*. Washington, D.C.: U.S. Government Printing Office, 1872.

Kirby, Sara Miller. *Kindergarten Papers*. New York: Butterick Publishing Company, 1896.

Kraus-Boelte, Maria, and John Kraus. *The Kindergarten Guide* (vol. 1, *The Gifts*; vol. 2, *The Occupations*). New York: E. Steiger, 1877.

Kriege, Matilda H. *The Child, Its Nature and Relations*. New York: E. Steiger, 1872.

Moore, Nina. *The Kindergarten Manual of Drawing*. London: W. Swan Sonnenschein & Allen, 1879.

Peabody, Elizabeth P., and Mrs. Horace (Mary) Mann. *Moral Culture of Infancy and Kindergarten Guide*. Boston: T.O.H.P. Burnham, 1863.

Ronge, Johann and Bertha. *A Practical Guide to the English Kindergarten*. London: A. N. Meyers, 1855.

Sherreff, Emily. *Life of Friedrich Fröbel*. London: Chapman and Hall, 1887.

Snider, Denton J. *The Psychology of Froebel's Play-Gifts*. St. Louis: Sigma, 1900.

Stockham, Cora L., and Emily A. Kellogg, eds. *Mothers' Portfolio*. Chicago: Alice B. Stockham, 1889.

Van Coehoorn-Stout, Johannes Wierts. *De Kindertuin*. Amsterdam: H. Wierts Van Coehoorn, 1904.

Von Marenholtz-Bülow, Bertha. *Reminiscences of Friedrich Froebel*. Translated by Mrs. Horace (Mary) Mann. Boston: Lee and Shepard, 1891.

—. *Woman's Educational Mission—Being An Explanation of Friedrich Fröbel's System of Infant Gardens*. London: Darton, 1855.

Wiebé, Edward. *Paradise of Childhood*. Springfield, Mass.: Milton Bradley, 1869.

Wiggin, Kate Douglas, and Nora Archibald Smith. *The Republic of Childhood—I—Froebel's Gifts*. Boston: Houghton, Mifflin, 1895.

—. *The Republic of Childhood—II—Froebel's Occupations*. Boston: Houghton, Mifflin, 1896.

II. BOOKS ON ART AND ARCHITECTURE

Albers, Joseph. *Josef Albers*. Edited by E. Gomringer. New York: Wittenborn, 1968.

Banham, Reyner. *Theory and Design in the First Machine Age*. London: Architectural Press, 1960.

Barr, Jr., Alfred H. *Cubism and Abstract Art*. New York: Museum of Modern Art, 1936.

Blotkamp, Carel, et al., *De Stijl: The Formative Years*. Cambridge, Mass.: MIT Press, 1986.

Brooks, H. Allen. *La Ville et l'Urbanisme après Le Corbusier*. La Chaux-de-Fonds, Switzerland: Editions d'En Haut, 1993.

—, ed. *Le Corbusier*. Princeton: Princeton University Press, 1987.

—. *Writings on Wright*. Cambridge, Mass.: MIT Press, 1981.

Doesburg, Theo van. *Principles of Neo-Plastic Art*. London: Percy Lund Humphries, 1968. (Originally published as *Bauhausbücher 6, Grundbegriffe Der Neuen Gestaltenden Kunst, 1925*.)

Friedman, Mildred, ed. *De Stijl: 1917–1931 Visions of Utopia*. New York: Abbeville Press, 1982.

Fry, Edward F. *Cubism*. London: Thames and Hudson, 1966.

Grohmann, Will. *Paul Klee*. New York: Harry N. Abrams, 1955.

—. *Wassily Kandinsky—Life and Work*. New York: Harry N. Abrams, 1958.

Gropius, Walter. *Bauhausbücher 1—Internationale Architektur*. Munich: Albert Langen, 1925.

Guiton, Jacques. *The Ideas of Le Corbusier*. New York: George Braziller, 1981.

Hahl-Koch, Jelena. *Kandinsky*. New York: Rizzoli, 1993.

Herzogengrath, Wulf. *Josef Albers und der "Vorkurs" am Bauhaus 1919–1933*. N.p., n.d.

Holtzman, Harry. *The New Art, The New Life: The Collected Writings of Piet Mondrian*. Boston: G. K. Hall, 1986.

Itten, Johannes. *Design and Form: The Basic Course at the Bauhaus*. New York: Reinhold, 1964.

Jaffé, Hans L. C. *Piet Mondrian*. New York: Harry N. Abrams, 1970.

Kandinsky, Wassily. *Kandinsky, Complete Writings on Art*. Boston: G. K. Hall, 1982.

—. *Concerning the Spiritual in Art*. Mineola, N.Y.: Dover, 1977.

—. *Kandinsky 1901–1913*. Berlin: Der Sturm, 1913.

—. *Point and Line to Plane*. Mineola, N.Y.: Dover, 1979.

—. *Text Artista*. Moscow: The Department of Art of the People's Commisariat of Education, 1918.

Klee, Paul. *The Diaries of Paul Klee 1898-1919*. Berkeley: University of California Press, 1964.

—. *Pedagogical Sketchbook*. London: Faber and Faber, 1968.

Le Corbusier (Jeanneret, Charles-Édouard). *Journey to the East*. Cambridge, Mass.: MIT Press, 1987.

—. *The Modulor*. Cambridge, Mass.: MIT Press, 1968.

—. *Towards a New Architecture*. 1931. Reprint, Mineola, N.Y.: Dover, 1986. (Originally published as *Vers une architecture*, 1923.)

Lupton, Ellen, and J. Abbott Miller. *The Bauhaus and Design Theory*. New York: Princeton Architectural Press, 1991.

Manson, Grant Carpenter. *Frank Lloyd Wright to 1910*. New York: Van Nostrand Reinhold, 1958.

Nerdinger, Winfried. *der Architekt Walter Gropius*. Berlin: Gebr. Mann, 1985.

Read, Herbert. *A Concise History of Modern Painting*. London: Thames and Hudson, 1985.

Rebay, Hilla, ed. *In Memory of Wassily Kandinsky*. New York: Solomon R. Guggenheim Foundation, 1945.

—, ed. *Kandinsky*. New York: Solomon R. Guggenheim Museum Foundation, 1945.

Rubin, William. *Pablo Picasso, A Retrospective*. New York: Museum of Modern Art, 1980.

—. *Picasso and Braque: Pioneering Cubism.* New York: Museum of Modern Art, 1989.

—. *Primitivism in 20th Century Art.* New York: Museum of Modern Art, 1984.

Secrest, Meryle. *Frank Lloyd Wright.* New York: Alfred A. Knopf, 1992.

Seuphor, Michel. *Piet Mondrian—Life and Work.* New York: Harry N. Abrams, n.d.

Storer, William Allin. *The Frank Lloyd Wright Companion.* Chicago: University of Chicago Press, 1993.

Verdi, Richard. *Cézanne.* London: Thames and Hudson, 1992.

Warncke, Carsten-Peter. *De Stijl, 1917–1931.* Cologne, Germany: Benedikt Taschen Verlag, 1991.

Whitford, Frank. *Bauhaus.* New York: Thames and Hudson, 1984.

—. *The Bauhaus Masters and Students by Themselves.* Woodstock, N.Y.: Overlook Press, 1993.

Wingler, Hans. *The Bauhaus.* Cambridge, Mass.: MIT Press, 1969.

Worringer, Wilhelm. *Abstraction and Empathy.* New York: International Universities Press, 1980. (Originally published as *Abstraktion Und Einfühlung,* 1908.)

Wright, Frank Lloyd. *Ausgeführte Bauten und Entwürfe von Frank Lloyd Wright.* Berlin: Ernst Wasmuth, 1910.

—. *An Autobiography.* New York: Duell, Sloan, and Pearce, 1943.

—. *A Testament.* New York: Horizon Press, 1957.

Zurcher, Bernard. *Georges Braque Life and Work.* New York: Rizzoli, 1988.

III. Books on the history of education and others

Ashwin, Clive. *Drawing and Education in German-Speaking Europe 1800–1900.* Ann Arbor: UMI Research Press, 1981.

Barnard, Henry. *Pestalozzi and Pestalozzianism.* New York: F. C. Brownell, 1859.

Burke, John G. *Atoms, Blacksmiths, and Crystals.* Los Angeles: University of California Press, 1967.

—. *Origins of the Science of Crystallography.* Berkeley: University of California Press, 1966.

The Committee of Nineteen. *Pioneers of the Kindergarten in America.* New York: Century, 1924.

Downs, Robert B. *Friedrich Froebel.* Boston: G. K. Hall, 1978.

—. *Heinrich Pestalozzi.* Boston: Twayne, 1975.

Education in Japan. Tokyo: Department of Education of Japan, prepared for the 1915 Panama-Pacific International Exposition, 1914.

Hardy, George. *Richter's Anchor Stone Building Sets.* Charlottesville, Va.: George Hardy, 1993.

Heiland, Helmut. *Bibliographie Friedrichfröbel Primär und Sekundärliteratur 1820–1990.* Hildesheim, Germany: George Olms Verlag A. G., 1990.

Hirsch, Elizabeth S. *The Block Book.* Washington, D.C.: National Association for the Education of Young Children, 1984.

Korzenik, Diana. *Drawn to Art.* Hanover, N.H.: University Press of New England, 1985.

Krüsi, Hermann. *Krüsi's Drawing Manual for Teachers—Inventive Course, Analytic Series.* New York: D. Appleton, 1873.

—. *Krüsi's Drawing Manual for Teachers—Inventive Course, Synthetic Series.* New York: D. Appleton, 1873.

—. *Pestalozzi, His Life, Work, and Influence.* New York: American Book, 1875.

Lawlor, Robert. *Sacred Geometry.* London: Thames and Hudson, 1982.

Lawrence, Evelyn. *Friedrich Froebel and English Education.* London: University of London Press, 1952.

Montessori, Maria. *The Montessori Method.* New York: Frederick A. Stokes, 1912.

Niederhäuser, Hans R., and Margaret Frohlich. *Form Drawing.* Spring Valley, N.Y.: Mercury Press, 1984.

Pestalozzi, Heinrich. *ABC der Anschauung, oder Anschauungs-Lehre der Massverhältnisse.* Tübingen, Germany: J. G. Cotta, 1803.

—. *The Education of Man.* Translated by Heinz and Ruth Norden. New York: Philosophical Society, 1951.

Plato. *Timaeus and Critias.* Translated by Desmond Lee. London: Penguin Books, 1977.

Rousseau, Jean-Jacques. *Émile.* Translated by William H. Payne. New York: D. Appleton, 1892.

Sketches of Froebel's Life and Times. Springfield, Mass.: Milton Bradley, 1914.

Sperr, Portia, ed. *Building Block Art.* Philadelphia: Please Touch Museum, 1986.

Tharp, Louise Hall. *The Peabody Sisters of Salem.* Boston: Little Brown, 1950.

Vandewalker, Nina. *The Kindergarten in American Education.* New York: Macmillan, 1908.

Weber, Evelyn. *Ideas Influencing Early Childhood Education.* New York: Teachers College Press, 1984.

IV. Books about the Centennial

Dando, Thomas S. *What Is the Centennial and How to See It.* Philadelphia: n.p., 1876.

Historical Register of the Centennial Exposition. New York: Frank Leslie's Magazine, 1876.

New York Tribune. Extra, No. 35. New York, 1876.

Randel, William Peirce. *Centennial—American Life in 1876.* Philadelphia: Chilton Book Company, 1969.

Smythe, J. Henry. *Guide to the Centennial Exposition.* Philadelphia: Jno. A Haddock, 1876.

Walker, Francis A. *The World's Fair—Philadelphia 1876—A Critical Account.* New York: A. S. Barnes, 1878.

Westcott, Thompson. *Centennial Portfolio.* Philadelphia: Thomas Hunter, 1876.

PHOTOGRAPH CREDITS

INDEX

159